ERIC FISCHL

PAINTINGS AND DRAWINGS
1979 - 2001

ERIC FISCHL

PAINTINGS AND DRAWINGS
1979–2001

HATJE CANTZ PUBLISHERS

CONTENTS

PREFACE

THE VISION OF ERIC FISCHL

The most important thing if art wishes to convince and captivate its audience on the longer term is the artist's own compelling vision, and not some label it is given for convenience, attributing it to a particular direction or movement. The American artist Eric Fischl, born 1948 in New York, is commonly regarded as one of the protagonists of post-modern art of the 1980s, which had the audacity to jettison the more or less dogmatic modernity of Pop Art and Minimal Art and completely ignore Conceptual Art. But Fischl's painterly position is so unique and so original that it makes the historical context of his generation fade into the background. At that time, the joint stance against Modernism, in what was almost a regressive affront, was outwardly distinguished by a synthesis of traditional subjects, craftsmanship and sensuality—all forbidden fruit back then. Today, some two decades on, all that counts is the individuality of the artist and the quality of his work.

Looking back on the last quarter of the 20th century, Fischl cannot be thought of as mainstream. There were always painters alongside the heroes of Modernism who were rated more as outsiders, such as Max Beckmann beside Pablo Picasso, Pierre Bonnard beside Piet Mondrian, Edward Hopper beside Jackson Pollock, and Lucian Freud beside Elsworth Kelly. And in contemporary painting there is no less a place for Eric Fischl than there is for a Brice Marden. Removed from all the pathos and platitudes of Postmodernism, the singularity of his vision becomes all the more apparent. This exhibition, which includes works from thirty years of his production, makes this abundantly clear.

Fischl's paintings and drawings narrate the anything but heroic stories of middle class America, caught in allegorical depictions in which he either directly portrays the actors or personifies them by means of figures from the past. These are so to speak historical paintings ex negativo. The suburbanites who populate his works have had no part in illustrious historical deeds, as are to be found in classic European historical painting. Nor are they shown at work: they are seen rather amusing themselves in comfortable surroundings at their favourite leisure pursuits: lounging about, sitting around, playing, barbecuing, sun bathing, and having sex. In these pictures it always seems to be Sunday afternoon; time is being quietly killed, it stretches out between emptiness and fullness, while under the surface emotions are on the prowl.

These lonely individuals are shown in different phases of their lives, with their attendant psychological experiences. The phase of puberty with the discovery of desire and sexuality, the phase of adulthood between life quality and life crises and the search for meaning, and old age with the confrontation with death. The wealth of flesh that is on show here not only betrays an obsession with Eros, but also with Thanatos. These genre pieces from the "American Way of Life" breathe such mystery because they are charged with allegorical meaning. Conversely, the allegorical mises-en-scène are so down to earth and realistic that they seem almost familiar and everyday.

Although a representational painter, Fischl is not a naturalist. Everything in his paintings is constructed like the films of the Italian Neo-Realists. The scenes, formed almost like tableaux-vivants, have a strongly cinematic and theatrical dimension: the paintings give the impression of filmed theater. Not by chance, circus artistes also make their appearance, including the artist himself as a clown. Like a director, Fischl uses various film or stage sets for his interiors and exteriors: bedrooms, living rooms, bathrooms, houses, gardens, swimming pools, parks, beaches, studios, churches, temples, galleries. The scenery changes from American suburbia to the south of Europe, to India and Rome, from the present to art historical past, before returning to contemporary New York. In his American scenarios, the painter adopts a distance in order to gain insights into the surrounding social realities. Foreign lands, from outside the U.S., are brought up close, adapted, and updated in the cultural context of his homeland. The props he uses are beds, baths, chairs, or cars; the floors of his stage sets consist chiefly of lawns, sand, parquetry, stone, or even water. His dramatis personae appear as single, isolated figures in nudes or portraits, or play their tragic-comic roles in family scenes. The dramatic action in the paintings is concentrated on fruitful moments, those peak experiences when time seems to come to a standstill and the human comedy is revealed in its most evocative form. Although Fischl's paintings depict human stories, the narrative is fo-

cused on small actions and minimal occurrences. There is also scarcely any dialogue in the pictures, which are mostly dominated by an uneasy silence, an atmosphere as if after a breakdown or before a crisis. The group pictures are reminiscent of the conversation pieces of William Hogarth, but without the conversation.

The emotional content is mostly to be found under the skin of the paint, which is rendered transparent by an all-illuminating, all-eclipsing light. Hidden away in there are meanings that convey not glad tidings about the *conditio humana,* but rather an existential despair. The light, midsummer-bright when outdoors, assumes dramatic accents indoors through the sharp contrasts and harsh shadows, which denude and lay reality bare. The paint is as sensual as the palpable skin of a beautiful body, while the picture surface is immaterial, filmic, and the colors appear as a light that outshines the mental image we hold. Fischl's pictures are magnetic and repelling, seductive and distant, warm and cool, hot and cold, as if uniting lust, fear, pain, life and death.

The contributions in this catalogue are all concerned with precisely this: Eric Fischl's unique vision. The American art critic Peter Schjeldahl takes us through Eric Fischl's developments in the 1980s. This decade is also the concern of art historian Jörg Garbrecht. The Baroque specialist Victoria von Flemming follows Eric Fischl on his ways through Rome and finds him in the twilight of chapels and churches, where he encounters the sacred and the profane. Carolin Bohlmann, art historian and restorer, examines the technique in Fischl's drawings. Last but not least, the exhibition's curator, Annelie Lütgens, takes as her starting point Fischl's recent work, and presents him as a sensitive contemporary, an artist one can listen to with pleasure and intellectual gain, as demonstrated by the conversation between Fischl and the American writer Frederic Tuten. The illustrations section of the catalogue follows the structure of the exhibition, inviting the reader to discover various thematic fields in the artist's many-sided work. We wish to extend our grateful thanks to the public and private lenders and especially to Eric Fischl.

This retrospective, Fischl's first major appearance in Germany and the first in Europe for over ten years, has been generously backed by the Volkswagen Bank.

As previously, this support has made it possible to lay on a cost-free coach service to and from the museum and the schools in the region. In this way the Kunstmuseum can once again truly function as a place of learning outside of school, in which art can be experienced in the most perfect way: from the originals.

Gijs van Tuyl
Director

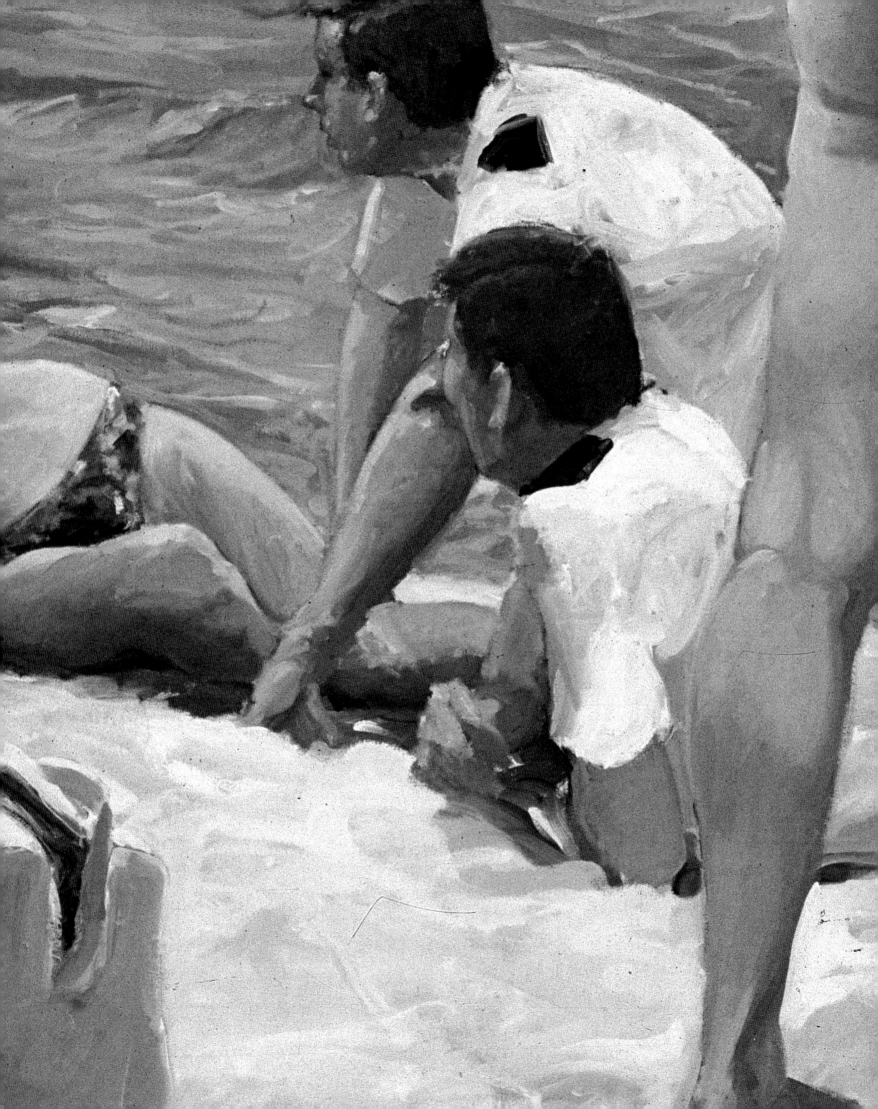

PORTRAIT OF THE ARTIST AS A YOUNG MAN

PETER SCHJELDAHL

Eric Fischl is the first great painter of the U.S. in national decline. His morally ambitious, tragi-comic images reflect the frittering away of American expansiveness, American economic and cultural swagger, American star turns on world stages. After decades of pace-setting for Western visual arts—projecting local products as universal goods—the U.S. has in Fischl a major artist so homegrown in root and branch as to be practically untranslatable, a national classic as special as Winslow Homer or Edward Hopper, Walt Whitman or Mark Twain. Perhaps confirming that the U.S. is no longer an exporting country, Fischl's work baffles most Europeans with its deadpan humor and avoidance of apparent ideological or obsessive edge. It nonplusses Americans, too, but in a way that thrills many: with the intimacy and immediacy, the suddenness, of its address, as if in a room where you thought you were alone, someone spoke in your ear. That room is the besieged mental space of American innocence.

He is a native son of the non-urban middle class, the main factory of innocent American souls. He has the idealistic reflex and temperamental buoyancy of his class, but mixed with a rebellious passion—born of hurt both personal and epochal, an agreement of biography and history—to tell whole truths. He is also the sometime renegade product of a sophisticated art education, inheritor of avant-gardist modes which, at a crucial moment, his work shrugged off. In the early 1980s, Fischl seemed to propose that "modern art" was truly over. His recent, multi-paneled paintings are distinctly re-modernized, rehabilitating cubist and minimalist ideas, but his earlier, radical break remains a permanent challenge, basic to his significance. No conservative return (finding nothing to return to), it reflected—and still reflects—an inspired understanding of what it means to go forward without faith in the future though with confidence, after forty-some years of apocalypse postponed, that there will probably be one. It means having an appetite for available joy and an iron pragmatism.

Eric Fischl is so American he's Canadian. Or so, with a bit of justification, some people in Canada like to feel.

It was at the Nova Scotia College of Art and Design in Halifax, where Fischl taught for four years in the mid-1970s, that the elements of his mature art began to appear and to be duly appreciated, though the first paintings recognizable as "Fischls" would be made in 1979, in New York—as would, two years later, the picture titled *Bad Boy* that staggered the American art world. No one could recall anything like that bizarre bedroom scene, teetering between titillation and horror, in which a boy stares at the crotch of a sensual naked woman while putting his hand into her purse. As a painting, it defied judgement. (It is moderately good by the criterion Fischl's work has since established for itself.) Like a boxer's short punch, known to be more devastating than the roundhouse variety, it seemed to land from somewhere unsuspected because so nearby. That its maker was Canadian, a false report I believed at the time, seemed as reasonable a partial explanation as any.

It turned out that Fischl and the stuff of his art came to New York from far closer that Canada, though they had meandered considerably en route. His development is emblematic of an American generation that had its stumbling youth in the chaos of the 1960s and whose members found their separate ways, or didn't, in the twilit '70s. He also exemplifies the notion that the most original artists survive personal and social displacements, accidents of upbringing that bless and curse them with singularity. The elements in his case range from a classically unhappy childhood to a recent, distinctly American ordeal by fame. However, neither the anxious child he was nor the ambivalent celebrity he has become seems much in key with the kind of artist Fischl is: robustly audacious and idealistically committed, an old-fashioned suitor of the muse. He maintains the gap between "the man who suffers and the artist who creates" that T. S. Eliot deemed essential, though narrowly enough to test, to affirm, art's capacity to redeem pain and to forestall cynicism.

Fischl was born in Manhattan in 1948 and grew up in suburban Port Washington on Long Island in a series of houses, more or less comfortable according to his family's shifting fortunes. He was the second of four children born to a second-generation Austrian-American salesman of industrial-film services and a woman from a well-to-do background in St. Louis. She was an alcoholic, bringing about the special hell known to all families thus burdened. By his own account, Fischl was an unprepossessing youth with no particular inclination toward art or anything else. He entered college in Pennsylvania in 1966, flunked out in record time, and in

(fig. 1) Eric Fischl, **Funeral**, 1980
Oil on canvas, 60" x 96"
Hirshhorn Museum & Sculpture Garden, Smithsonian Institution,
Washington DC

1967 joined his generation's lemming run to San Francisco's Haight-Ashbury. It was a time creative in the mass and horrendously destructive for many individuals, an experience not adequately expressed in any art until years later. (Hardly ever "ahead of its time," art is commonly a generation behind: styles of the '60s were dominated by '50s-type technocratic and social optimism.) It was a key moment for Fischl, who recounts his failed leap at liberation with characteristic wit.

"I remember being in a crash pad with thirty people and realizing I didn't like any of them," he says. "I thought there must be something wrong with me and maybe I should take more drugs to straighten myself out." What tore it for him, finally, was an expedition to Big Sur with a friend and the friend's girlfriend. They were going into the interior to lead the savage life, striking fire from flint and so on, and prepared themselves by ingesting quantities of LSD and befriending an Indian rather less wise to the wild than they supposed. On the first day the Indian returned ashen-faced from scouting to say there was a bear ahead. "The only thing we had between us," Fischl recalls, "was an aluminum knife I just bought at a gift shop. I looked at the aluminum knife and thought about what a bear is like. I ran all the way down the mountain, with everybody else right behind, into a gorge it took us three days to get out of." In 1968 Fischl showed up at his parents' new home in Phoenix, where he lay around the house for some weeks and then got a job delivering patio furniture.

A fellow truck driver was an art student and an aspiring, not very good avant-gardist: "he glued slices of bread to windowpanes." In a mixed spirit of curiosity and rivalry, Fischl decided to try art, too. He went to a junior college for a while, then enrolled in the quite substantial art school at Arizona State University. There a painter named Bill Swaim, a devoté of Kandinsky's mystical theories of abstraction and Arshile Gorky's organic surrealism, was the kind of teacher Fischl says "everyone needs who is going to amount to anything, the kind who ignites your being." At Swaim's urging, in 1970, he applied to CalArts in Valencia, California, an art school that had been taken over and revamped by the Disney organization. One of Walt Disney's last and least likely brainstorms, CalArts had been conceived as a hands-off, anything-goes center for the aesthetic equivalent of pure research, which in practice became pell-mell avant-gardism and student behavior so scandalous that utopian policy later gave way to hard-headed rules. With David Salle, Ross Bleckner, Matt Mullican, Jack Goldstein, and others destined to make names for themselves, Fischl joined the school's remarkable first entering class.

Also in 1970, back in Phoenix, Fischl's mother ran off a road in the car she was driving alone and was killed. It was the terrible end of a grim situation: a rigidly maintained veneer of normality suppressing literally unspeakable fear, rage, abandonment, and self-blame. "When I was growing up," Fischl has said of his mother, "my family was very united around the problem of her drinking. The tragedy of her death blew us apart." The family deposited her ashes in the Arizona desert, conducting a sad, furtive rite that bespoke their alienation. One of Fischl's first figurative paintings, done nine years later, *Funeral* (fig. 1) is a composite of snapshots Fischl and others took at the ceremony—indecorously observing the occasion in more than one sense, presumably to keep a self-protective distance. The painting is about death's devastation of the living, bleakly isolated in grief or, like the boy looking at the viewer (hating the camera, transfixed by the camera), sullen distraction. It is a harsh, rasping picture, ironized by its John Fordian setting and widescreen proportions and given a surreal chill when one realizes that the man dumping the ashes has two heads! It seems Fischl simply couldn't decide what attitude to give that figure. He often complains that, having grown up mostly among women, he is incapable of empathetically visualizing adult males.

The worst part of having an alcoholic or otherwise addicted parent is probably the realization, unbearable for a child, of being loved less than a mere substance, a *stuff*. Fischl recalls feeling unwanted: "I always felt, 'I shouldn't be here'." The experience is tragically common, though hardly universal. All but universal in the U.S. since World War II, however, is some milder variant of deficient parental love, springing from relentlessly debilitating social forces: disappearance of the extended family, loss of geographical roots, communal culture's death in electronic culture—the list is numbingly familiar. The alcoholic parent is only an extreme case of the exhausted and distracted parent most Americans can call readily to mind, overburdened pillar of a nation failing as both Mother Country and Fatherland. A consequently

lifelong, identical ache in so many hearts may go far to explain Fischl's popularity, though it is immaterial, finally, to the complicated miracle of his art.

At CalArts, Fischl was an abstract painter, then an unhip thing for a young artist to be. By the early '70s, all received forms of avant-garde art, never mind more traditional varieties, had been done to death by a compulsive turnover of styles and ideas in an exponentially expanding American Art world. Though often fiercely intelligent, the last throes of modernist progress were not a pretty sight when they were a sight at all: conceptualism, catchall term for all manner of formalized ephemera, made art a rumor. Obligatory truculence toward the bourgeoisie finally succeeded, against tall odds, in dampening nouveau-riche appetites for aesthetic novelty. The contemporary art market nosedived. At the same time, never in American history had so many artists been ensconced in so many institutions. Fischl joined a nationwide community of driven, confused youths who knew they wanted to be artists but had no secure notion of what artists do.

"Everybody at CalArts knew that painting was dead," Fischl says. "Nothing was good enough. I remember we'd have critiques where people would tear each other to shreds simply out of boredom"—though so, he acknowledges, out of a kind of honor, the imperative of a pitiless generational bullshit-detector. The action was in conceptualist, photographic, performance-oriented work, much of it informed by feminist consciousness-raising. Marooned from the past and from the wider society, CalArts was essentially tribal, a big, weird family to replace, for Fischl, the family shattered by his mother's death. He was as awkwardly out of step in the one as in the other, true to a "sense of metaphysical mission" he attributes to Swaim. Unable to stamp out Fischl's idealism, the skeptics of CalArts gave it a good, hard tempering. In his typically delayed, ruminative way, he would also profitably apply some CalArts-type aesthetics, taking a detour into conceptualist work that led him back to painting.

Photographs of paintings Fischl made in 1974, soon after arriving at the Nova Scotia College of Art and Design, show an attempt to infuse abstraction with psychological heat—along lines laid down by the sculptor

Joel Shapiro. Shapiro was causing a mild but influential sensation with tiny, block-like, cast-metal pieces in the shape of houses, chairs, bridges, animals, and so on: naive images piquantly and somehow movingly at odds with a cool and impeccable minimalism. Fischl's paintings *Bridge* and *House* cultivate a similar doubleness, making worldly references in a language of geometric abstraction. *Bridge* goes as far as it can to describe a bridge over a gorge without rupturing a *de rigueur* flatness reinforced by use of tactile oil/wax medium (à la Jasper Johns and Brice Marden); and *House* cautiously reinforces the shape of the image by having it be also the shape of the canvas. Such work brought Fischl a response at once favorable and very frustrating: "I would have this form or this color stand for a certain feeling, a certain *meaning*. There would be meaning in it for me, but I came to realize the meaning wasn't there usually for anyone else. Everybody else would be talking about formal ambiguities, ground and picture plane, Hans Hofmann push-pull. I would get so disappointed." The formalist era of Frank Stella's dictum "what you see is what you see" had cauterized people's inner eye, and all Fischl's devotion to the ideals of his elders couldn't get it open again.

If, in Halifax, Fischl did not become Canadian, it was not for want of willingness. He found security in an institution with a tradition of attentiveness to European art combined with active connections to minimalist and conceptualist circles in New York. He met the painter April Gornik, his companion ever since; and he became intoxicated by the old, pungent fishing culture of Nova Scotia, akin to the ones that stirred Winslow Homer and Marsden Hartley in Maine—except that for Fischl the idea rather than the reality counted. By one reckoning, he was merely falling in with the "regionalist" vogue of that ecology-minded moment, a roots-inventing nostalgia for anything presumably primitive. (Every second new art work in those days seemed to have fur on it.) However, Fischl really was sinking roots for himself, if only provisionally and in imagination—projecting a Great Good Place as the antithesis to the Great Wrong Place of his childhood. He regressed into a healing fantasy.

He made regionally flavored, metaphorical sculptural objects including some fish—if fish, like ducks, could be gotten with decoys, they would serve—accompanied by texts derived from a book on phonetics. "At the back

of the throat where the tongue begins," reads one word panel. The startling linkage of fish and tongues is tense with a desire to *speak* through images. Then Fischl realized the natural mode of this desire: narrative. He would tell stories. Yet again, he was following a contemporary mini-movement, but in this phase his originality became unmistakable. "Narrative art" was a widely pursued conceptualistic styloid, usually combining photographs and texts and usually hermetic in appeal. Its practitioners told dull stories on principle, the better to display their structural manipulations. Right from the start, Fischl's stories were gauchely gripping.

First came the Fisher Family, *Ur*-form of the proliferating families that have since given Fischl's complete work the human density and ramification of a Russian novel. The Fisher Family comprised a fisherman, his wife, and their children. As endlessly retold in public by Fischl—whose peculiar sense of being duty-bound to communicate has made him a heroically forbearing interview subject and lecturer—the tale of the Fishers is crude, quirky, and compelling, answering some unkillable childish yen in anyone for magical love. It is less a story than a rudimentary, elemental drama. The father must leave his family for the dangerous sea so that they may survive. At home, the son plays with toy boats in preparation for being like his father. The wife, whose household chores (aided by the daughter) have no bearing on the family's chance for survival and thus may be ignored, performs "sympathetic magic" by staying in a bath while her husband is at sea. This helps him catch fish. "Beat the fish" is inscribed on the drawing of a boat next to the drawing of a bathtub captioned "Get one wish."

"Beat the fish, eat the fish," goes another of the chanted "prayers" of the Fisher Family, set to music for a performance staged by Fischl in three Canadian cities in 1977. (During the performance, in semi-darkness, Fischl brushed developer on a mural-sized photo negative, revealing an image he had drawn with a flashlight: the woman in her bath.) The mythic family conjuring the fishy depths is a vision of innocence congested with mysteries of adult love and work, power and responsibility, as conceived by a child. However, the Fishers are also blatantly a compensatory fantasy veiling Fischl's actual childhood: father at sea to explain an absent father, mother in a tub to replace a mother in her cups, and son at initiatory games

blocking the memory of a neglected boy in forlorn, obsessive play. Usually psychoanalysis of art is a procrustean bed, but here the couch fits. Unwittingly, guided by faith in art and feelings of pathos and pleasure, Fischl had rigged up a classical reaction formation, standing his emotional truth on its head. He was, symptomatically, humiliated when a cruel and accurate friend called him on it: "Gerry Ferguson told me, 'Quit kidding yourself about myth. This family is really middle-class, suburban American.' That made me mad, but he was right." Flayed alive, the Fisher Family died.

In New York, where Fischl and Gornik moved in 1978 (and where she has made the grand and haunted landscapes that partly reflect her own experience in Nova Scotia), he continued a series of variable drawing compositions on big sheets of glassine, begun in Halifax, that amounted to experiments with the demythified remains of the Fisher Family. Now the members were as Gerry Ferguson had described them: generic suburbanites drawn from magazine photographs and snapshots, with that air of vulnerable life that seems always to be at Fischl's fingertips. He both knew, and didn't know these characters, these anonymous conductors of intimate electricity. Shuffling father, mother, son, and daughter on separate translucent sheets, he rested the nuancing of body language by distance and position and reveled in the multiplication of narrative possibilities. It would be easy, again, to psychologize, suggesting that Fischl was controlling in fantasy a situation defined, while he grew up, by his lack of control. Whatever its drive, however, his work has entered that area of serious play where acts of art can only be explained by other acts of art. His motive was becoming one with the universal mechanics of narrative art, from the Brothers Grimm to Alfred Hitchcock. Playing with the homely technique of the glassines, he prepared to reintroduce these mechanics to the art of painting.

Painting was in line for many aggrandizements in the late '70s, after two decades of virtual banishment from the center ring of contemporary art. Long starved and scorned in aesthetic philosophies programmatically skeptical of metaphor—the trope without which painting has no business in the world—the old art was suddenly gobbling up a generation's best energies like Pac-Man.

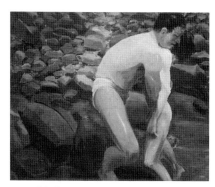

(fig. 2) Eric Fischl, **Grief**, 1981
Oil on canvas, 60" x 65"
Cincinnati Art Museum, gift of the RSM Company

SLEEPWALKER
page 26

Americans, Germans, and Italians had a "Hunger for Images," in the phrase of Berlin critic Max Faust; and summer nights in loft districts were perfumed with the loamy smell of oils. Most of the new stuff was flimsy, though infectious. (A brief impulse called "Bad Painting" put to rigorous test the notion that it was now impossible, even on purpose, to paint a lousy picture.) Most of it essentially celebrated the moment rather than taking full creative advantage of the opportunity. Fischl's edge—as, again and for the last time, he might be seen to have taken a cue from fashion—was that he had a *use* for painting.

Fischl's first naturalistic oil painting depicted a toy boat. It said goodbye to the Fisher Family and pointed to Fischl's focus for the next three or so years: the initiation of children into secrets of adulthood. His second painting, *Sleepwalker* (pl. p. 26), shows a boy masturbating in a backyard plastic pool in sight of empty, parental lawn chairs. It seems a pathetic image at first, but the boy's fierce intentness gives rise to an awed sense that this painting is about power: the primal, explosive power to give oneself pleasure, just discovered by a boy. While painting it, Fischl says, he burned with the boy's feelings, of enjoyment mixed with fear of the shameful exposure, which, as an artist, he was unaccountably guaranteeing himself: the picture, whose illusionistic space was still taboo in the art precinct Fischl inhabited, would look corny to the hipsters and obscure to everybody else. In fact, one former critical supporter did pronounce anathema on Fischl's new mode of work, but the effect of that, while distressing, was just to convince him that there could be no going back. Meanwhile, responses from his American contemporaries were vastly different: moved, delighted, and curiously grateful. He was onto something.

Fischl was onto a violent disagreement of American cultural forms with American feelings, part of what President Jimmy Carter, at about the same time, properly and incautiously termed a national "malaise." (Much of the citizenry turned on Carter with the indignation of a confronted alcoholic and, in the next election, opted for pick-me-ups before lunch ever after.) Fischl had no civic intent, wanting only to be an artist (whatever that was) and to relieve his own intolerable emotions; but the luck of the moment synergized the two drives and gave him a shamanistic role. To individuals whose frustrations readied them for catharsis, Fischl's subjects didn't especially matter: a masturbating boy was neither here nor there as an issue, though the haunted view of sexuality thus introduced refreshingly dissolved some residual goo of '60s peace-and-love. What counted was *Sleepwalker*'s inescapable authenticity. On the simplest level, you wouldn't paint anything like that unless you had to, and you would have to only if and because it happened to be the truth. Fischl was promulgating the one great ethical lesson it is within the power of art to teach: how to be true.

When I grasped Fischl's importance, at the beginning of 1982, it was already the occasion of his third solo show with Edward Thorp and the moment of *Bad Boy* (pl. p. 27), an image so disturbing to me that I didn't give it a long look until much later. I was more comfortable with some raucous beach scenes in grisaille, including *Boy Oh Boy* and *Catch*, though a note I scribbled about them and still have—"shades of Reginald Marsh"—tells me that I missed their character by a mile. It was inconceivable that an artist (one of the intelligentsia, one of *us*) could present such vulgar folk with emotional identification, being *of* their coarse and sportive class. (For all his proletarian sympathies, Marsh palpably condescended to the proles.) Another painting slipped under my obtuseness and pried me open like a can of corn. In *Grief* (fig. 2), a man lifts a lifeless boy from the water at a rocky shore. The image packs the punch of a photograph by Weegee, but in tones delicately, vibrantly painterly. Fischl's first completely masterful work, it's a *watery* picture, with anemone colors and a humid feel (a smell, almost). The stones seem about to throb slightly with incipient life, unlike the rag-doll child in the man's useless embrace. The tender handling (extending to the old-fashioned, deliberately inadequate title) eases the way ever so tactfully to a thudding, blazing recognition of death as something that *happens*, banal and ghastly and final.

Fischl's 1982 show gave me another, clinching surprise in the improbable form of the xeroxed artist's statement that accompanied it. What the statement said excited me. It has since piqued many critics, who automatically quote it in writings on Fischl, but as yet without a proper assessment.

"I would like to say that central to my work is the feeling of awkwardness and self-consciousness that one experiences in the face of profound emotional events in one's life. These experiences, such as death, or loss, or sexuality, cannot be supported by a life style that has sought so arduously to deny their meaningfulness, and a culture whose fabric is so worn out that its public rituals and attendant symbols do not make for adequate clothing. One, truly, does not know how to act! Each new event is a crisis, and each crisis is a confrontation that fills us with much the same anxiety we feel when, in a dream, we discover ourselves naked in public."

Things to note skeptically about that highly rhetorical text are, first, that it universalizes a personal debility (observe the sneaky shift from "one" to "us") and, second, that it makes an emergency of a timeless condition of American life that some have regarded positively: the freedom to self-invent, untrammeled by "public rituals and attendant symbols." Wasn't it a little puerile in 1982 to be decrying a fundamental experience to two dozen generations? It was, but with a puerility—an unassuageable insistence on the painfully obvious—that is the archetypal voice of American prophecy, a voice heard rarely which, when heard, gives Americans a shock of recognition. Thoreau, Huckleberry Finn, Nick Adams, Bigger Thomas, Kerouac, or Holden Caulfield (the voice is more often fictional than embodied)—the figure of the unreconciled youth who sees and says the state of things does indeed announce emergencies, though the things are always the same. The voice is male, and it speaks of the otherness of women, society, and the unknown. It speaks—it yells—when the relation between self and world changes sharply, and common sense gives way like a rotting floor. In American history, otherness typically has been "out there" to be discovered and either subdued or propitiated by the innocent ego. In Fischl's abruptly updated variant, otherness is a high tide that comes pouring in, threatening to annihilate an ego seeking only to be *presentable*.

A prophetic document, Fischl's 1982 statement pointed to work he had not yet done—and it still does, giving him a range of potential growth practically inexhaustible. (That's what it means to be rooted accurately in native soil—fraternal opposite to the cosmopolitan who leaps among pinnacles of an international nowhere-in-particular, apt for extraordinary feats and subject to calamity

in a twinkling.) Aside from the minor but faultless *Grief* and the great but perhaps overwrought *Bad Boy* (Fischl ahead of himself, as in his statement), and also the powerful but oddly isolated *Time for Bed* (its flat-out expressionism an option he let drop), his painting before 1982 groans a bit under the weight of his ambition for it. Color is a problem, coming on top of the problem of how, at that late date, to retool a pre-modern deep space. In the grisailles, he set aside the first problem to concentrate on the second, and they are more successful as paintings than other early works, *Bad Boy* included, which seem less colored than "colorized," infused with acidic tints. The tints have an expressive effect—abrasive, biting—but make for an ungenerously drab impression overall. Still, it was obvious to many by early 1982, and I was at last one of them, that this painter stammering toward eloquence in a half-learned language was a presence.

Bad Boy was reproduced seemingly everywhere that year, as if people couldn't get enough of it. New York being New York, wits worked overtime: playing on a form of title used by Neil Jenney, Robert Pincus-Witten dubbed an article on *Bad Boy* "Snatch and Snatching," neatly pegging its contrivance. Laugh as one liked, however, there was no taming an image that seemed to come from somewhere beyond art and, firing through the art world like a particle through a cloud chamber, to be headed somewhere else. Fischl was publicly accommodated, and belied, by being usually lumped under the rubric of "neo-expressionism," with the apparent logic that, like other artists thus designated, he was "hot" in content and in market performance. (The market was going crazy for reasons that the disgruntled reduced to "dealer hype," though dealers were mainly hanging on for dear life. Some had a tighter grip than others, of course, and no one was surprised in 1983 when Fischl joined the very tenacious Mary Boone.) As he had been as a hippie and an art student and a participant in shows of Canadian artists, Fischl was again odd man in.

Since more must be said about *Bad Boy*, a zone of turbulence I have yet to stabilize in my own judgement, let it be said by Fischl, always the best exegete of his paintings. He has a story for the evolution of every one of them and enjoys telling it, with a literary flair that pleasantly reverses the normal expectation that pictures illustrate words. Shortly after painting *Bad Boy* in 1981, he wrote how it happened:

BAD BOY
page 27

"How I make a painting, picture it…

A bowl of fruit. Yes fruit! Apples and oranges but especially bananas. I love to paint bananas; big bananas. Pan across the bowl of fruit…

Where is it? A bedroom? Ah! a bedroom. Put in the bed. Put in a window. Pull the blinds. Light streaming through the bamboo curtains. Southern light, feel the heat. Border town. Borderline behavior. Put in table. Install the phone. What if someone calls? Take the phone off the hook.

Anyone home? A couple's on the bed. What've they been doing? Feel the heat!

No, he's not right. He has to go. She rolls over. Hot, idle, a little bored, she's picking at her toenail. Look what she's showing us! A real looker. Eyeful. She's not alone. There is a child on the bed looking out the window.

Who are these people? She's old enough to be his mother. She is his mother! Feel the heat. Feel the edge.

He gets off the bed; goes to the table. He can't take his eyes off her. What's he doing now? Reaching back behind him. He's reaching into her purse. Change the telephone to a purse. He's going through her purse. He's stealing her wallet! Bad boy."

In common with all gifted story-tellers, Fischl wields the enrapturing power of regulating— tantalizingly retarding, thrillingly accelerating—the arrival of an inevitable conclusion. This power demonstrates the survival in adults of the childlike capacity to dissolve self-consciousness in an imaginary experience of time. While working, Fischl says, he is "hooked on time," which is how I feel when in the spell of his art. That a complex story is telescoped into a single, static image only intensifies my pleasure as, thinking backward and forward, unfolding the tale like an accordion, I combine within myself the roles of tranced story-teller and wide-eyed listener. Fischl provides everything needed (and nothing not needed) to make the story, then gets out of the way. His self-abnegation is basic to the communal subject/object that is my sense of the masterpiece: a specifically occasioned abolition of distances between inside and outside, private and public, self and other, space and time. Of course, the form of the communion is limited culturally, confined to those who can identify with what any particular story is *about*. Fischl limits his international appeal by becoming the virtually religious artist of a savagely secular class.

Fischl has said he wishes he were Roman Catholic, for the "drama" of it, and often "feels Jewish," as in New York anyone is apt to; but he was raised in the most pragmatic of sects, the Congregational, and though non-believing has a soul distinctly Protestant. "Every man his own priest," Martin Luther's liberating, comfortless tenet, catches Fischl's wavelength, a rawly American one with little remaining echo in the social-democratized Protestant Europe. Surely only the U.S. in all the world still allows and inflicts such radically fragmented selfhood: not "individualism" as an ideology (sheer hypocrisy in a corporate order) but individuation as a fate.

Fischl had long been growing up, an intimate process publicly manifested in his work from the guilty excitement of *Sleepwalker* to the exasperated self-consciousness of *Portrait of the Artist as an Old Man,* and it should not be surprising, though somehow it is, that finally he grew up. His development recalls a classic pattern of writers who begin with family novels and proceed to lay imaginative hold on wider worlds, a pattern so extremely rare among painters that I am only a little embarrassed not to have grasped it right away. Done with revisiting sore sites of formative experience, he was ready, and obliged by the irreversible logic of growth, consciously to wield his knowledge. For followers of his art, as for himself, the change entails a loss and a gain: loss of escape from isolated selfhood into poignant vicariousness, and gain of self-affirming autonomy, the adult's equivocal reward for acknowledging death and limitation. The movement, as I've said, is from obsession to ambivalence—meaning from trouble as a crisis to trouble as a permanent state, from pain that afflicts youth to the acceptance that compensates age. Maturity is the condition and the very content of Fischl's recent art, and the viewer is not excused from its implications.

Maturity for Fischl has nothing in common with sweetness or serenity, as is evident in the cold fury of *Saigon Minnesota* and the utter wildness of the triptych *Manhattoes* (named after Manhattan's vanished original natives). The most purely fantastic of Fischl's pictures, the latter is also the most purposefully spectacular (pl. p. 36): a carnival of witches and clowns drawn from collective memory, fiercely particularized, and convened behind the back of the goddess Liberty. Fischl was objectifying—thereby, in a way, killing off as creative material—arche-

MANHATTOES
page 36

types of feelings latent throughout his work, notably an attractive/threatening principle of the female.

How American is Fischl? He is more and more overtly, as he grows, a faithful dramatist of ever declining, ever persisting puritanism, the old spiritual wiring that feeds the mind's products back to itself colored "good" or "bad," meaning under or out of control. With a humor so mordant one may well forget to laugh, he displays the absurd ravages of an ethos not so much weakened as just crazy, demanding categorical judgments in situations hopelessly undermined by the pressure of uncooperative other minds: the ongoing debacle of American innocence, abroad and at home.

The above is a substantially abridged and slightly edited version of a text that originally appeared in Peter Schjeldahl and David Whitney, eds., *Eric Fischl*, New York 1988. Used by permission of the author.

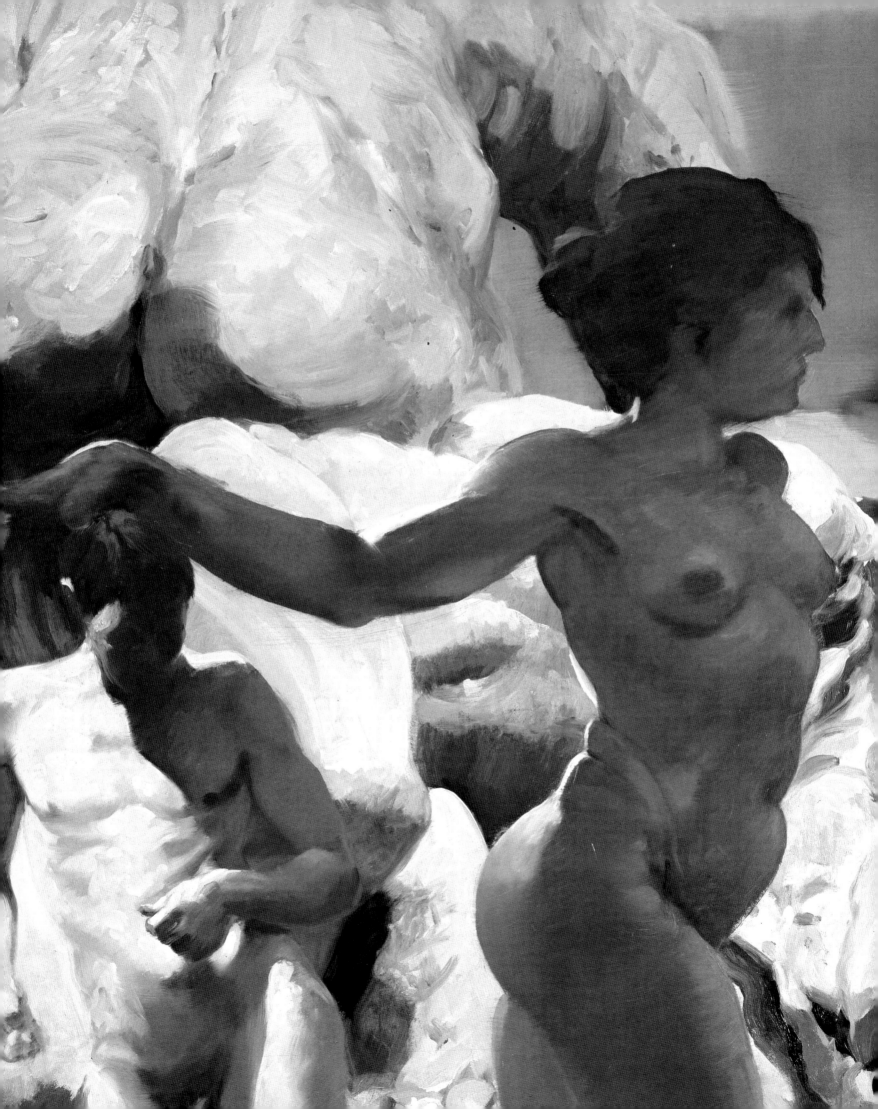

TOUCHED
ERIC FISCHL – BODY SPACE AND LIGHT

ANNELIE LÜTGENS

REMEMBERING

"Early in his career, the simple fact that he was painting people was as weird ... as anything else he might have been up to. For some time, figure painting had been a highly suspect activity."[1] This sentence would constitute an apt introduction to any text on the art of Eric Fischl. It is an exact description of the situation in 1980.[2] "For some time" is not referring to the late seventies but to the late nineties, and the artist referred to is not Eric Fischl but John Currin, an artist born in 1962.[3] Today, two conclusions can be drawn from this. First, the art world's memory does not even extend back even as far as twenty years. Seen from the art-history point of view, the eighties are about as far away as the middle of the nineteenth century. Even today, that decade still has the flat aftertaste of a renaissance in neo-expressive painting that was hyped up by the art market, of a salon art of the late twentieth century. The years of the Reagan administration were years of plenty particularly in the U.S.; a great deal of money was invested, for example, in modern art, and many a painting was bought for its speculative rather than its artistic value.[4] When the magazine *Art Forum* recently dedicated two thick volumes to the eighties, this was a clear sign of the real need to reconsider the decade, to recall its variety and its contradictory nature—aspects that come clearly to the fore in the interviews in *Art Forum* with artists like Cindy Sherman, Richard Prince, David Salle, Jeff Wall, Ross Bleckner, Robert Longo, Jenny Holzer, and Nan Goldin.[5]

Second, it is obviously still possible today for art that is concerned with the human figure, the body and sexuality to disconcert both critics and the general public. At the beginning of Eric Fischl's artistic career, paintings like *Sleepwalker* und *Bad Boy* (pl. pp. 26, 27) did just that. Overnight, these paintings made him famous as a harbinger of unpleasant social truths and infamous as "[a] moralist, as someone who holds up an ethical mirror to us, without mercy," a description given by Arthur C. Danto in 1986.[6] It was not the subjects he chose, it was, more than anything else, his representational style of painting that made the early works of Eric Fischl so scandalous. But the bad boy did grow up. In the following years he experimented with multi-part canvases; perfected his style of painting; developed—inspired by journeys to India and Rome—a new desire to paint light; and began to work in the field of sculpture at the beginning of the nineties.

Looking back over his work of the last few years, it then seems that Fischl, with the assuredness of a sleepwalker, has devoted his attention to themes like orientalism, baroque church interiors or naturalistic sculpture that modern art had not judged to be worthy of consideration since the Second World War.[7]

DRUMMING

Fischl's visit to India in 1989, came, without doubt, too late for an artist whose hippie phase, like everyone else's in his generation, was long over, and who was neither following the Hare Krishna movement nor going to see Bhagwan in Poona. However, for an artist who had been swept away by a tidal wave of success—the ultimate weighty monograph (by Schjeldahl and David Whitney) was published in 1988, right on time for his fortieth birthday—and who had already imagined himself as a *plein-air* painter, old before his time (*Self Portrait as an Old Man,* 1984; pl. p. 57), it was exactly the right time to go.

The list of artists who went to the Orient in order to invest their work with a new lease on life is a long one. However, those artists who, wishing to receive their inspiration first hand, actually went there themselves (Eugène Delacroix, Gustave Flaubert, August Macke, and others) traveled to the French colonies of North Africa. India, on the other hand, a colony of the British Empire since the middle of the eighteenth century, remained, for western painting, an unknown continent. It was Rudyard Kipling and Mahatma Gandhi who first shaped our image of it. In India, Eric Fischl was confronted with, above all, distrust, color, and dust.

All of the 1989/90 paintings which resulted from the photographs that Fischl took in India show outdoor scenes, and almost all of them depict people who cast dark, distrustful looks at us, the viewers. This is how the local people looked at Fischl the tourist, at the water tap, in the tire shop, at the dog races, in front of the temple. Contrary to the assertions of some critics, Fischl is not enticed by the lure of the exotic, or at least, not as a rule.[8] By painting the looks he received, he reveals himself as the stranger he wished to remain. The one exception is the portrait of the friendly, smiling *Chicken Man*

[1] Mark van de Walle, "Against Nature," *Parkett* 65 (2002), p. 36.

[2] See also the essays by Jörg Garbrecht and Peter Schjeldahl in this catalogue.

[3] The young New York artist John Currin, whose work was shown in Germany in the Frankfurt exhibition *Lieber Maler, male mir* (2003), is currently enjoying great success in the United States. His virtuoso perfection of old master painting techniques and his penchant for large-bosomed women join together in a mannered, vulgar mix of styles that is as fascinating as it is disturbing.

[4] For more on art and the art market in the eighties, see Max Hollein, *Zeitgenössische Kunst und der Kunstmarktboom,* Vienna 1999, pp. 23–37.

[5] *Art Forum, 40th Anniversary. The 1980s,* 2 vols., March/April 2003.

[6] Arthur C. Danto, "Eric Fischl," in: Arthur C. Danto, *Reiz und Reflexion,* trans. Christiane Spelsberg, Munich 1994, pp. 32–38.

[7] See also the essay by Victoria von Flemming in this catalogue, p. 114.

[8] Jean-Luc Chalumeau, "Le peintre en bad boy/The Painter as a Bad Boy," in *Ninety: Art des Années 90,* May 1995, pp. 12–13; compare this with the quote from Robert Storr, p. 13.

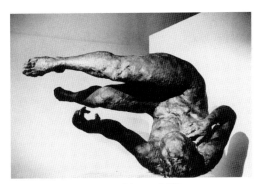

(fig. 1) Eric Fischl, **Tumbling Woman**, 2002
Bronze, collection of the artist

CHICKEN MAN
page 44

KOWDOOLIE
page 43

9 Eric Fischl in an e-mail to the
 author.
10 Leonardo da Vinci, "How to re-
 present a battle," in: *Leonardo on
 Painting,* edited by Martin Kemp
 (selected and translated by Martin
 Kemp and Margaret Walker),
 New Haven and London 1989,
 pp. 228–233.
11 Some examples are: *Arabian
 Horses Fighting in a Stall,* 1843/44,
 Baltimore, Walters Art Gallery,
 or the massacre *The Death of Sar-
 danapal,* 1827, Paris, Musée du
 Louvre.
12 See also David Rakoff, "Post-9/11
 Modernism. Controversy over E.
 Fischl's Statue Tumbling Woman.
 Interview with Eric Fischl." *The New
 York Times Magazine,* 27 October
 2002, p. 15.

(pl. p. 44), an old man with a stick—not a beggar but a man carrying out an undignified job with dignity: he is acting as a walking advertisement, carrying an enormous chicken head. It is interesting that Fischl avoided any folkloristic background effects. Instead, he has painted the man in front of a wall; cutting diagonally across the painting is a poster that appears to be advertising a "circ[us]." There is an artistic philosophy hidden in this confrontation between modernist forms of painting and a Jeff Koons-like object along with a human being: Fischl is not a modernist; Fischl is a painter of people. In India, he was even a painter *among* the people. Or, at least, this is how the group portrait *Kowdoolie* could be interpreted (pl. p. 43). Here we see the painter, a handkerchief wrapped around his head and a drum under his arm, in a group of men and boys, dressed partly in western and partly in Indian clothes. Again, there are no specific local references; the larger-than-life statue of a sitting goddess on the left side of the painting seems to float in the air. Both the goddess and the group are enveloped in a diffuse blue-orange-red light that penetrates every shape and obscures our view. This is dust, mixed in with the red of the evening sky. Fischl described this as follows: "As for Kowdoolie, it is the time of day at dusk when the cows are herded home. The mixture of dust and dusk produces an extraordinary color atmosphere."[9] The painter-drummer communicates this with colors that bring together the cowherds and the fertility goddess, the artist and the children, desire and reality, without resorting to sentimental transfiguration. The flaming red tones, however, also suggest that these people, who seem to have appeared out of nowhere, have escaped from some kind of danger. In his writings on the painting of battles, Leonardo da Vinci speaks at length about nothing other than how one should paint the smoke and the dust and the red mire that is created from dust and blood.[10] Eugène Delacroix, the influential French romantic painter who was an enthusiastic traveler to the Orient, applied and radicalized these ideas in his oriental battle scenes 350 years later.[11] Nineteenth-century European painting discovered a compaction of color and atmosphere in the theme of the Orient. Fischl is aware of this tradition and dusts off any last traces of exoticism.

TUMBLING

In October 2002, public outrage brought the intensely withdrawn painter back into the limelight. As a memorial to September Eleven, Fischl displayed his sculpture *Tumbling Woman* (fig. 1) in the Rockefeller Center in New York. Fischl did not have the intention of creating a universal memorial; what he wanted to express with this figure of a falling woman was his own personal grief and dismay at the terrorist attack. He had not realized that the people of New York were not (yet) ready for an expression of grief in such an artistically compact and timeless form. The bronze sculpture, which brings to mind the work of Auguste Rodin and of Aristide Maillol, shows a twisting and falling female body whose shoulders and head alone touch the ground and whose rounded back and bent legs seem to float in the air. The body seems intact; only the rough, raw surface of the bronze suggests violence. This sculpture and its public exhibition could also be seen as a gesture of atonement, for the woman seems to be floating instead of forcefully hitting the ground. What was intended as a symbolic figure was, however, perceived by its viewers as an atrocity, as a kind of sculptural photojournalism. The images of people jumping and falling from the collapsing Twin Towers were the hardest to bear on that dreadful day and so were the first to disappear from the media. The sculpture awoke memories of these pictures, and was removed after only a few days because of the many angry letters sent by the public.[12]

Perhaps this first statement from an artist, one year after the terrorist attack on the World Trade Center, came too early; perhaps it should have been understood as an expression of individual grief, and not as one of collective grief, which is how it was received. It shows, however, that Eric Fischl has in no way stopped rendering visible that which is painful and that which is denied. The artist is still concerned with existential themes, like our relationship to the body; the relationship between women and men; intimacy, privacy and their boundaries: motifs that bring together sexual, ethical, and social orientations.

The Wolfsburg exhibition shows how the arena of his pictorial narratives has shifted throughout the years, and how their content has become more compact: from family life around the pool of the suburban bungalow, to the theater of nudity found on (mainly)

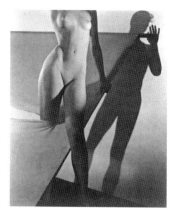

(fig. 2) George Platt Lynes,
Untitled, 1942
Gelatin Silver Print, 9" x 7"
The Kinsey Institute for Research in Sex,
Gender and Reproduction, Inc.

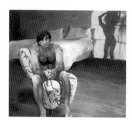

THE BED, THE CHAIR,
DANCING, WATCHING
page 69

[13] Running parallel to the Wolfsburg exhibition is a performance from the Haus Esters in Krefeld in the Mies-van-der-Rohe building, which is based on the current cycle of paintings showing the subjects of *The Bed, The Chair....*

[14] Michel Foucault, "Photogenic Painting," in: Gilles Deleuze and Michel Foucault, *Photogenic Painting. La Peinture Photogénique*, London 1999, p. 91.

[15] His two-part painting *Bayonne* from 1985 made reference to a photograph from Platt Lynes, about whose ambivalence Fischl wrote: "Platt Lynes' photography is cold in a peculiar kind of way. The viewer sees a naked, young, pre-pubescent girl standing there with legs spread wide, and the penetrating effect of the picture comes from the cold way in which the girl is portrayed. ... It is neither clinically nor explicitly sexual, and its neutrality creates an incredible ambivalence. This brings the picture to life: the viewer wants to quickly put it into context—is it good, bad, desirable, not desirable—or is it taboo?" (Fischl, in: Arthur C. Danto et al., eds., *Eric Fischl 1970–2000*, New York 2000, p. 136.)

European beaches, deep into other cultures and then back to the sparsely furnished rooms of his earliest paintings, in which man and woman, bed and chair, present an intimate play in several acts.[13]

PLAYING

The repetition of *The Bed, The Chair...* in the titles of a group of fifteen paintings from 1999–2001 is a clear indication of the montage process that Fischl has used: a few repeating elements can express a broad range of relationships and interactions. The contents of every picture are always listed—a formula that brings to mind Marcel Duchamp and his *Etant donné: 1° La chute d'eau, 2° Le gaz d'éclairage (Given: 1. The waterfall, 2. The illuminating gas)* (1947–1966). Embedded in Duchamp's objects is a female nude in the form of a doll; the viewer has to look voyeuristically through two holes in a massive wooden door in order to catch a glimpse of what Duchamp is portraying. For Fischl, the act of seeing plays a similarly explicit but—as we are here concerned with painting—much more subtle role. Bed and chair (a white armchair decorated with a red bamboo pattern) are his "Etant donnés," which, using computer-manipulated photographic source images, are itemized and changed around in each painting: *The Bed, The Chair, Play, The Bed, The Chair, Dancing, Watching,* and so on.

The series is ultimately a good example of how the intelligent use of (digital) photography can give painting new freedom. Here, photography does not function, as it normally does, as a prop for the memory or as a photographic image source, as was the case in Fischl's Rome or India paintings; instead it is something that the imagination can play with. The slide projector that the photorealists of the seventies used to project their motifs onto the wall so that they could copy them in minute detail—which led to the critical comment by Michel Foucault in 1975 that "they capture an image, and nothing else,"[14]—is given a prominent place in *The Bed, The Chair, Projection* (pl. p. 71). The slide carousel, along with a bottle of ice tea and a paper cup, dominates the foreground of the painting, in front of the sex scene on the bed. The couple are portrayed with much less precision than the objects on the table and seem to be distracted as they are both

turning their heads to the left. We do not see whatever it is that attracts their attention. In any case, the projector is switched off. And so the projection begins.

Further protagonists, in addition to the furniture and the couple, also participate in this intimate piece of theater: the light, and the viewer, male or female. The latter do not have to peer through a keyhole, as Fischl often lays out his compositions in such a way that we seem to be right in the middle of the room with them. The naked man in *The Bed, The Chair, Dancing, Watching* (pl. p. 69), sitting in a ludicrous armchair directly facing the viewer, is attentive and concentrated. In the background, next to the bed, the shadow of a woman is seen. With her bent arm lifted above her head, she seems to be taking off her clothes, moving, dancing. And it becomes clear that it is she who is watching the man. He is the passive one; he is not looking at us. We see him looking at the woman whom we do not see, and so have to look at her shadow if we want to find out what it is that is holding his attention.

Fischl drew on the photographs of George Platt Lynes (1907–1955) for inspiration on the interaction between male bodies and the shadows of women, between the nude, the space, and the light. In works like *Untitled* (fig. 2), 1941 he binds together a torso-like female nude and the shadow of a male nude in an abstract geometric composition, in which the human body is understood, above all, as a shape. This results in what Fischl has, on another occasion, called "coldness."[15] He feels that the perfectly composed modernist photographs are lacking in life, emotion, warmth, and atmosphere—all the elements that account for the appeal of his own paintings. However, he is also inspired by the ambivalent way in which Platt Lynes stages and eroticizes the body. Another of his photographs shows a naked young man with crossed legs on a bed, directly facing the viewer. The bright light falling on him not only throws a sharply defined oblique surface onto the dark wall behind the bed, it also dissects the body diagonally into zones of light and shadow. Thus the young man offers his body and withholds it at the same time, which is exactly the appeal of an erotic mise-en-scène. Fischl also uses this appeal in *The Bed, The Chair, Play* (pl. p. 68). Here the light casts warm shadows all over the bedroom, whose diagonal composition is formed by the sunlit armchair on the right and the bed with the naked woman on the

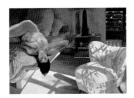

**THE BED, THE CHAIR,
PLAY**
page 68

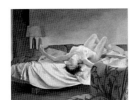

**THE BED, THE CHAIR,
TOUCHED**
page 70

left. She has turned herself towards the light, her closed thighs bent over so that her hips form a ninety-degree angle with her upper body. Her head upside-down, she smiles as she looks at something outside the picture. The scene has the spontaneity of a snapshot; it transmits warmth and intimacy. However, this time, we, the viewers, are spoken to directly, not as secret observers as we were twenty years ago in *Bad Boy* but as participants in an erotic game. The empty armchair directly in the very front of the painting suggests: there is a place for you here!

Fischl does not, however, turn the viewer into the passive counterpart and co-player of his figures, he also appeals to our feelings of shame and compassion. Neither the room nor the woman on the bed in *The Bed, The Chair, Touched* (pl. p. 70) are inviting the viewer to join the game. There are no patches of sun, no erotic decorations on the bedside table, no playful smiles: the room is dull and bare; the bed stretches across the entire width of the painting; the back of the armchair projects into the scene from below like a barrier, a *repoussoir*. The naked body of the woman is utterly convulsed: her hollow back; her thrown-back head which, as the blurred contours suggest, is shaking vigorously back and forth; her wide open arms and bent-up knees all make her appear to be the victim of some kind of attack. It is painful to see her this way, so fragile and defenseless. The viewer would like to pull the sheet up over her, to talk gently to her. However, it is exactly this that the painter does not allow. We are damned to watch, whether we want to or not.

"Touched" not only has a haptic and emotional meaning, but also one of being "stupid, not all there." Fischl has painted the condition of being beyond oneself, and he has done so in the tradition of the representation of female hysteria.[16] Why? Is it in order to add something to his collection of non-classical nudes? Or to evoke with his brush powerful movements—for example, a head shaking—and so to further his project of the reanimation of photography?

I think that with the fixed repertoire of pictorial elements he uses in the series: *The Bed, The Chair...* he is inventing something like a game of scrabble for body language: a scene (a word) is composed by using parts (letters) of another, and one small change can result in a completely different meaning, creating

an unforeseen change of direction from playfulness to seriousness, from desire to pain—a range of emotions that we normally only experience when we are in love.[17] Thus, in his paintings, he could be seen to set up psychological experiments in order to explore the pre-conscious moment: "I paint to the moment before I had words to describe the feelings."[18] This "pre-conscious" does not have any morals. By using body language to communicate with the viewer in his intimate theater pieces, he provokes in us feelings that oscillate between fascination and discomfort. Touched: we are the ones, who at the end—in every sense of the word—stand touched.

[16] See also, *inter alia,* Sigrid Schade, "Charcot und das Schauspiel des hysterischen Körpers," in: Silvia Baumgart et al., eds., *Denkräume zwischen Kunst und Wissenschaft,* Berlin 1993, pp. 461–484; Peter Gorsen, "Die stigmatisierte Schönheit aus der Salpêtrière. Kunst und Hysterie im Surrealismus und danach," in: *Die verletzte Diva. Hysterie, Körper, Technik in der Kunst des 20. Jahrhunderts,* exh. cat. Städtische Galerie im Lenbachhaus, Munich, and Staatliche Kunsthalle Baden-Baden, Cologne 2000, pp. 43–60.

[17] "It is body-language I respond to most. Gestures trigger memory and associations and I use them as doorways or entrances to events that will evoke in the viewer similar feelings and associations." (Eric Fischl in a conversation with Frederic Tuten in this catalogue, p. 98.)

[18] *Ibid.,* p. 100.

FROM POOL TO BEACH

TELEVISION HAS BEEN MY MAIN INFLUENCE BECAUSE THAT'S WHAT
I LOOKED AT WHEN I WAS GROWING UP, AND THEN LESS FREQUENTLY
FILM ...
I PREFER FILM TO TELEVISION. FILM HAS A RICHNESS OF LIGHT THAT
TELEVISION DOESN'T. IT HAS A REAL, SENSUOUS QUALITY.
I FEEL COMPETITIVE WITH FILM AND PHOTOGRAPHY. THEY'RE SUCH
INCREDIBLE VISUAL INVENTIONS.
IN MY PAINTINGS, I'VE USED IMAGES OF TELEVISIONS, WALKMANS,
TELEPHONES, BINOCULARS, ET CETERA, BECAUSE THEY'RE ALL
SENSE EXTENDERS ...
IT'S A CONFLICT BETWEEN THE INNER AND THE OUTER BODY,
BETWEEN THE LIMITATIONS OF THE PHYSICAL WORLD AND THE DESIRE
FOR THE ALL—SEEING, ALL—HEARING, ALL—KNOWING THAT IS PART
OF OUR EGO.

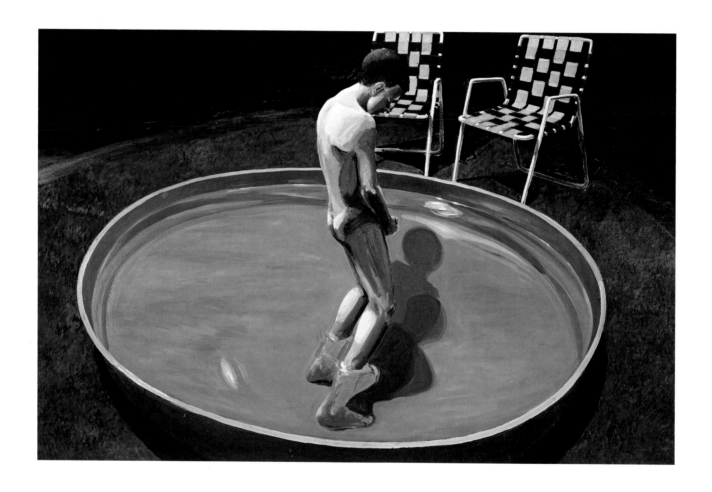

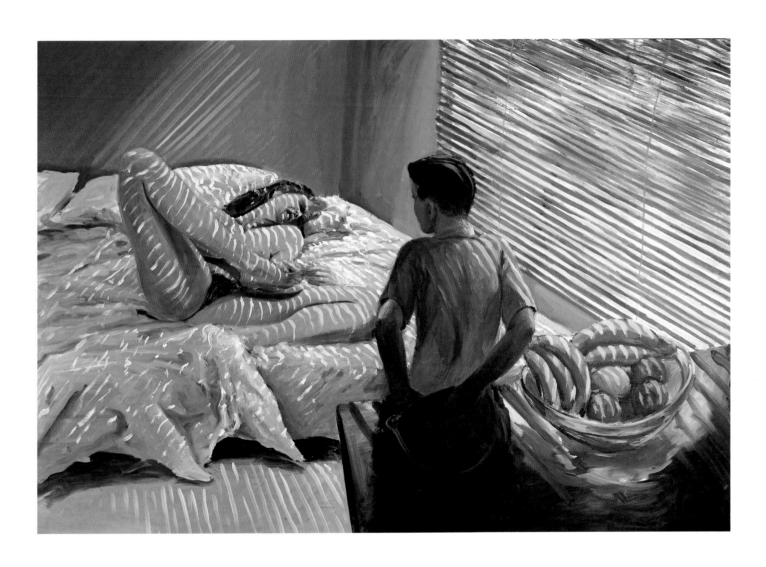

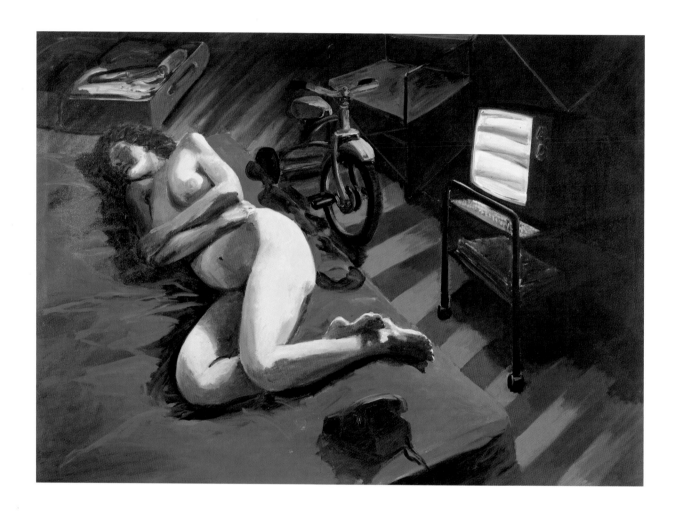

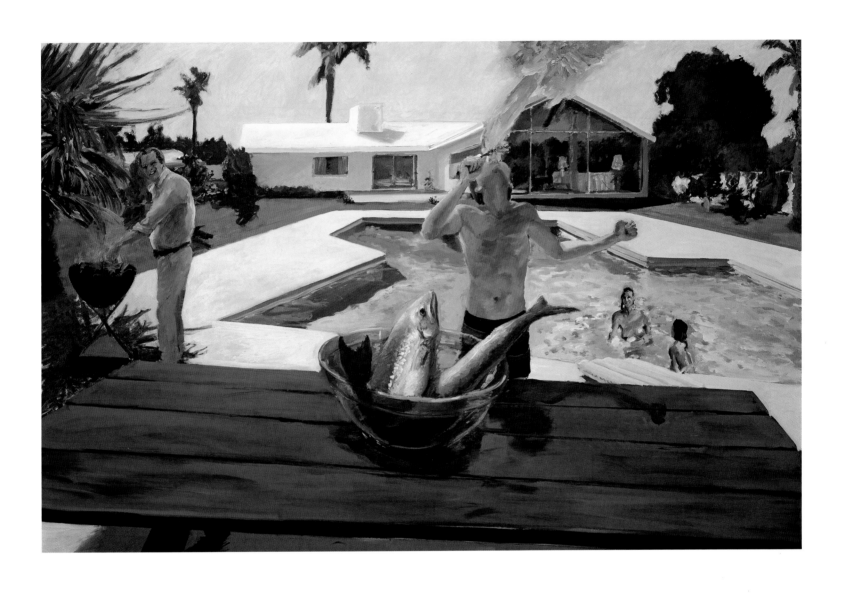

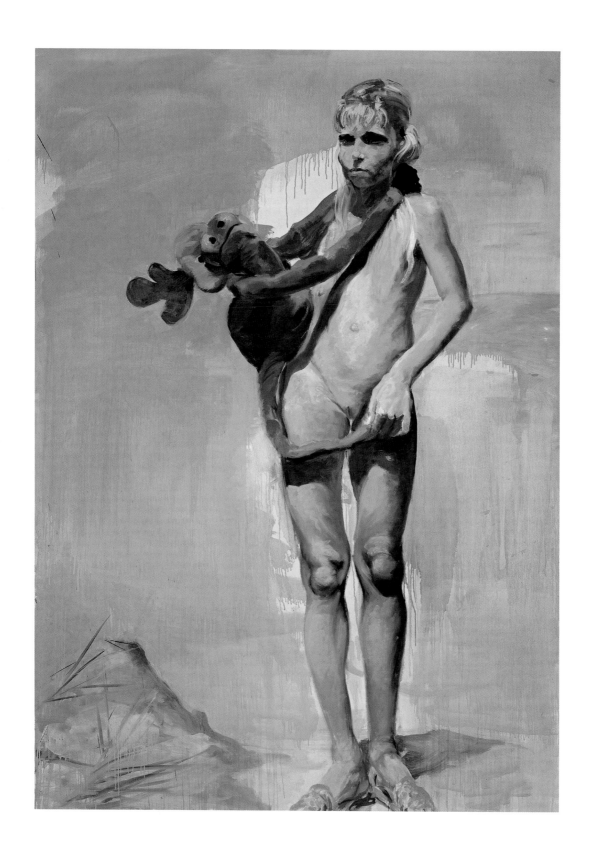

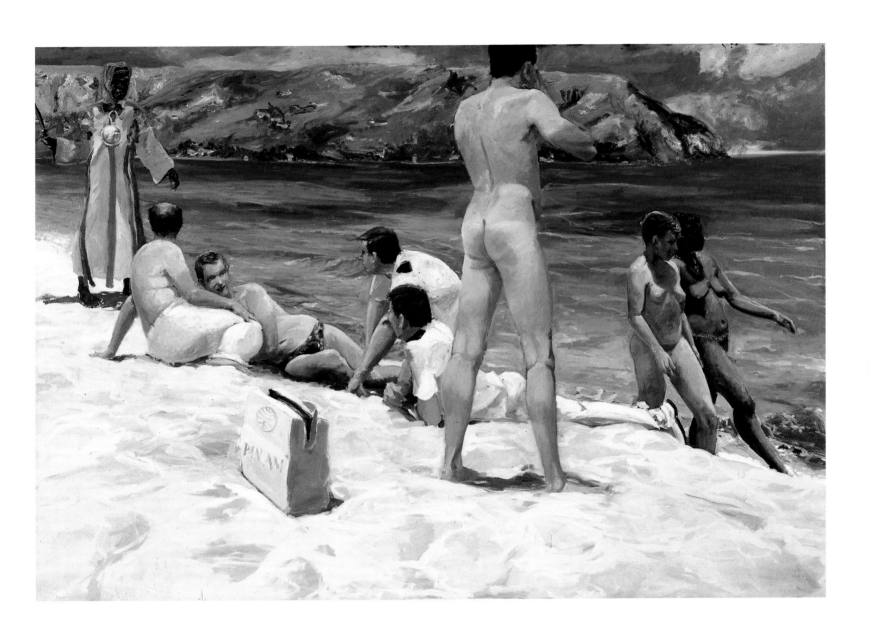

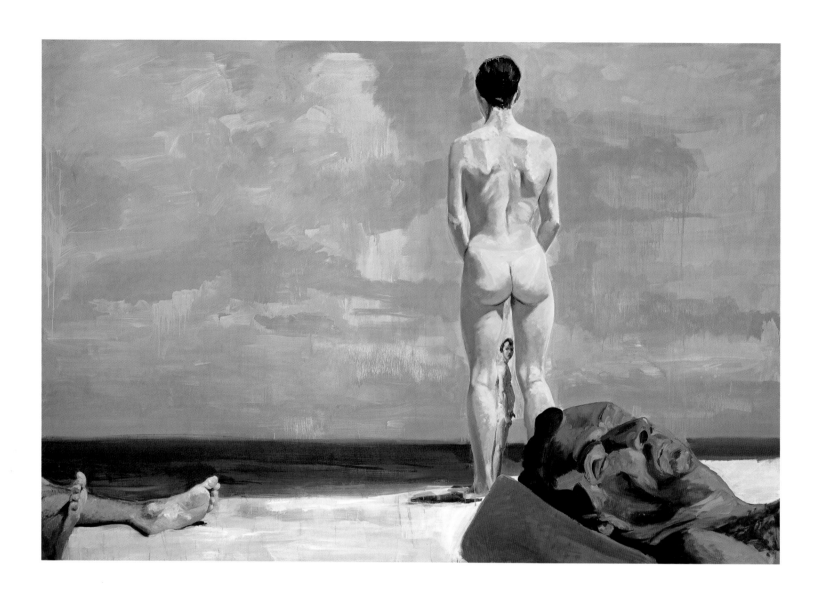

ALLEGORIES OF POLITICS AND PRIVATE LIFE

THE MULTIPLE CANVAS

THE MULTIPANELED PAINTINGS OF THE MID–1980s WERE A DRAMATIC
BREAK FROM THE WAY I USED TO MAKE PAINTINGS.
TIME IS VERY MUCH A PART OF THE EXPERIENCE OF THE WORKS:
THE TIME IT TAKES TO CONSTRUCT THE SCENE AND THE TIME IT TAKES
TO BREAK IT DOWN. EACH PAINTING HAS ITS OWN SPECIFIC SHAPES.
FOR ME EACH PANEL WAS LIKE A SEPARATE BUT INTACT ARTIFACT
OF MY MEMORY.
I WANTED THE VIEWER TO EXPERIENCE THE CONSTRUCTING OF THE
SCENE SIMULTANEOUS WITH THE DISCOVERY OF THE SCENE.

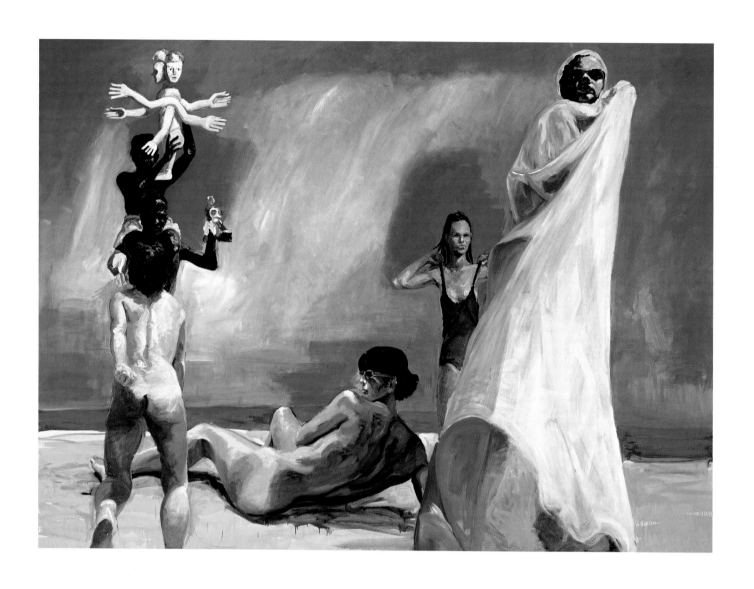

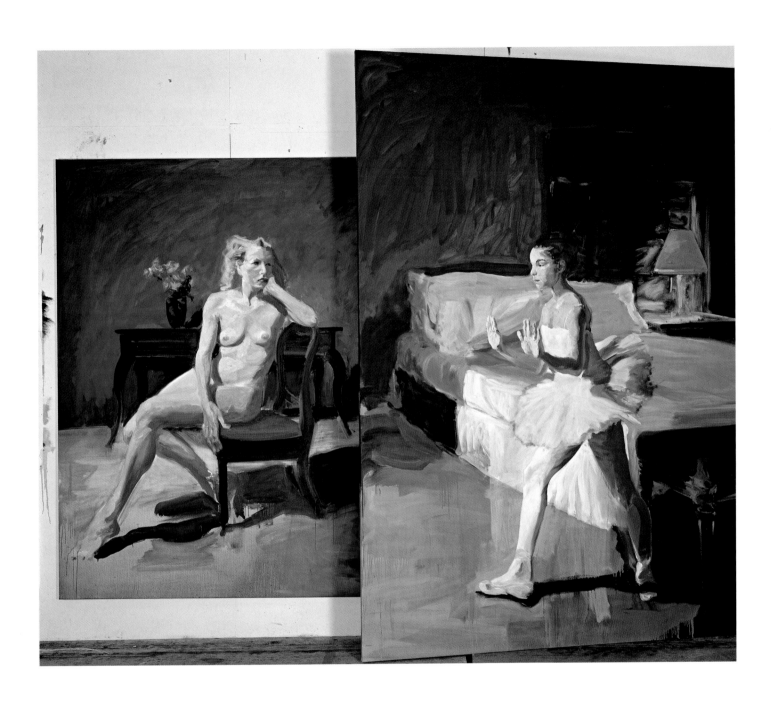

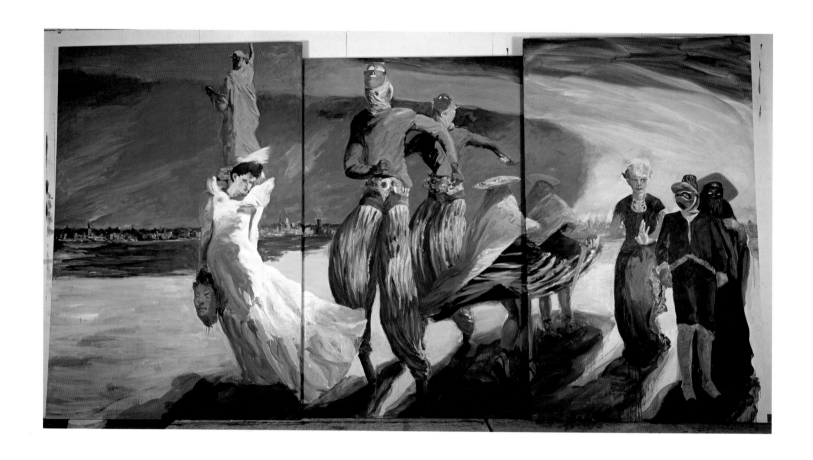

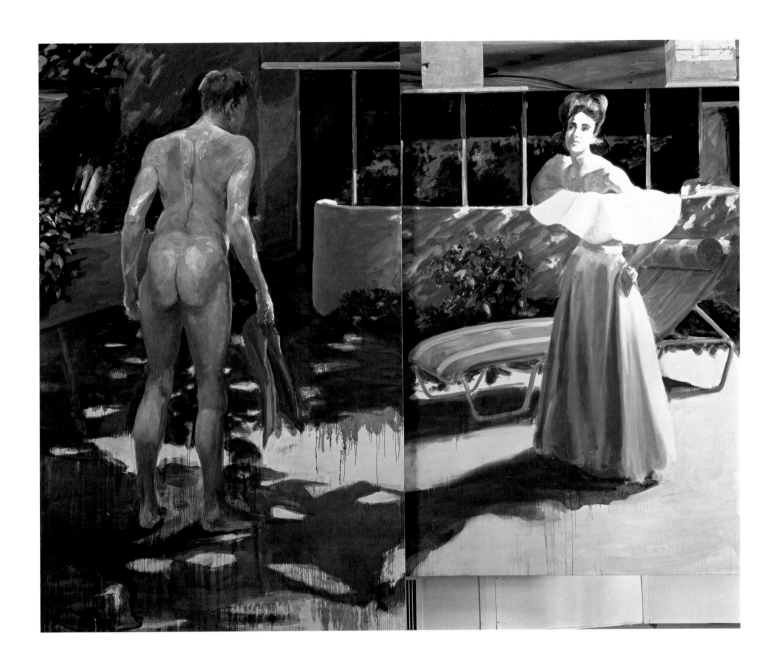

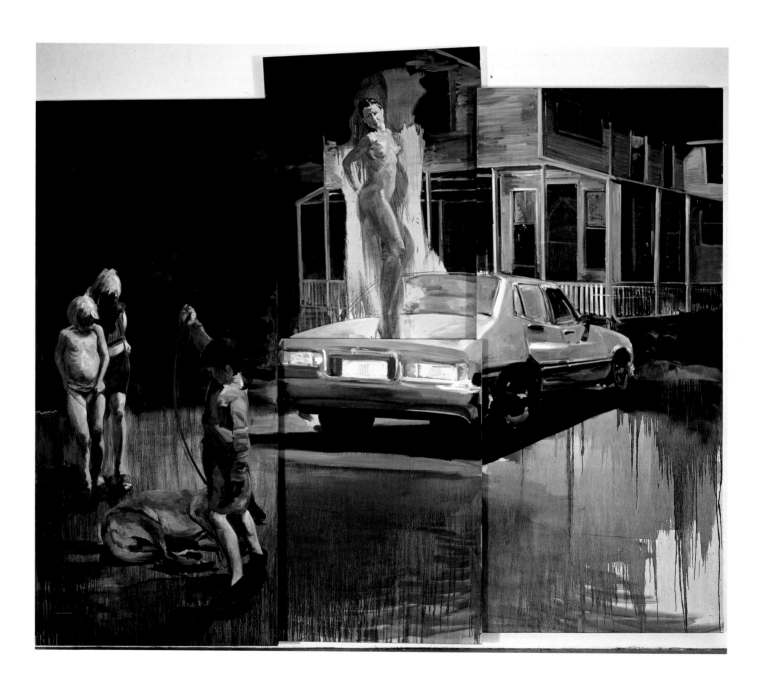

SEEN ABROAD

INDIA WAS THE BIGGEST CONFRONTATION I EVER HAD WITH
OTHERNESS, AND THERE WAS NO WAY I COULD PENETRATE THE MANY
LAYERS OF CULTURAL MEANING.
WHEN I LOOK AT THE BODY OF PAINTINGS I DID FROM THAT TRIP
I REALIZE HOW I FELT LIKE SUCH AN OUTSIDER.
WHAT WAS SO INTERESTING TO ME ABOUT INDIA IS THAT BECAUSE
THE BODY IS SO HIDDEN IT BECOMES THE SAME THING AS NAKEDNESS.
IT'S THE OPPOSITE AND THEREFORE THE SAME.
AND, OF COURSE, INDIA IS INCREDIBLY SENSUOUS. IT'S SO MUCH
ABOUT THE SENSES—SMELL AND TASTE AND THE VISUAL.
WHEN I WAS THERE I WAS SO HAPPY TO HAVE AN EXCUSE AND
A JUSTIFICATION FOR EXPLORING OTHER COLORS.

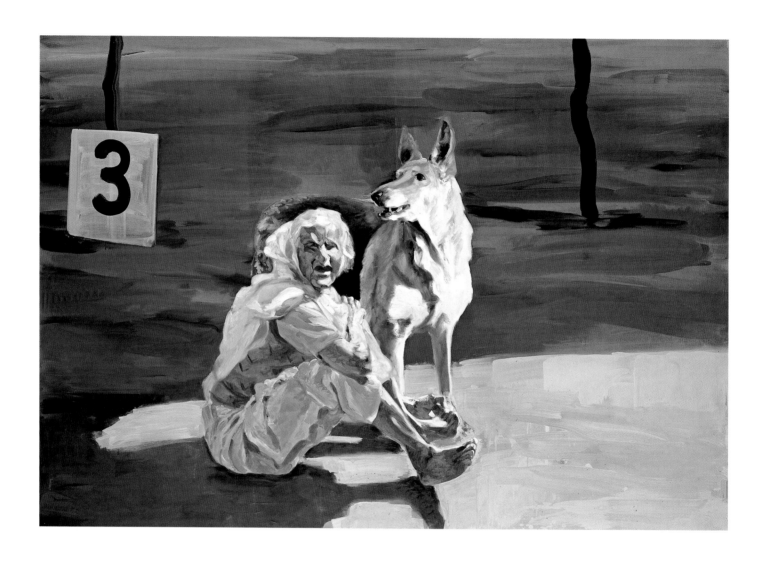

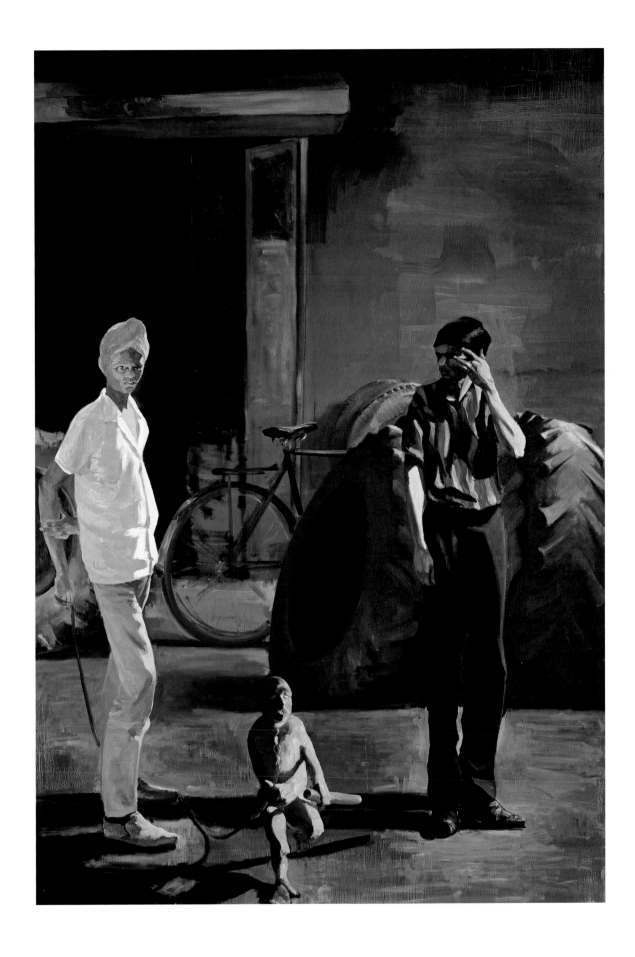

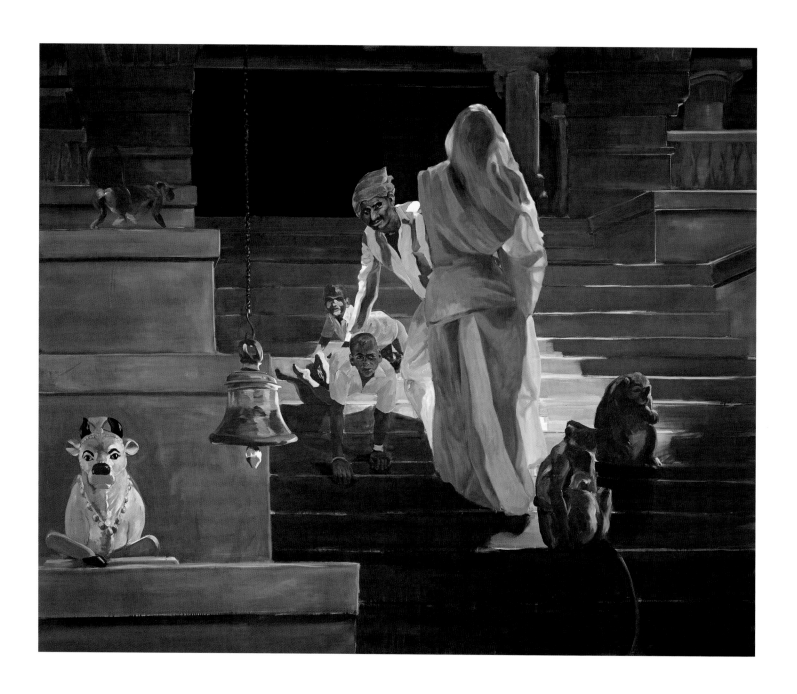

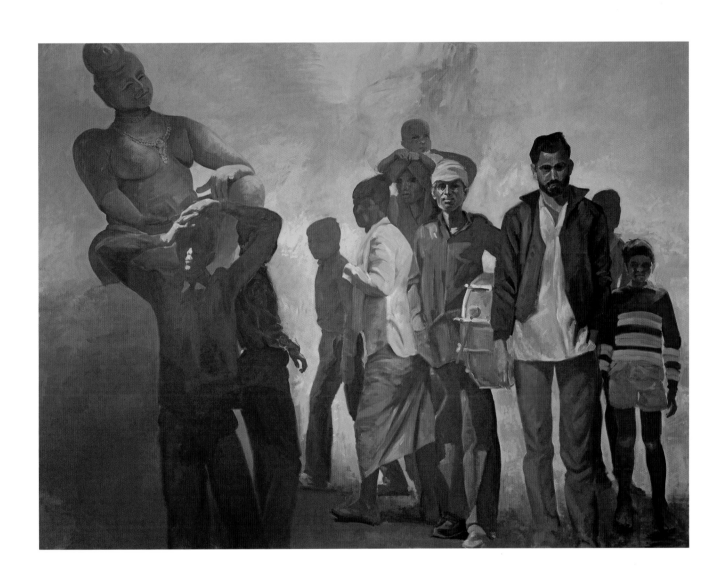

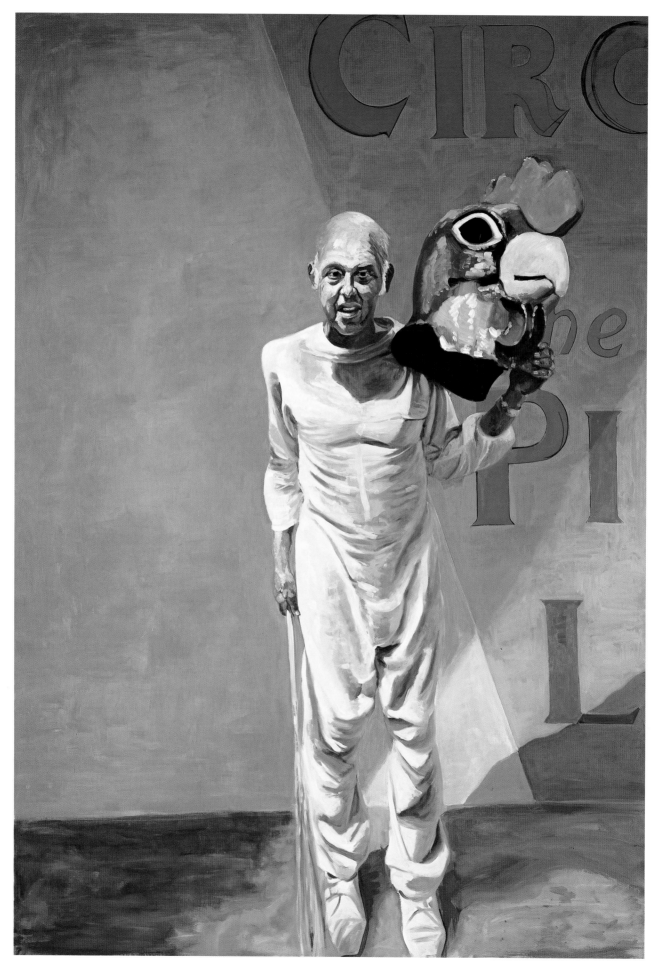

CHIAROSCURO

IF YOU NEED TO MOURN—AND I WENT THERE JUST AFTER MY FATHER HAD DIED—ROME IS THE BEST PLACE TO DO IT. IT'S A CITY THAT IS ALL ABOUT MEMORY; IT'S ABOUT THE PAST AND ITS CONNECTEDNESS TO THE PRESENT ...

IT'S ALSO A CITY IN WHICH RESURRECTION IS PART OF EVERYDAY EXPERIENCE BECAUSE WORKERS KNOCK OVER A STONE IN A ROAD AND A RUIN APPEARS UNDERNEATH ...

IN ROME YOU LIVE WITH GREAT ART, AND GREAT ART TALKS TO YOU ABOUT LIFE AND ABOUT DEATH, ABOUT GRIEF AND ABOUT LOSS, AND GIVES YOU PERMISSION TO HAVE ALL THOSE FEELINGS ATTACHED TO THEM.

IN THE ROME PAINTINGS I USED EUROPEAN ARCHITECTURE TO EXPRESS LONGING. IT'S ALSO WHERE I BEGAN TO WORK WITH THE CHIAROSCURO THAT I FOUND SO INSPIRATIONAL IN ITALIAN BAROQUE PAINTING.

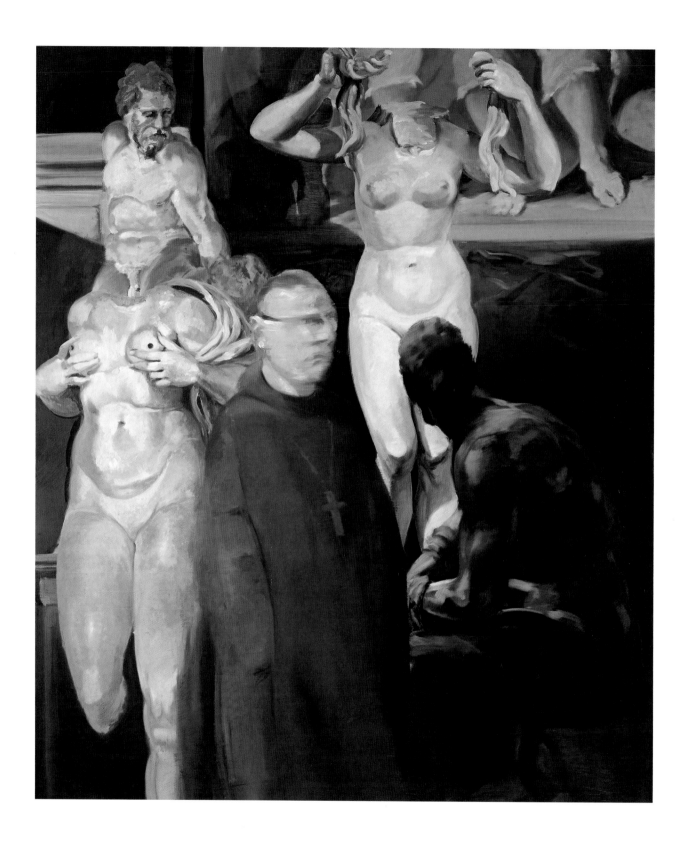

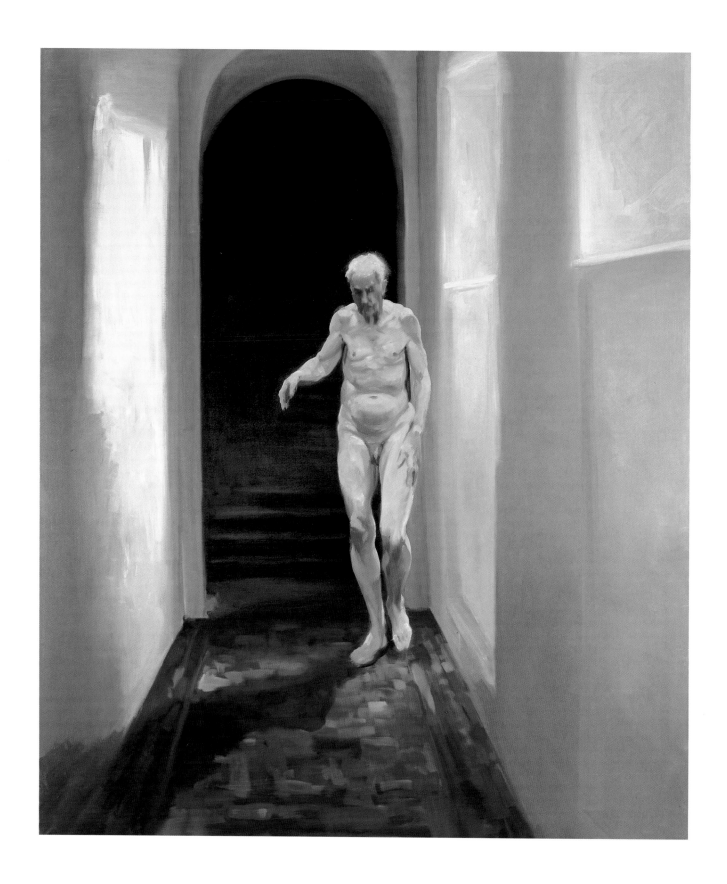

FRAILTY IS A MOMENT OF SELF REFLECTION 1996

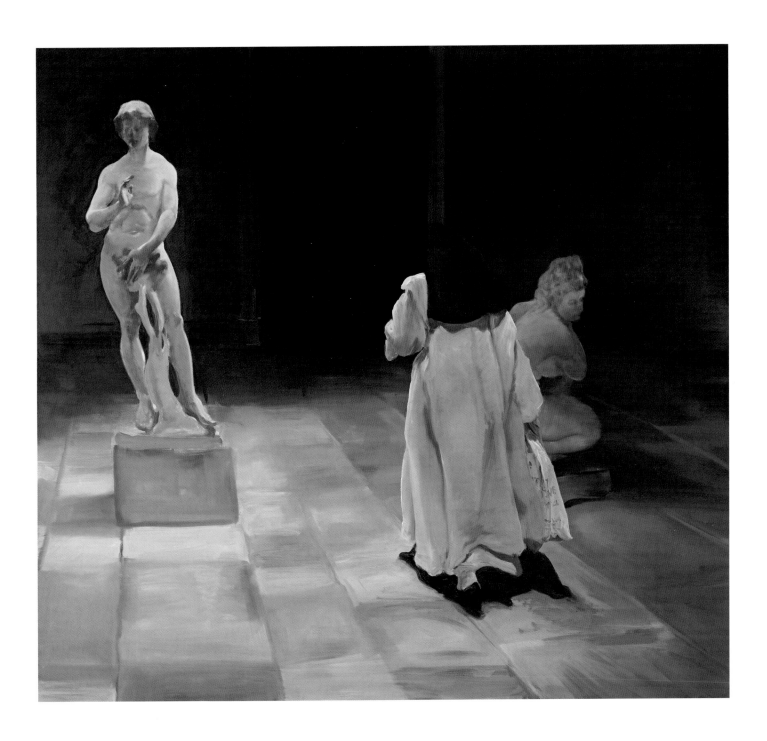

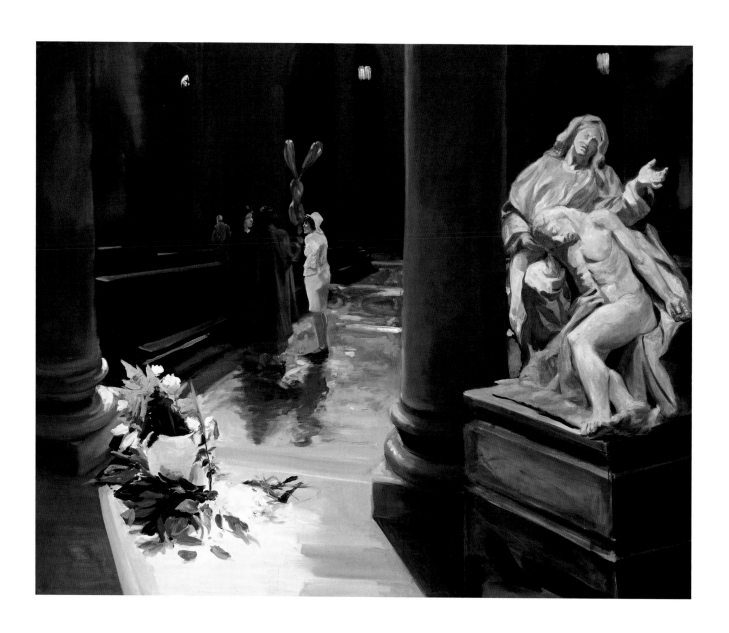

IN THE PARK

'WHY THE FRENCH FEAR AMERICANS'

THE PAINTING IS SET AGAINST A CAROUSEL BACKGROUND, SO THERE'S
A SENSE OF BOTH AMUSEMENT AND OF LIFE AS A MERRY-GO-ROUND.
THE WOMAN WHO'S TAKING HER CLOTHES OFF IS ELDERLY AND
THERE'S SOMETHING SELF-ASSURED ABOUT HER.
SHE'S SO CONFIDENT THAT SHE MUST BE SENILE. THERE'S A
FRENCHMAN SITTING ON A BENCH PASSIVELY WATCHING.
MAYBE THE WHOLE THING IS A PROJECTION, A FANTASY ON HIS PART.
BUT I WAS THINKING WHAT MAKES THE FRENCH UNCOMFORTABLE
IS ANY BREAK FROM THE BOURGEOIS STANDARDS AND MORES.
THEY'RE CAPABLE OF GROSS BEHAVIOR. ALSO, THE FRENCH ARE
APPALLED BY THE UGLY BODY AND HERE'S A WOMAN WHO
CLEARLY HASN'T ATTEMPTED IN ANY WAY TO KEEP HERSELF UP.
I THINK THAT WOULD BE A SOURCE OF EMBARRASSMENT.

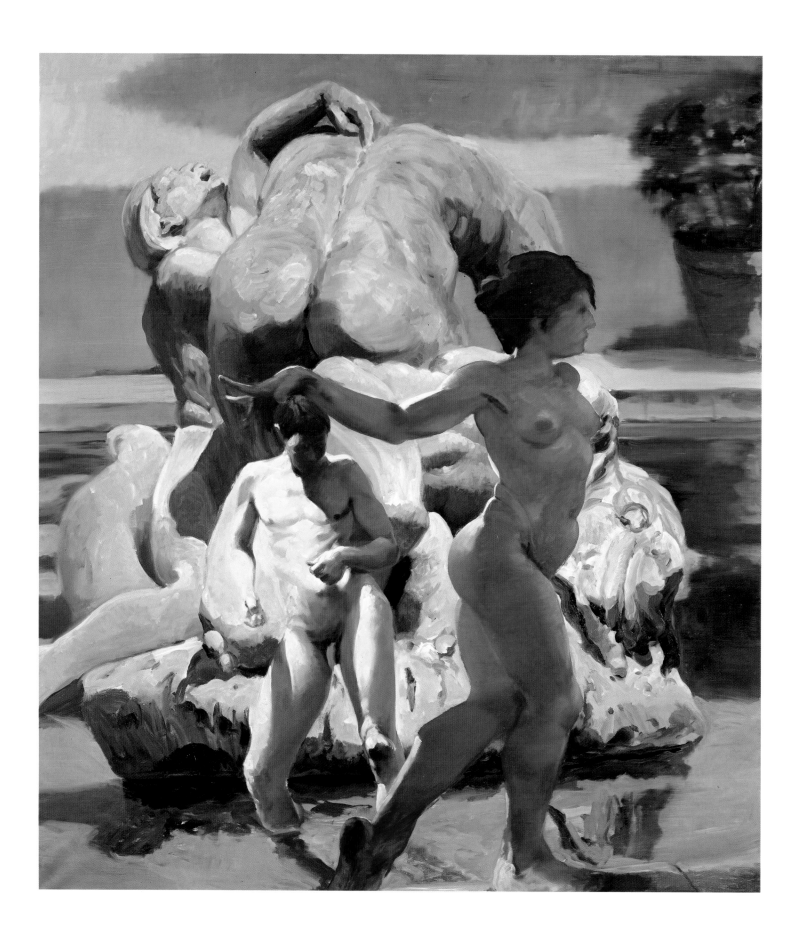

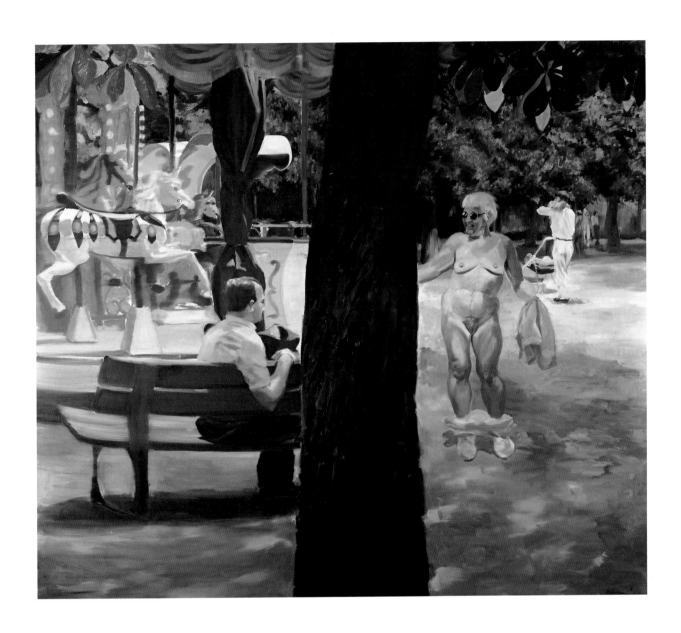

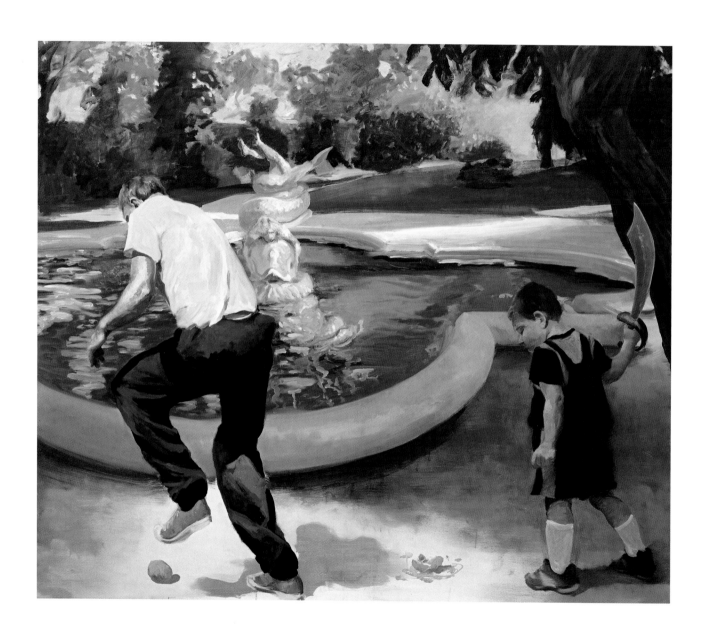

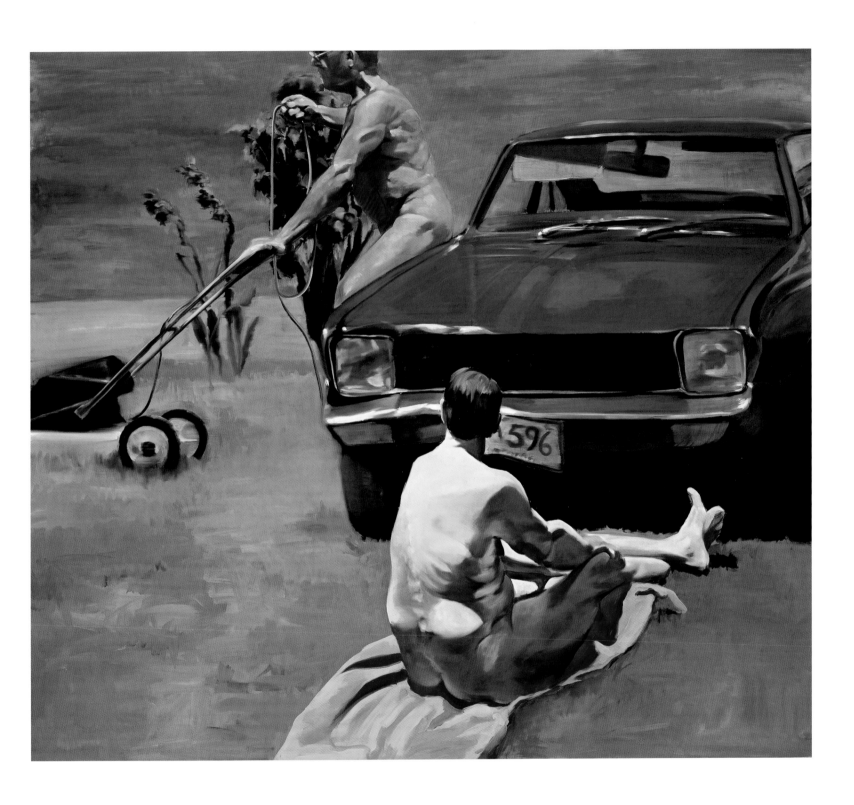

AN ARTIST'S ROLE PLAY

BEING A PAINTER

I PAINT TO TELL MYSELF ABOUT MYSELF. PAINTING IS A WAY OF SAYING WHAT IT IS LIKE TO BE ME. IT'S ALSO A WAY OF SAYING WHAT IT IS LIKE TO BE ME LIVING WITH YOU. IT'S ABOUT THE INDIVIDUAL PSYCHE AND THE INDIVIDUAL FORMED BY THE OTHER.

SELF-PORTRAITURE

I SO OVEREXPOSE MYSELF IN MY WORK THAT THE IDEA OF EXPOSING MYSELF FURTHER IN A SELF-PORTRAIT SEEMS ABSURD.
I DON'T THINK THAT LOOKING THE WAY I DO CARRIES ANY OF THE THINGS I CARE ABOUT, FEEL ABOUT, OR WANT TO EXPRESS ...
IN 'PORTRAIT OF THE ARTIST' IT WAS LITERALLY AND FIGURATIVELY SELF-EFFACING TO PUT ON A MASK—SHRINER'S HAT WITH EYES AND EYEBROWS.
WHAT ATTRACTED ME TO IT WAS THAT IT INTEGRATED SO BEAUTIFULLY WITH MY FACE SO THAT YOU ALMOST COULDN'T TELL WHICH WAS WHICH, EXCEPT THAT IT WAS SO STRANGE.

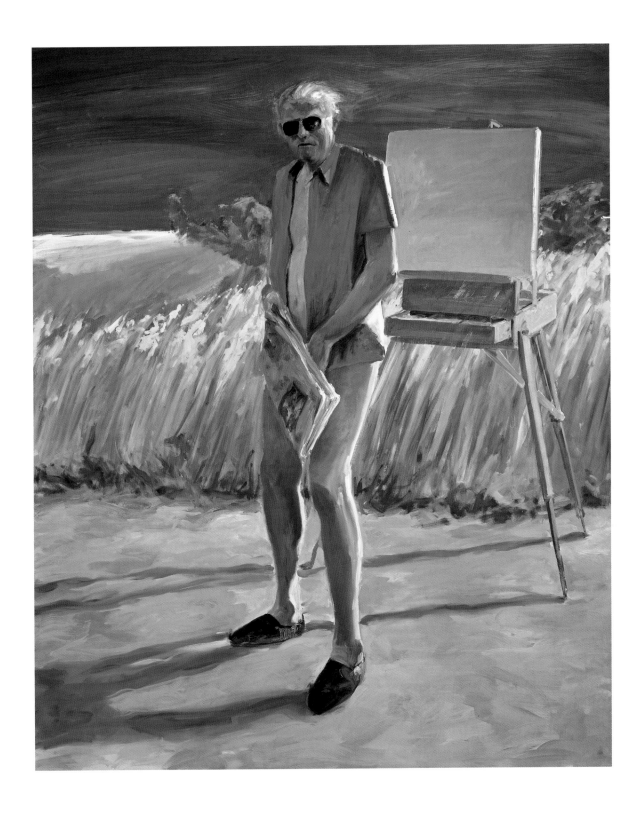

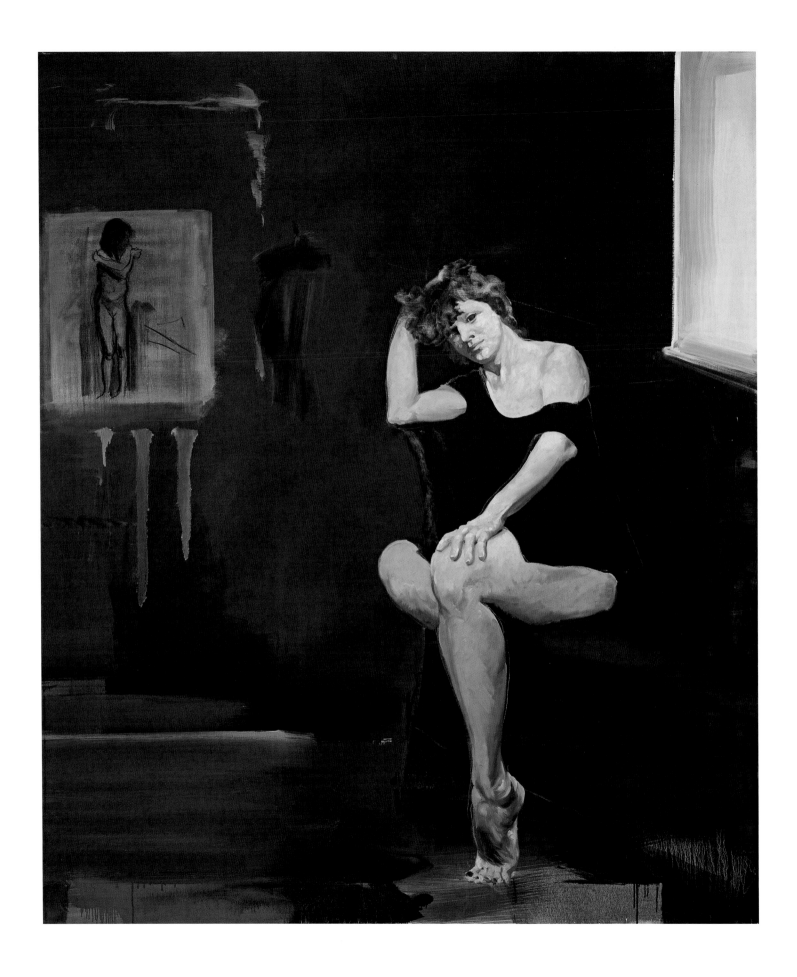

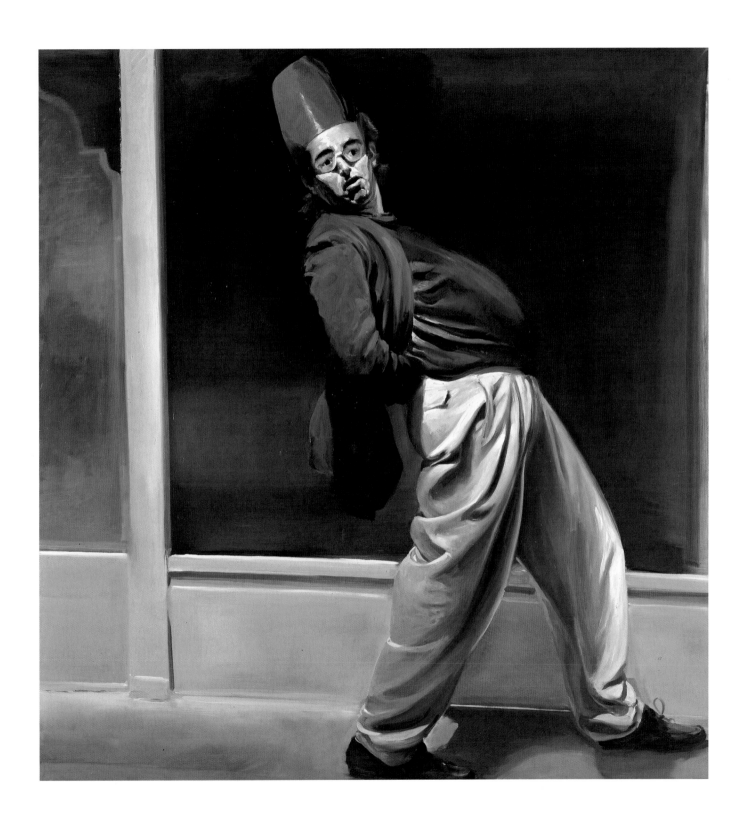

PORTRAITS

PORTRAITURE

PAINTING PEOPLE YOU KNOW IS TERRIFYING. IF YOU HAVE GOOD FRIENDS THE IDEA OF NOT LETTING THEM SEE HOW YOU SEE THEM MAKES NO SENSE. YOU NATURALLY MOVE INTO THE REALM OF FEELING.

IN A PORTRAIT YOU GO THROUGH MANY LIKENESSES BECAUSE A PERSON DOESN'T LOOK ONE REDUCIBLE WAY. THESE LIKENESSES CAN BE RADICALLY DIFFERENT, WHICH YOU SEE WHEN YOU TAKE A LOT OF PHOTOGRAPHS OF SOMEBODY; THEY MOVE SLIGHTLY, THEY ANIMATE THEMSELVES IN A DIFFERENT WAY, AND ALL OF A SUDDEN THEIR FACE CHANGES SHAPE, THEIR BODY CHANGES SIZE—IT'S AMAZING HOW MUTABLE THESE THINGS ARE.

SO WHICH PERSON DO YOU ARRIVE AT? WHICH ONE SUMS UP HOW YOU SEE THEM AND FEEL TOWARD THEM AND HOW YOU SEE YOURSELF IN RELATION TO THEM?

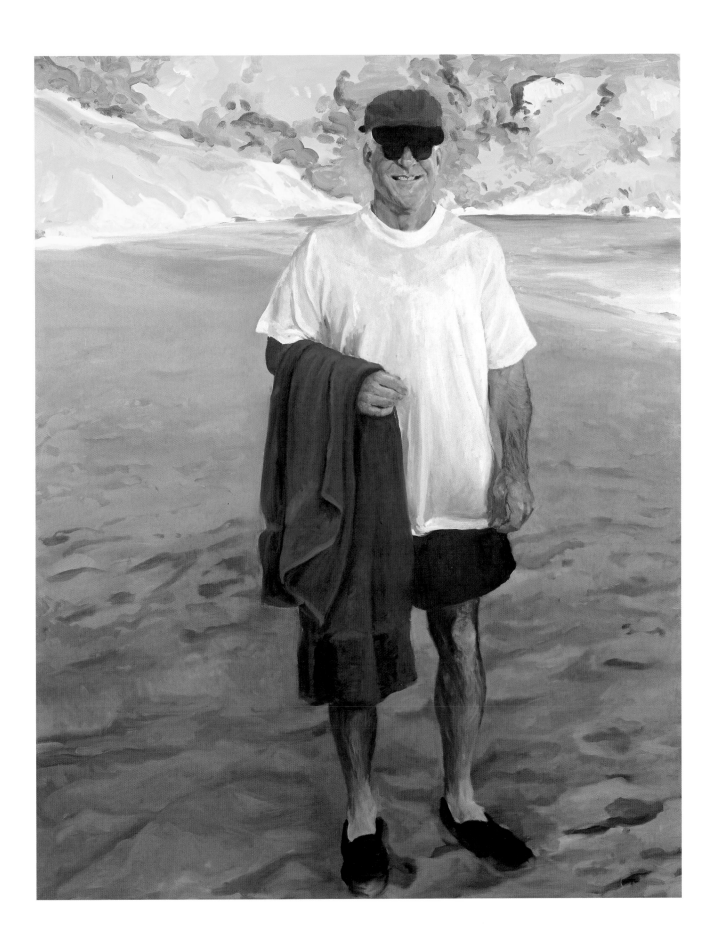

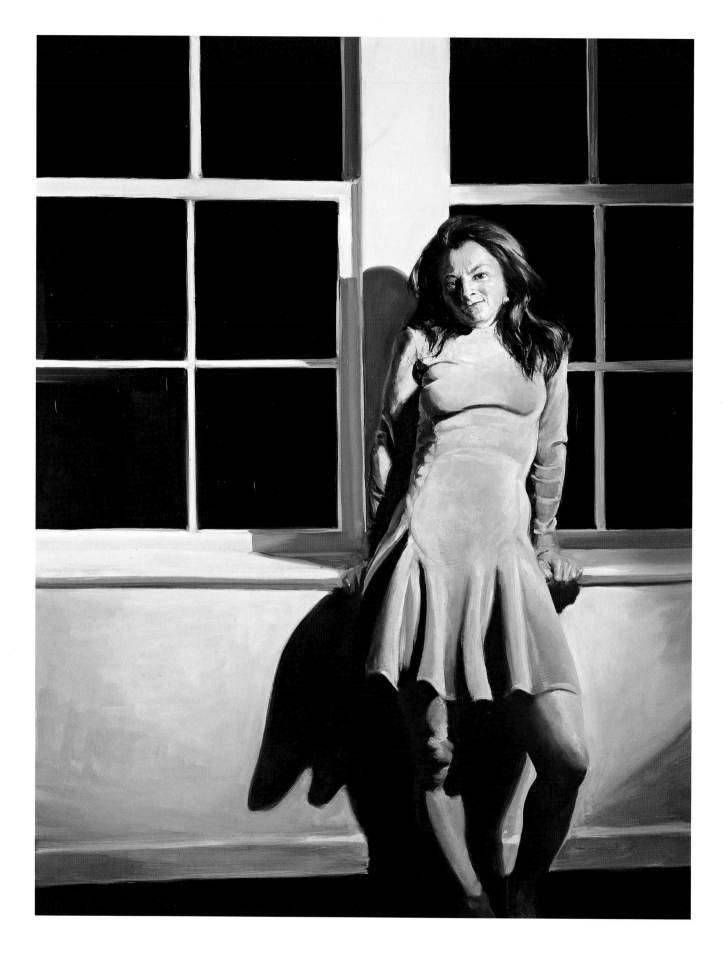

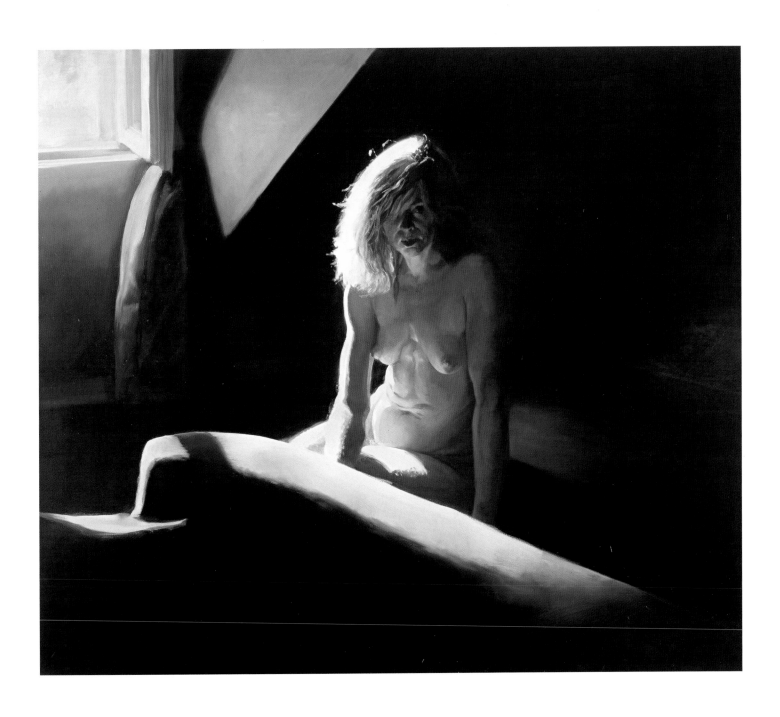

THE BED, THE CHAIR... SERIES

ON LIGHT

LIGHT HAS ALWAYS BEEN IMPORTANT TO MY WORK.
EARLY ON I WORKED WITH THE LIGHT OF THE SOUTHWEST, WHICH
IS HARSH AND FLATTENING. SHADOWS ARE CRISP AND HARD
AND THE LIGHT PERVASIVE. IT IS A LIGHT THAT HOLDS NOTHING BACK.
OVER THE YEARS I HAVE BECOME INTERESTED IN A DIFFERENT
KIND OF LIGHT, ONE WITH MORE DEPTH AND SUBTLER OPACITIES
AND TRANSPARENCIES.

ON AUDIENCE

THE EXPERIENCE OF A WORK OF ART REALLY IS AN ACT OF
POSSESSION. A PAINTER WANTS THE VIEWER TO INTERNALIZE THAT
PAINTING, WANTS HIM TO POSSESS IT, IF NOT TO PHYSICALLY
LIVE IT.
THAT'S WHERE THE UNION BETWEEN THE ARTIST AND
THE AUDIENCE OCCURS.

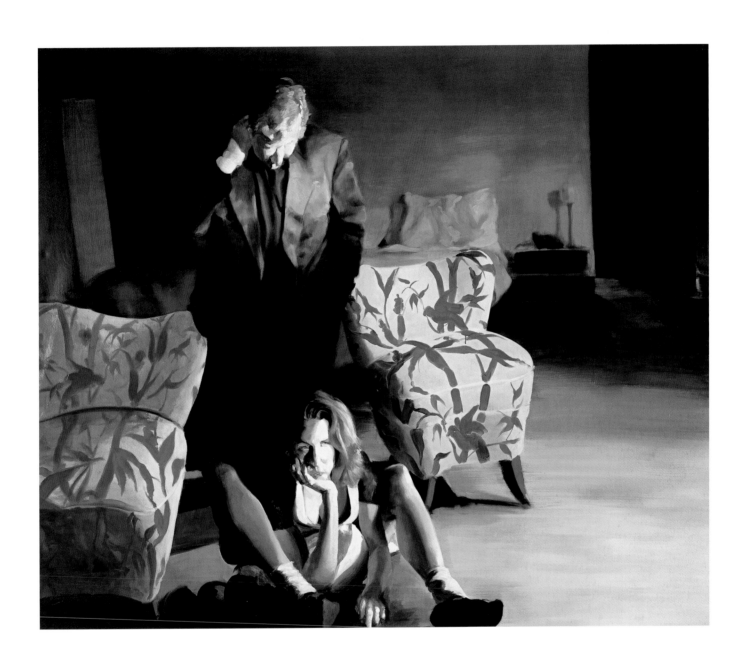

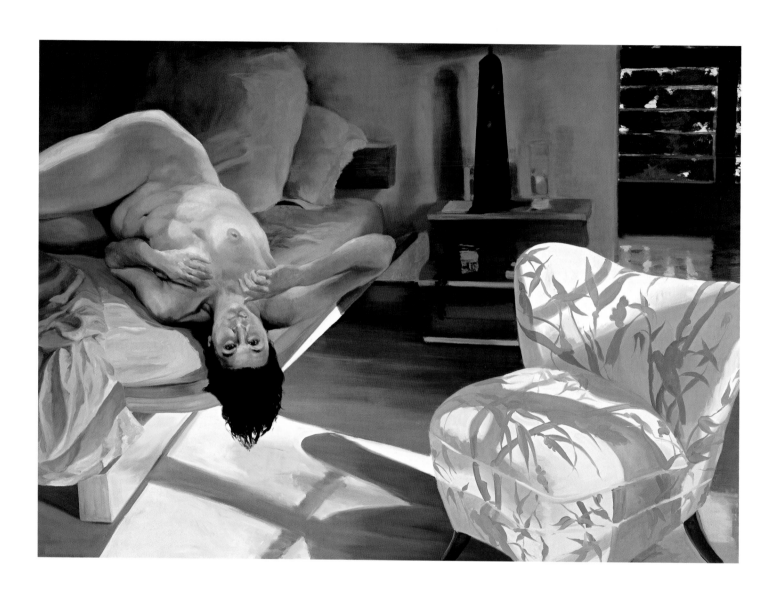

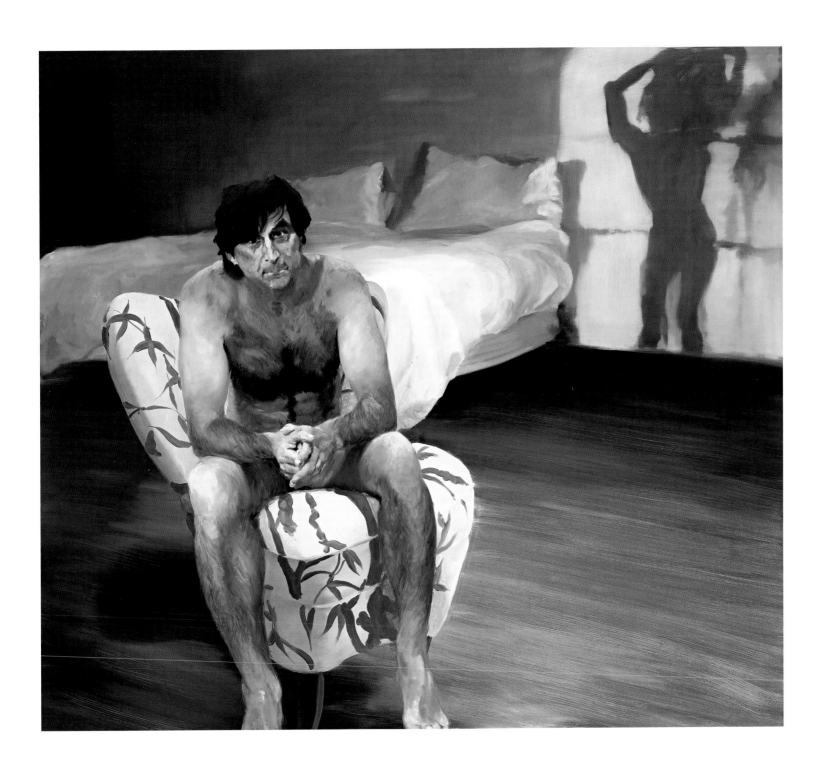

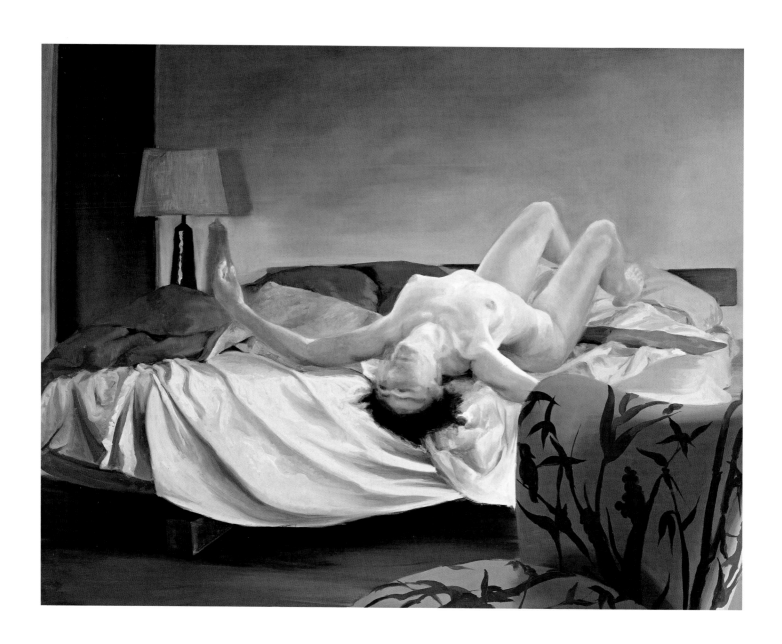

THE BED, THE CHAIR, TOUCHED 2001

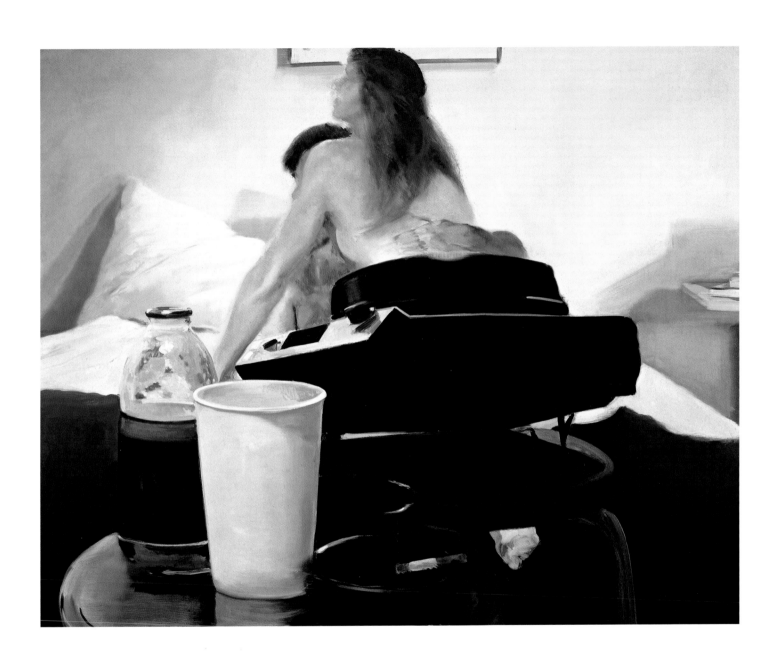

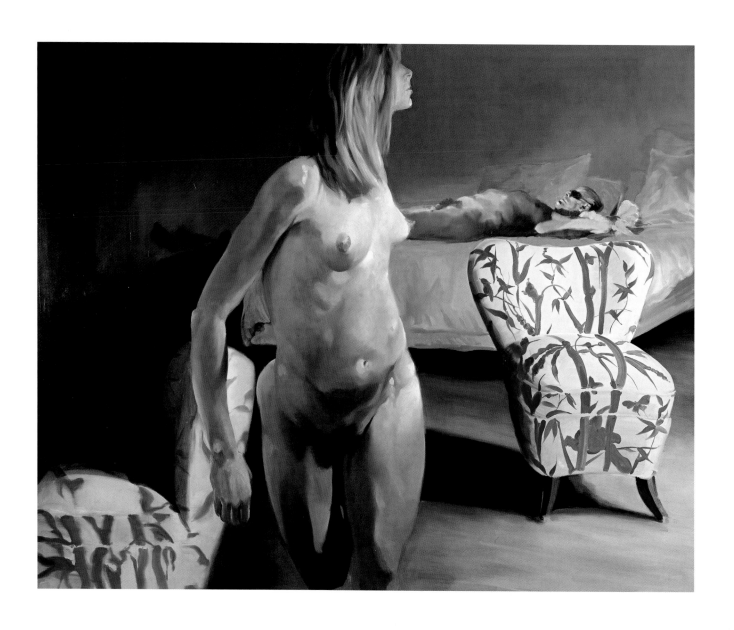

WORKS ON PAPER 1979–2001

ON THE BODY

I JUST CAN'T IMAGINE A PERSON ONE HUNDRED PERCENT
COMFORTABLE IN THEIR BODY. EVER.
THERE ARE MOMENTS WHEN THE BODY BECOMES AWKWARD AND
DIFFICULT AND BETRAYS YOUR INTERNAL LIFE.
I'M INTERESTED IN THINGS THAT LOOK LIKE ONE THING AND THEN
BECOME SOMETHING ELSE; AND FLIP BACK AND FORTH.
THAT HAS TO BE TRUE OF BODIES AS WELL.
I'VE USED GESTURES OF THE BODY AS A WAY OF EXPRESSING
TWO KINDS OF REALITIES: ONE IS THE MOTOR RESPONSE TO
AN ACTION, AND THE OTHER IS A PSYCHOLOGICAL RESPONSE THAT
TORQUES THE BODY IN A CERTAIN WAY.

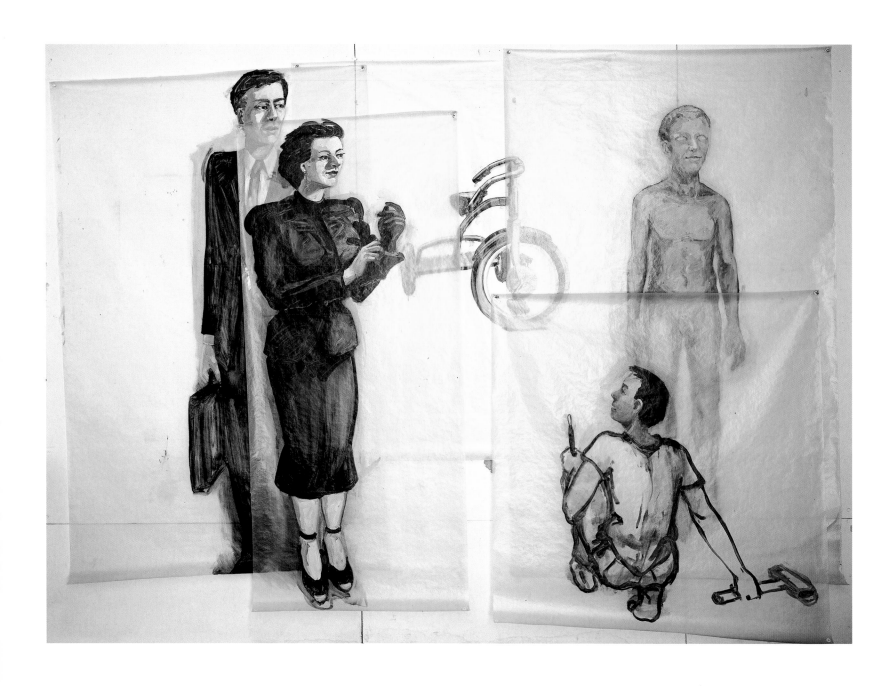

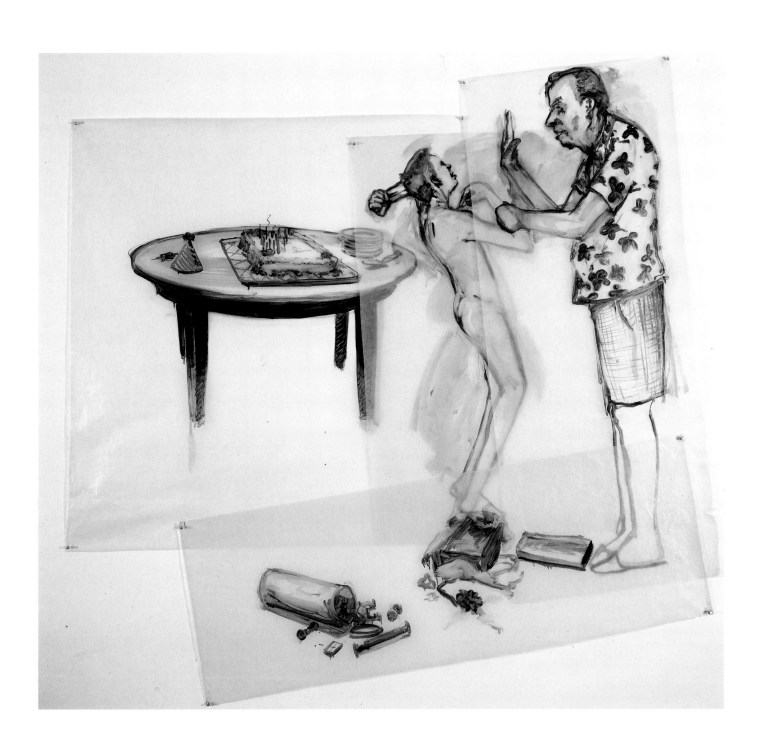

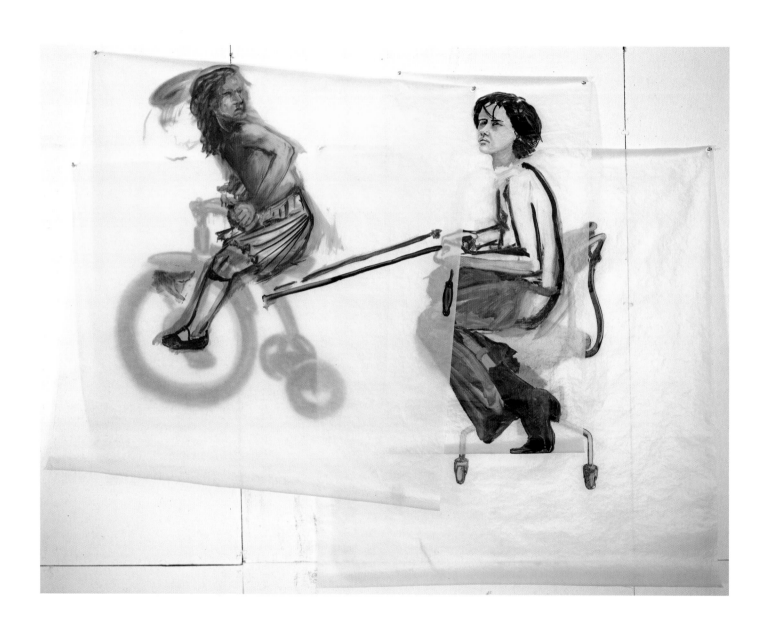

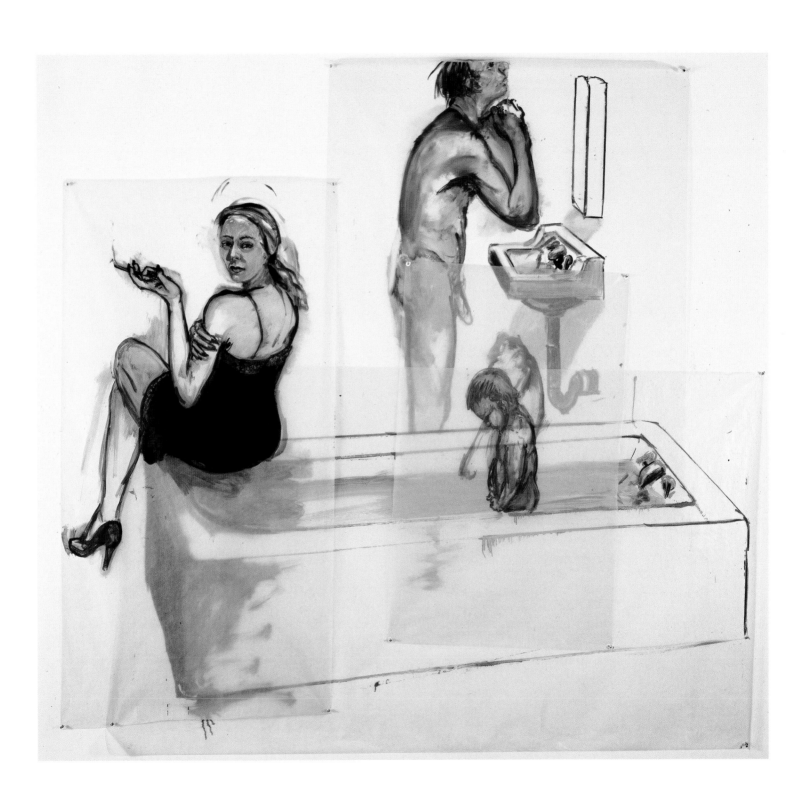

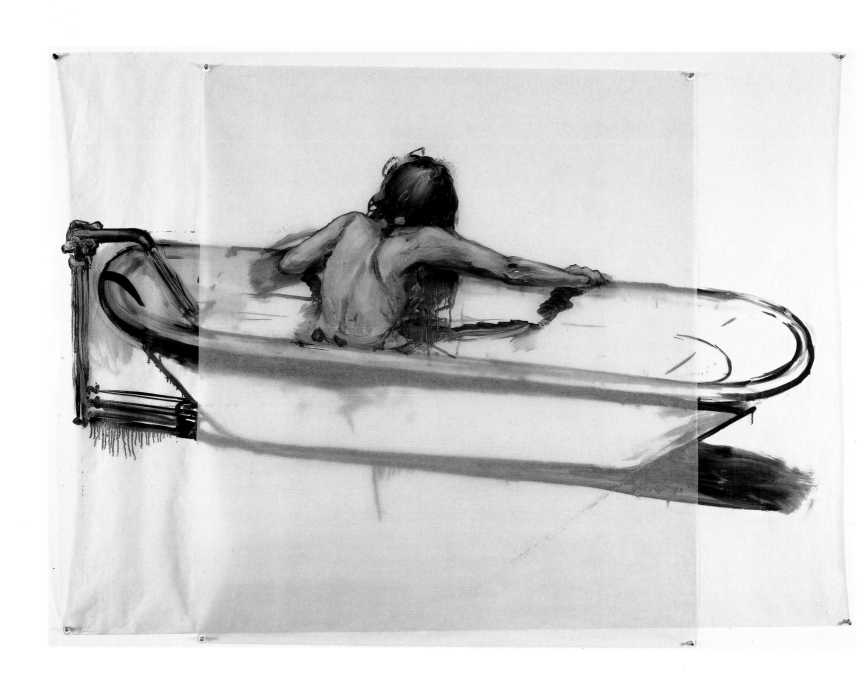

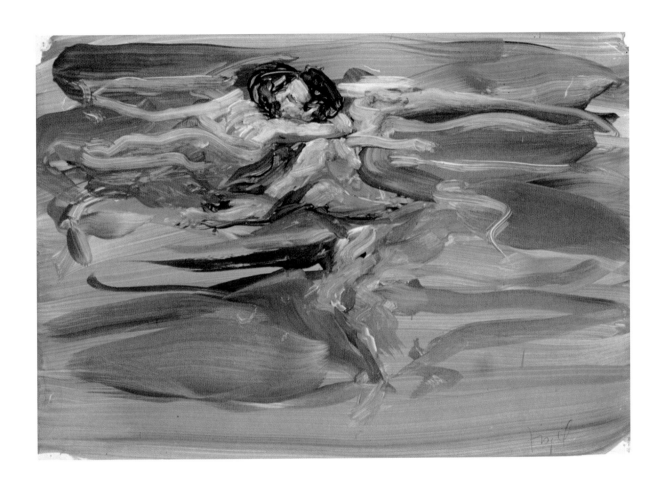

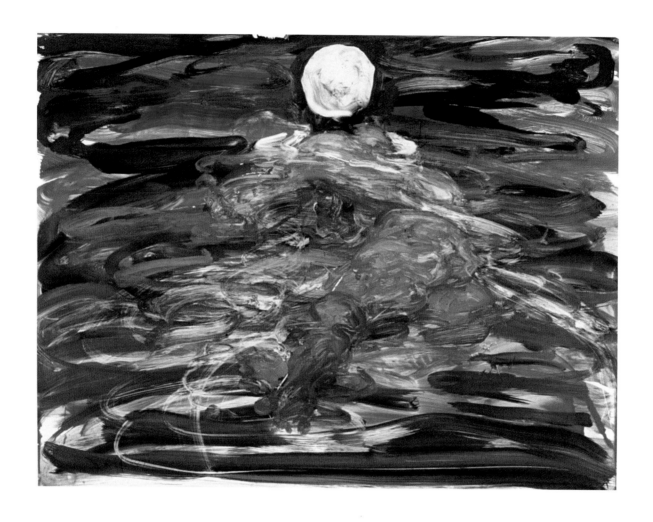

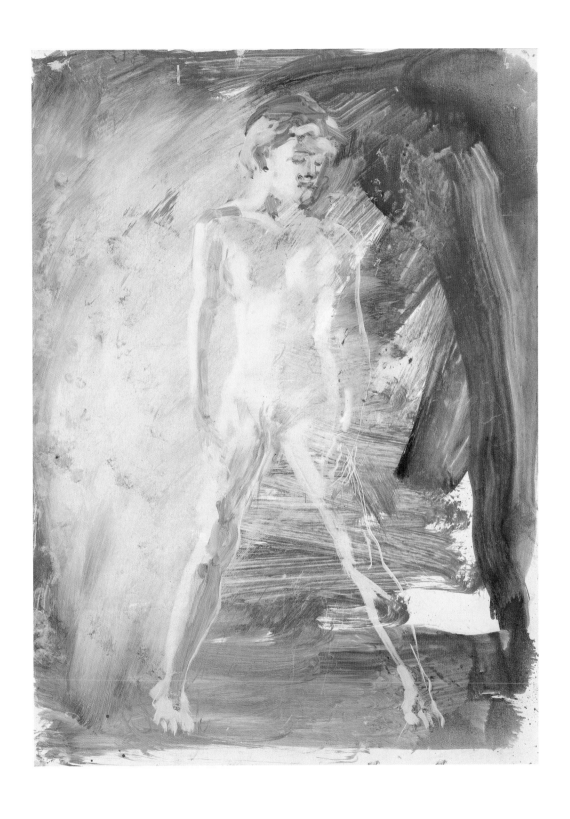

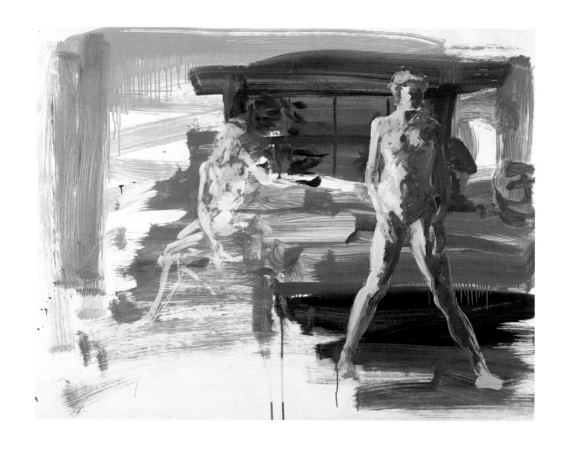

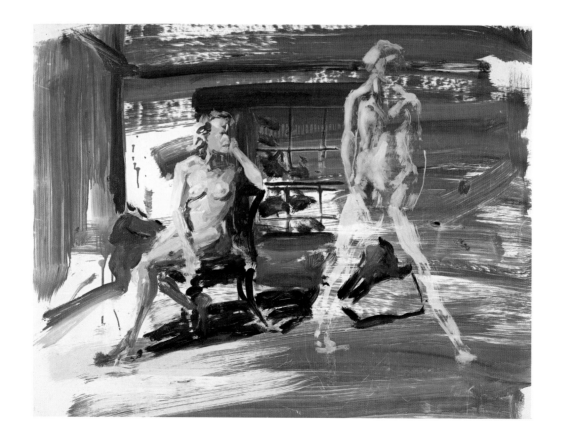

STUDIES FOR BAYONNE 1985

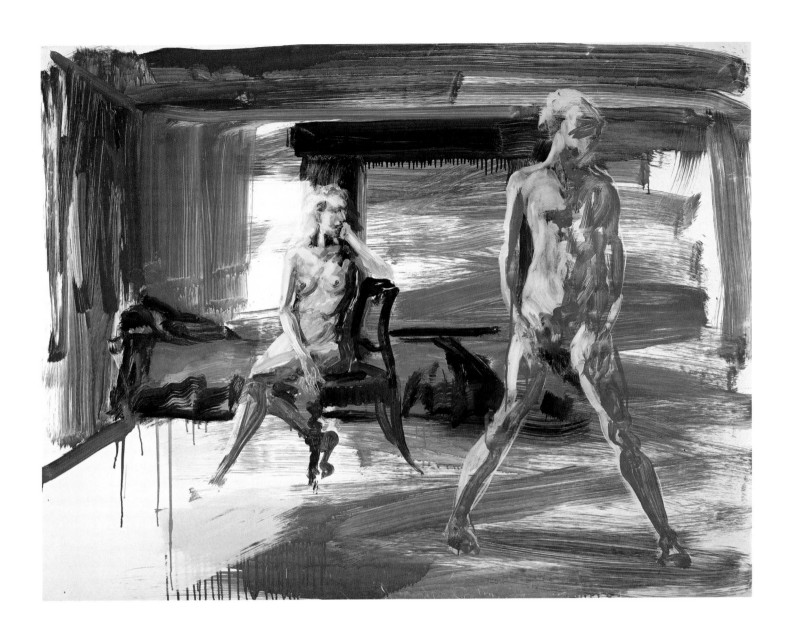

83 UNTITLED (STUDY FOR BAYONNE) 1985

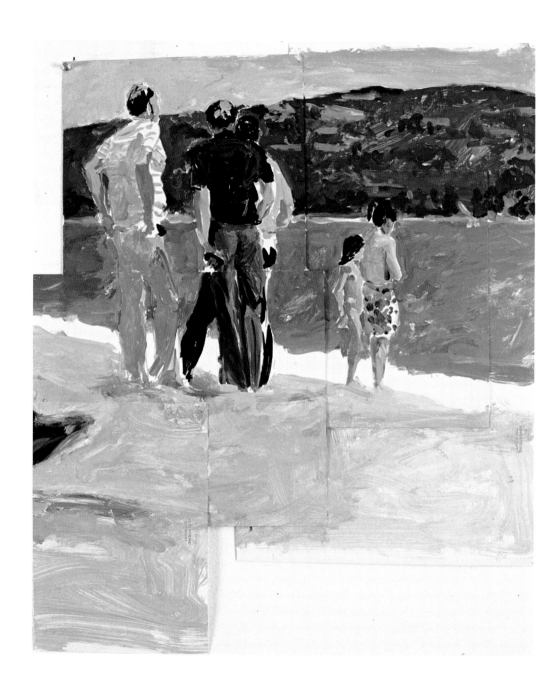

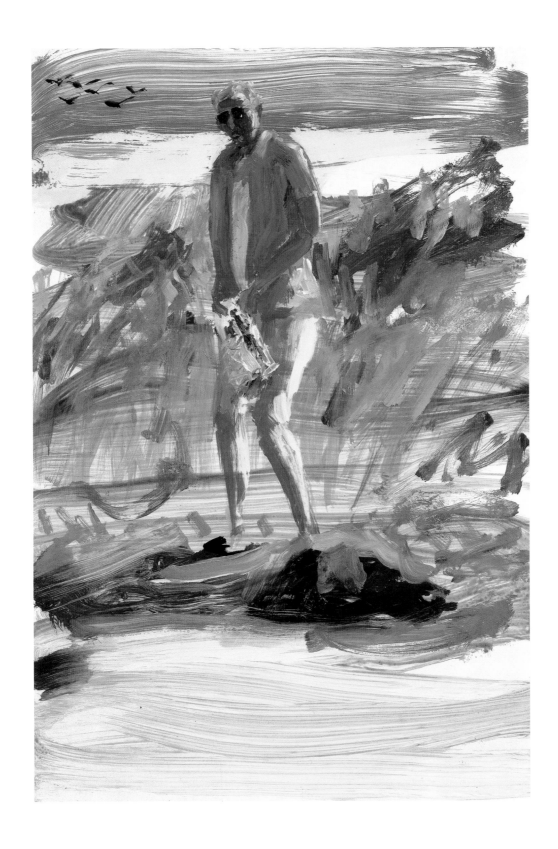

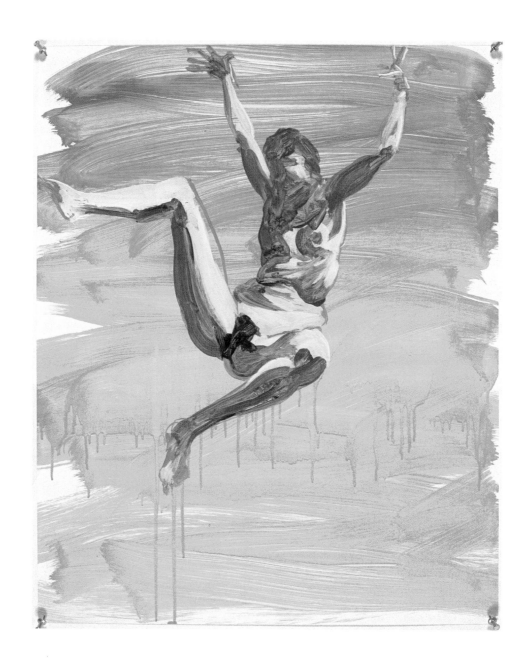

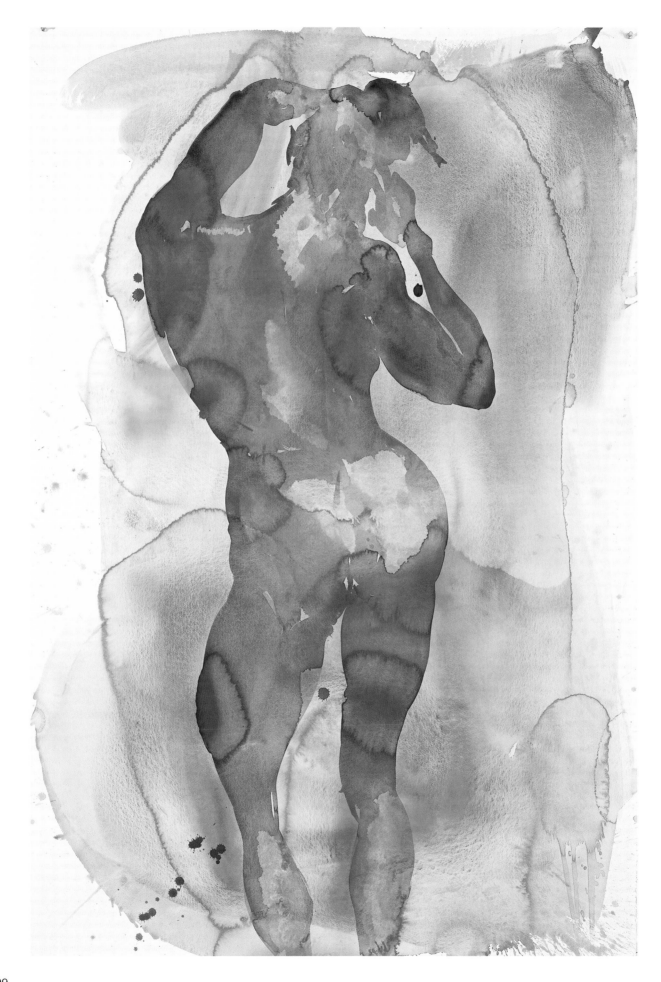

UNTITLED 1999

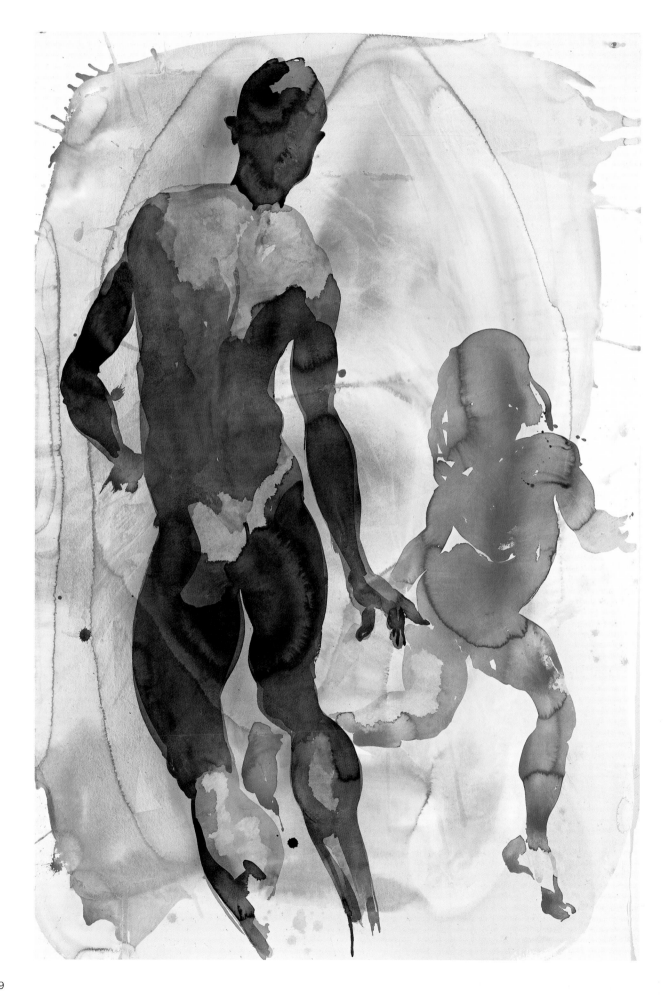

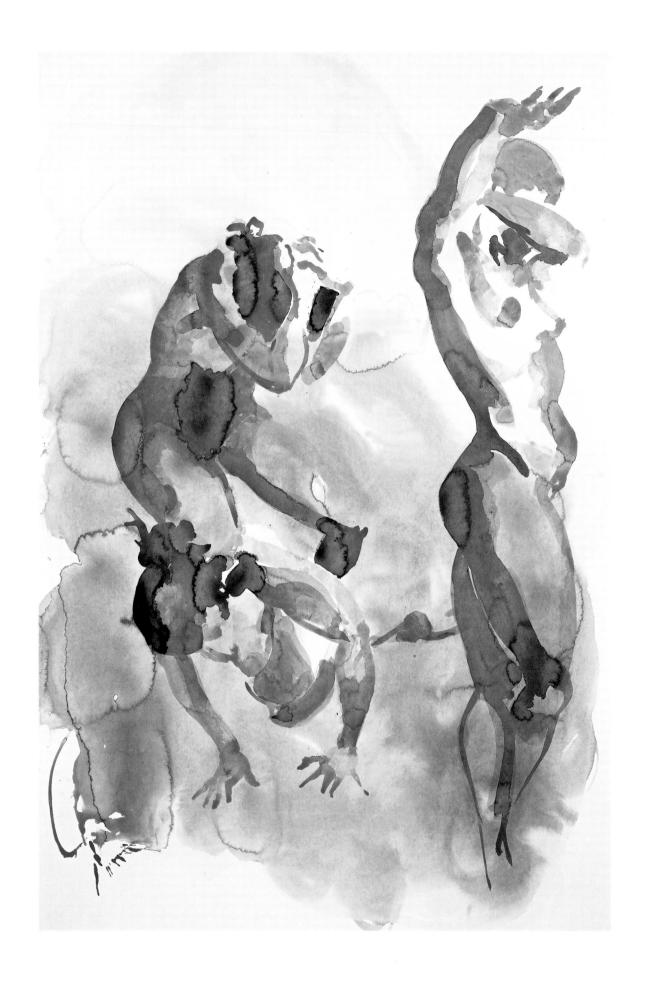

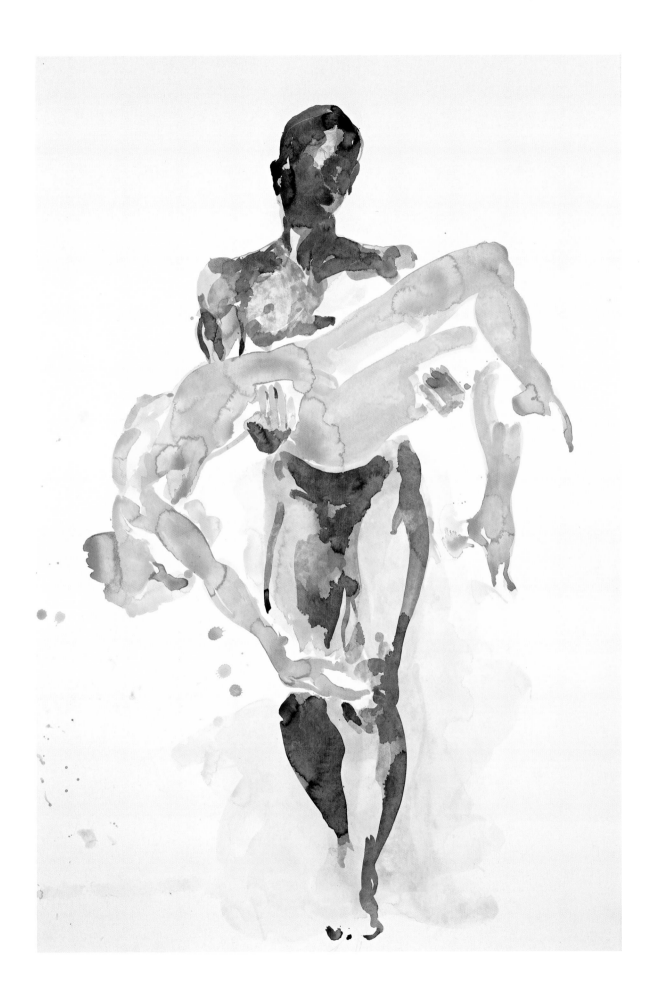

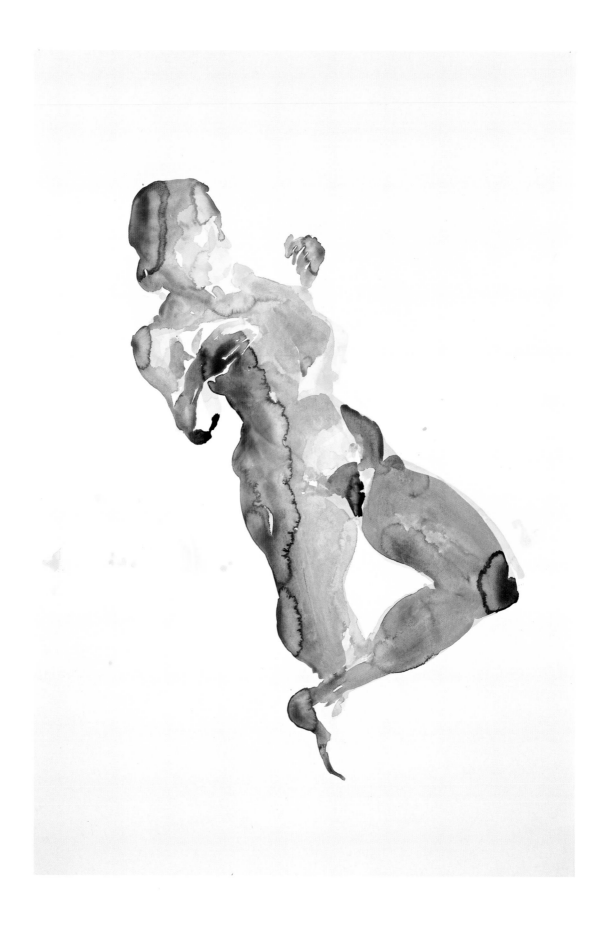

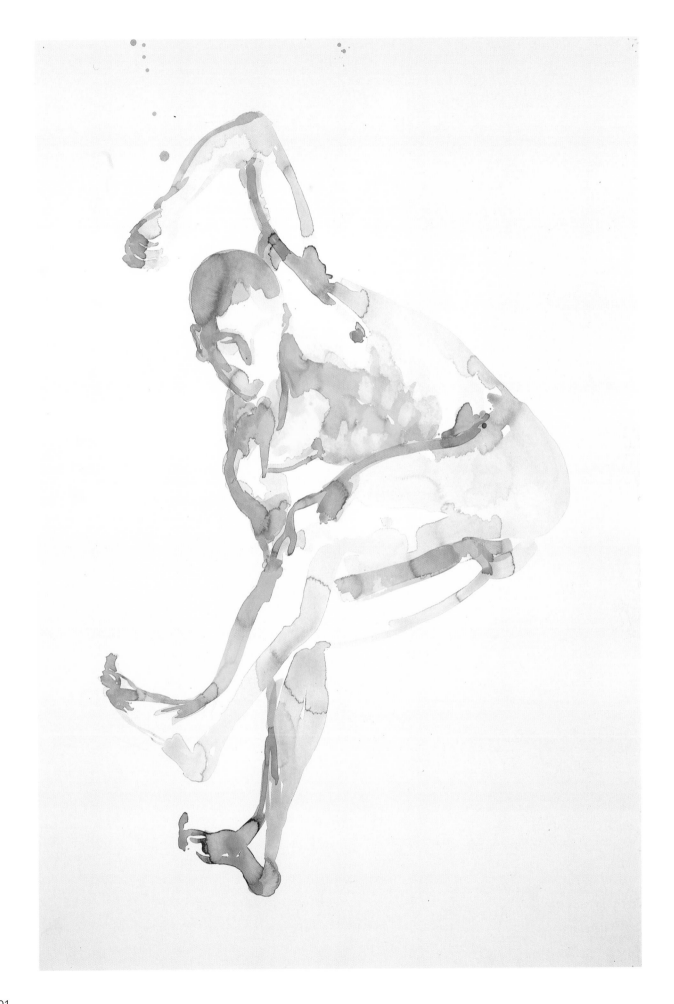

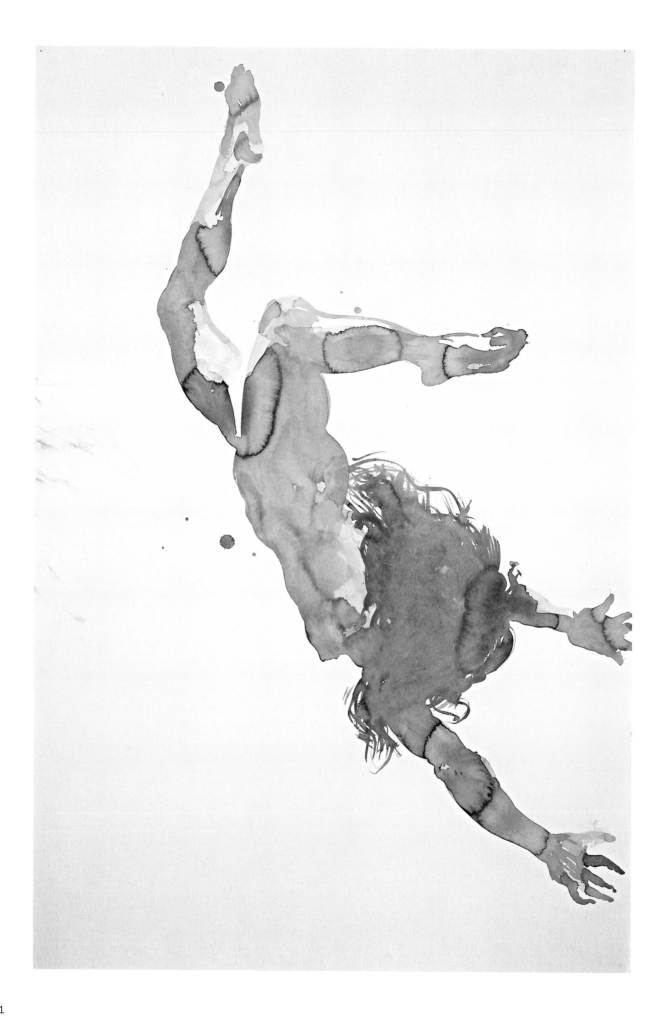

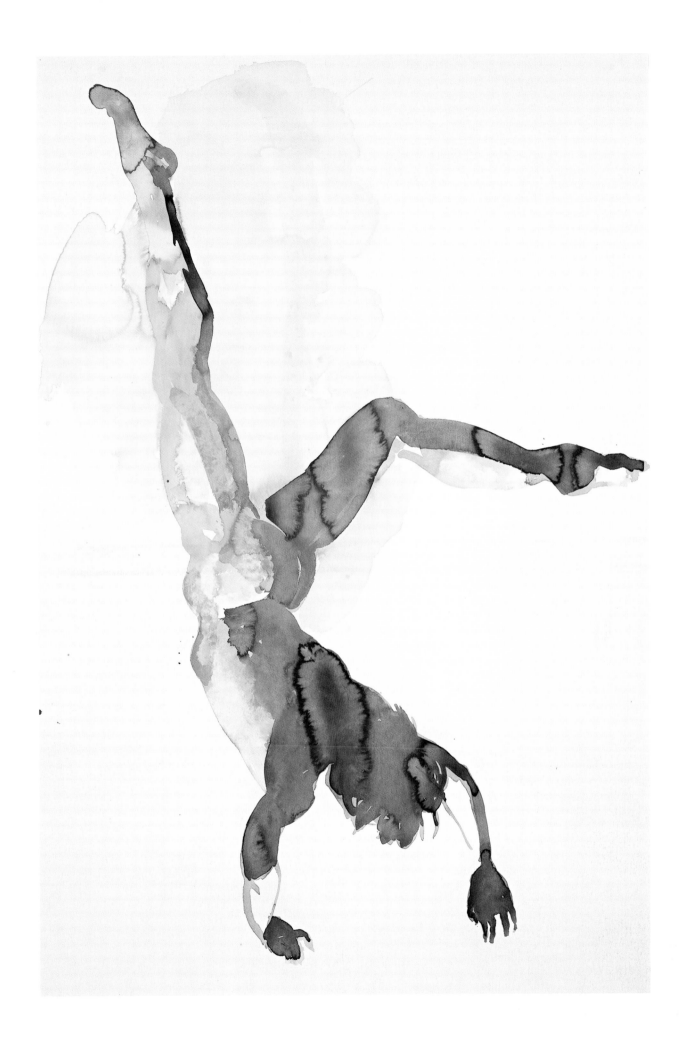

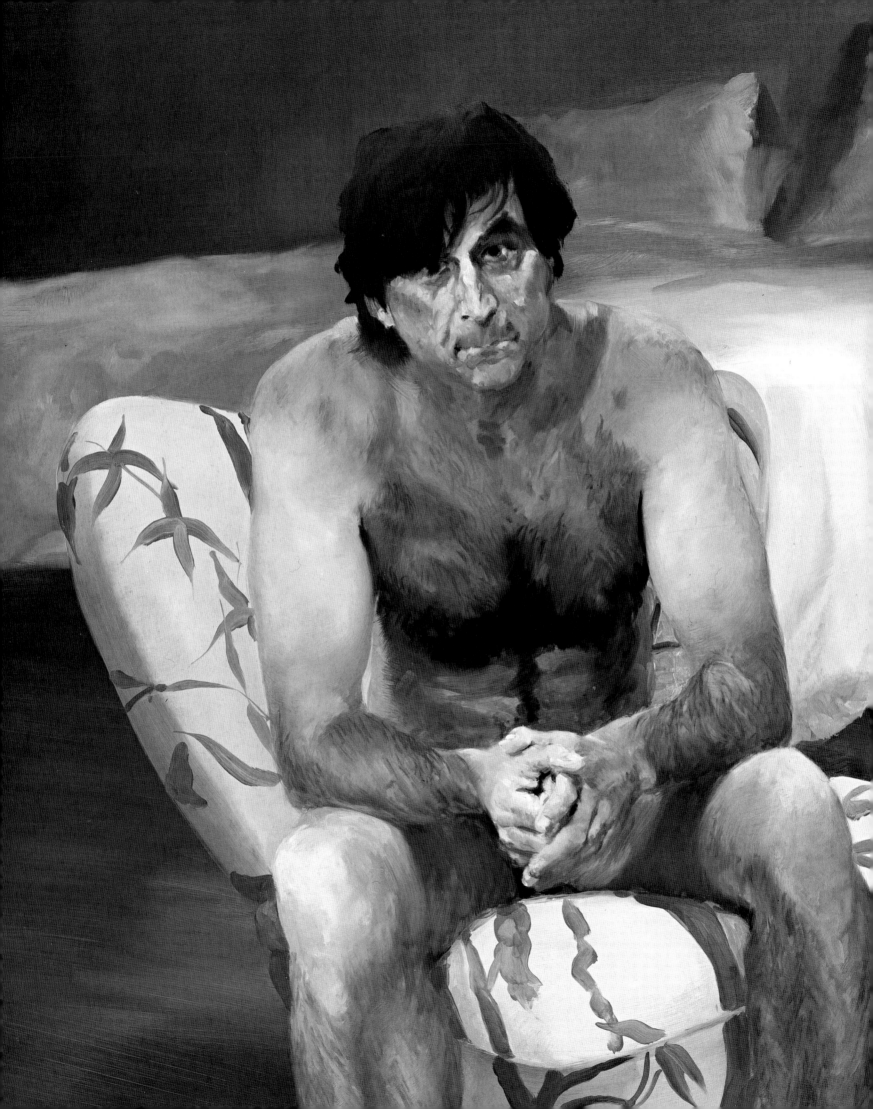

A DIALOGUE WITH ERIC FISCHL NEW YORK MAY – JUNE 2003

FREDERIC TUTEN

FREDERIC: Let me start with a slow ball. How and where did the posed scenarios for your recent group of paintings begin? Did you photograph the scenes you posed, if in fact you did pose them? What was your procedure here, and how was it different from other paintings with models, as for example the series *The Bed, The Chair...* from 1999/2001?

ERIC: The work you are referring to is for an upcoming show at the Haus Esters in Krefeld. For the project I hired two German actors and I furnished the house. For four days I shot photos of the actors in various situations in rooms throughout the house. I did not pose them, and I had no script. I simply set up some problem-solving situations and then let them go at it. I had never worked with actors before, and though to some extent my working method is similar to that with models I have used, the results were different. Both with the actors and the models, I don't really lead them. I prefer to just watch and to let them inform me. I like the process of discovery that I get into. There are always surprises.

After I returned from Germany I began to make the paintings that will comprise the show. I work with Photoshop and collage the scenes together. The paintings are not descriptions of what actually took place—they are reconstructions of feelings that were evoked during the actors' performances. Often a gesture that occurred in one room is cut out and pasted into an entirely different scene that takes place in another room. It is mostly body-language I respond to. Gestures trigger memory and associations and I use them as doorways or entrances to events that will evoke similar feelings and associations in the viewer.

FREDERIC: Let's talk about your search for subject matter and how it brought you to directing, or staging, a performance of sorts. What has led you in this new direction? Or is it a continuation and extension of the erotic surface of your art?

ERIC: I would say that narrative is a large part of the sexual domain insofar as it has as components an object, an audience, and a motive and that the search for satisfaction, the completion of desire, requires tactics—strategies for dominance, strategies for submission, for attraction, and for fulfillment. Desire is your cue that Mystery has entered the room. Mystery holds out the carrot of solution, thus the narrative is engaged.

FREDERIC: Picasso once said that Goya began something and he himself ended it. What do you think Picasso ended, and what is it that you are continuing?

ERIC: I can't imagine what Picasso was thinking when he made that stupid remark. Goya never makes you feel like he is at the center of the brutality and suffering he is expressing. Picasso never makes you think otherwise. With the exception of *Guernica,* Picasso is always at the center of his world. He is always in control of it. Goya, without accepting that it cannot be spoken of, accepts that he is a witness to a world he is not in control of. Sadness is his language. Sadness is not part of Picasso's emotional lexicon.

FREDERIC: Many people regard you as a quintessentially American artist dealing with bourgeois urban life. But you have also painted scenes or images related to, or taking place in, such locales as India, Japan and Rome. What is specifically American about your art?

ERIC: First some clarification. I became known not for painting scenes of urban America but for painting scenes of suburbia. It really wasn't until the late seventies that a strong enough case could be made for suburbia as a legitimate genre. A large percentage of artists of my generation were raised in the suburbs though we have chosen to live in the city. It is a kind of reversal of the migration of our parents. What is specifically American about my work is hard to articulate though I don't protest the label. I think of such things as the conspicuous lack of History Painting in our culture as something particularly American. Why no History Painting? We are the no-history culture. We are the culture of promise and of the future and we are the culture of the individual. Life is expressed meaningfully by representation of the intimate and personal. The upside is the brassiness of our irreverence. The downside is our loneliness.

FREDERIC: Some time ago I suggested that you were less interested in the materiality—the texture of realism—of painting than in the psychology of your scenarios. But in your work of the past five years especially, this seems less true, if ever it was true. Your art seems more and more out of time; your figures and the interiors in which they are set, seem abstracted from any pretense of an

identifiable local world. Would it be amiss to suggest that you are becoming a platonic realist?

ERIC: I have to admit I'm not sure what a platonic realist might be. As for the interest in psychological scenarios over the materiality of painting, I can only say that I have struggled with this conflict since I began to work. The relationship between what something means and how it is stated—it is always in flux. It is always a matter of proportion. It is always a surprise. There is a seduction to description. The seduction is that anything can be described in its greatest and most precise detail, and to do so will yield its deepest truth. But emotions distort. They shrink or enlarge or color the forms of the world. They animate objects in surprising and unnerving ways. This conflict, between emotional needs and pursuit of perfection, is what gives my work its vulnerability. It is for me always an uneasy truce that is arrived at in the painting. And perhaps this is another way to define "American": the willingness to make art open to its vulnerability. American art is resistant to refinement, most especially to style.

FREDERIC: How do you see Sargent and Whistler in relation to the resistance of style you're speaking of? And in addition to that, which American painters do you feel most in complicity with?

ERIC: You caught me in a broad generalization. Of course Sargent and Whistler are epitomes of style. But of course they are only slightly American. Sargent grew up in Europe and Whistler moved there young. I guess what I meant was that those artists who sought to find authentic American voices found style to be a European pretense. It is not that they were innovative. It is more that they were stripped down, modest and willing to let clumsiness be part of the experience. There is an acceptance of the object as vulnerable. I always feel at home among Hopper, Kuhn, Hartley, Park, Dove. I feel at home among thickness, I guess.

FREDERIC: Where is Europe in your art?

ERIC: Europe is not in my work. Europeans are incapable of making the kind of work I do—too blunt, too immodest, too quotidian. That is like saying, where are the Spanish in the art of Manet? Manet took out of his painting what made Spanish art Spanish.

FREDERIC: By the way, by platonic realist I meant an art seemingly representational—to use that old-fashioned word—yet abstracted from and transcending locale and time. Taken as a whole at this point in your oeuvre, I'm coming to feel that unlike almost any other American living artist you have what Miguel de Unamuno calls "the tragic sense of life." Perhaps this is also what separates you from modernism and post-modernism in general.

ERIC: I can think of too many exceptions to this idea that modernism, or for that matter post-modernism, has no room for the tragic.

FREDERIC: I really wonder who you are thinking of when you say you have many examples of modernist and post-modernist artists with a "tragic sense of life." In any case, I still think you do—at least in certain pictures. Some of the Italian paintings, for example. Perhaps what I'm longing to find expression for is a way of suggesting the depth of your work, a depth that is existential, and disengaged from irony and aesthetic ploys.

ERIC: Those who have that tragic sense are many. For instance, Picasso in all of his blue period. Or Matisse—there is one painting the name of which escapes me, in which he, or his likeness, is portrayed in striped pajamas internally combusting as he contemplates his disappointing relationship with his wife who is seated. Francis Bacon, or late Lucian Freud. Rothko. Beckmann. Bonnard. Hopper. Baselitz. There are more I'm sure but not springing to mind.

As for irony, I don't feel particularly disengaged from it in the work. I don't use it as an aesthetic ploy but it is the tonic that makes my work's bittersweetness a little easier to swallow.

FREDERIC: What made you start doing portraits? How do they fit into the pattern of your work?

ERIC: My first painted portrait was of Ralph Gibson. There was very little thought behind the choice to do a portrait. I simply had a great photo I had taken of him in Rome. It had this delicious light in it and I thought it would be fun to paint that. It is what happened after I finished the picture that convinced me to do more of them. When I showed Ralph his portrait he said that

though he had made his mark in the world of photography, it was this portrait that made him feel immortalized. What I took from that wasn't the flattery but the empowerment that one feels when one is "seen." It seems to me that that is the role of the artist—to see and to record what is seen. I realized that my life has been so privileged by all the people I have come to know and that I should record this. Everyone I know does something and does it well. I have been very fortunate to be surrounded by talent. I wanted to make a record of that.

FREDERIC: Tell me about the relationship of photography to your painting. Were Bonnard's photographs an influence?

ERIC: I have, since the late seventies, used photography to make my paintings. There is something you get from the photograph that you can't get any other way: awkwardness. The photo cuts time so thinly you get gestures you don't normally notice. Everyone in a snapshot comes up short. For me, the photo is a view into the soul of a character because so much of the arrested motion is unselfconscious. That kind of frozen moment is where you can see how comfortable they are with themselves. You can feel what their relationship to their body is like.

But a photo has obvious limits and I am not interested in working with those limits. Were I, then I would have become a photographer. What are the limits? For me it is mostly as an object that the photo loses its weight. The photo absents the photographer or preferences the photographer's eye. A photographer doesn't create a work so much— he "captures" one. This is not enough for a painter. Paintings are built. They are arrived at. There is a sense of time, of the length of time it took to arrive at that moment that both stops time and starts it going again. With a photo you never work back from its stopping point. Paintings differ from a photograph in the way one relates to it. What I like about painting is the way you relate to both the image and the object simultaneously. They are inseparable. What I like about the photo as a painting source is its degree of realistic depiction. The photo gives you enough but not too much information about what things look like. It has already done a lot of editing. It makes that part of my task easier. One of the reasons I looked to photography was that when modernism threw the figure out of painting, the figure went into photography. Where else would I go?

In answer to your second part of the question, I came upon Bonnard's photos well after I had been using photographs in my work. I love his photos. Stripped of his beautiful color, the photo reveals his profound anxiety and discomfort towards people. They were a revelation for me.

FREDERIC: How do you use the computer for your paintings—what does it do for you that is different than working without it?

ERIC: I use the Photoshop program to create the imagery for my paintings. I scan photos I have taken into the computer and then create images by cutting and pasting. Though I always have used photos and have always combined imagery to make my scenes I was slow to go to the computer. I was afraid at first that I would be sacrificing the art for a process that made imagery easier to achieve. I had been schooled to believe that the painter should not separate the discovery process from the execution. That without the tension naturally created by this, the expressive power would be diminished. What I found was entirely the opposite. By separating the two and working through all the permutations for a scene first, my execution was freed up and I could explore and express with greater range than I had imagined possible.

FREDERIC: Of course it is hard to frame such a large question without it being overwhelming, but I would like you to speak about your quest as an artist—your aesthetics and your goals.

ERIC: After all these years you would think I should be able to answer this question in some sort of direct fashion, wouldn't you? But I can't. The answer is redundant when standing in front of the work. I have tried to speak about my work in many different ways. One thing I said many years ago still feels true today: I paint to return my thoughts to feelings.

What do I mean by that? I mean that I paint backwards from what I think I know or feel, to the place right before I knew what I felt or thought. I paint to the moment before I had words to describe the feelings .

My goals are modest really. Like most artists, I want to stop the world. I want to create work so riveting it takes us outside of time.

FREDERIC: A propos of time: you know I've always felt that sense of timelessness in certain paintings by Puvis de Chavannes. I've always wanted to talk to you about him.

ERIC: I never got Puvis. I can see his influence on Picasso and Balthus. I always want to drink some water after looking at Puvis. His paintings are so chalky and static. Are these the essential qualities of modernism? There is a plane flying overhead right now as we speak. It is very beautiful and transient. It is fading to gray as I watch. Puvis would choose this moment to paint it. Not the moment of its greatest radiance. His would be a mark like that of chalk on a slate. I would try to capture its metallic brilliance. That is our essential difference. Perhaps his influence comes from that. He paints the faded light of history and gave the next generation the permission needed to break free completely.

FREDERIC: What is the relationship of the idea of beauty to your art? Is psychological truth a form of beauty?

ERIC: Beauty is not an idea. Perhaps a better phrased question would be: What is the relationship of beauty to the psychological truth of your work? And I would say, it is how one recalls, in all its lucid detail, moments of disturbing or overwhelming significance. That, for me, has a kind of exquisite form which is its meaning and I would call that beautiful. I find compelling those moments when a tragic experience is recreated in stunningly rich and surprising detail. It is precisely because there is a contradiction between the sad or disappointing experience and the sensual retelling that one glimpses the complexity of our very nature.

FREDERIC: Have your ideas about painting and your role as an artist evolved over the past twenty years?

ERIC: My ideas about life have evolved and that has exerted influence on the paintings. My ideas about painting have remained somewhat consistent in that I have always felt that painting should follow life and record where life leads.

Printed by permission of Frederic Tuten and the Watkins/ Loomis Agency.

THE TRIBUNAL OF MODERNISM VS ERIC FISCHL

JÖRG S. GARBRECHT

SLEEPWALKER
page 26

In 1979, Eric Fischl made his artistic debut in New York with his outrageously figurative painting *Sleepwalker* (pl. p. 26). The painting was regarded as outrageous since its mode of expression constituted a severe challenge to the entrenched modernist taste and the established theories of the art world. Fischl found himself eye to eye with the powerful advocates of modernism. The critic Kay Larson succeeded in capturing the atmosphere of this confrontation with a legal metaphor, comparing Fischl's art historical plea for a return to figurative painting to a fictitious trial in an imaginary courtroom. According to Larson, Fischl had to "take off his clothes and stand naked before the Tribunal ... of Modernism, hungry for all the feelings—vulnerability, anger, covert and overt hostility—that attend a disrobing."[1]

To get a feeling of how uncompromising and passionate the positions were in this art historical dispute, let us stay with Larson's metaphor and try to imagine the two parties in a fictitious courtroom: On the one side there were the artists and critics representing minimalist and conceptualist ideologies. Henceforth they will be called the Tribunal of Modernism and taken to represent the prosecution. On the other side was Fischl himself as the defendant. And what was it that brought Fischl—metaphorically speaking—in the dock in 1979?

The principal charge that was brought against Fischl was his painting *Sleepwalker.* Fischl's work contravened all principles laid down, and represented, by what Larson called the Tribunal of Modernism. *Sleepwalker* was a figurative painting and, as such, Fischl's painted plea for a return to the tradition of American realism. The Tribunal of Modernism, by contrast, expected art to develop teleologically towards an irreducible modernist essence according to the laws of Hegelian purification.

THE PROSECUTION

The 1979 Tribunal of Modernism was made up of artists and critics representing minimalist and conceptualist ideologies, but its origins actually date back to the middle of the twentieth century. Since the late 1950s, the Tribunal had made every effort to condemn figurative painting. Abstract expressionist ideas provided the ideological structure

of the Modernist Tribunal. Clement Greenberg—whose spirit still seemed to firmly hold the chair of the Tribunal in 1979—had vehemently argued his case against all figurative, narrative and illusionistic art. In Greenberg's eyes, art's purpose was not to allow the viewer to consume some painted replica of the world but to involve the viewer in the making of art. Jackson Pollock's drip-paintings and Barnett Newman's color-field abstractions were declared shining examples of the modernist conviction of *"ars est artem demonstrare."*

The highly influential Tribunal of Modernism consisted only of a "chosen few" who claimed the right to declare what in fact constituted "true art." In their secluded haven they indulged in continuous self-affirmation and self-congratulation.

The authority of the established art scene had already been questioned even before the minimalists took the chair. In the early 1960s rebellious pop art activists had launched a vigorous attack against the Tribunal's artistic aloofness and intellectual formalism. But although the pop artists plastered their canvases with recognizable imagery and rediscovered the human figure, they essentially continued to adhere to the modernist laws of flatness and of artistic detachment. Tom Wesselmann's nudes, for instance, stood firmly in the two-dimensional pin-up tradition and were clearly too thin a slice of life to reflect the complexity of the sexual experience. Briefly shaken by pop art, but not threatened in its authority, the Tribunal of Modernism maintained its firm grip on the art world.

From around 1963 minimalism presided over the Tribunal and took Greenberg's praise of a painting's flatness a significant step further. After condemning color and brushstroke as threatening the work's crucial non-referentiality, the minimalists declared the two-dimensionality of the pictorial surface with its figure-ground relationship redundant. Frank Stella's geometric color fields actually redefined the medium: the painting was no longer a mediator of meaning but merely a paint-bearing surface—"what you see is what you see," as Stella repeatedly stated. Since real space came to be seen as more powerful and effective than paint on a flat surface, the minimalists reduced painting to its physical components, to a three-dimensional *"specific object."* With minimalism, the formerly separate roles of artist and critic began to

[1] Kay Larson, "The Naked Edge," *New York*, 10 March 1986, p. 58.

merge: both Donald Judd and Robert Morris wrote several articles in which they ventured to explain and evaluate minimal art. [2]

The minimalists were superseded in the presidency of the Tribunal by conceptualists like Joseph Kosuth, John Balessari, and Mel Bochner. Conceptualism received widespread museum validation with the 1970 *Information* show at the Museum of Modern Art in New York. Swearing by the alleged teleological development of art, the conceptualists proscribed painting altogether in their quest for what they considered "true art." In their view, once an artist made paintings he had already accepted a certain form of artistic expression—in this case, painting—and was no longer questioning the nature of art as such. The act of naming soon replaced the artistic practice of showing, and the written word became the principal medium for the conceptualists. Mel Bochner defined the ideal conceptual work of art as having "an exact linguistic correlative, that is, it could be described and experienced in its description." [3] Going even further, Sol LeWitt pleaded that concept art had to engage the mind of the viewer rather than his eye or his emotions. Thus the idea itself was regarded as the very machine that "made" art. With the conceptualists holding the chair, the Tribunal of Modernism came to question painting and even art in general, from formalism and aesthetics to visual experience itself—thereby arguing itself into a precarious corner. After conceptualism, there seemed not much left for art to do, claim, or question. All possible positions had been exhausted, and the modernist essence in art had been discovered once and for all. It was at this moment that the spectacular case against Eric Fischl's *Sleepwalker* was brought to trial.

THE DEFENDANT

The outrageously figurative painting *Sleepwalker* marked the dramatic culmination of Fischl's ten-year struggle to develop his own form of artistic expression. During this time, Fischl went through different phases relating to three major artistic movements that the Tribunal of Modernism accepted as valid artistic forms of expressions: abstract expressionism, minimal art and concept art.

Fischl was first confronted with abstract painting while studying at Arizona State University in 1969. Having enrolled at the California Institute of the Arts a year later, Fischl was taught by Paul Brach who felt a particular kinship with Barnett Newman's large abstract color fields. After graduating from Cal Arts Fischl worked hard to develop an iconography of his own when he found that he could not identify with the abstract rationale of compositional relationships. More importantly, Fischl regarded abstract painting as no longer capable of carrying content or conveying meaning.

Fischl's decisive break-through in the development of his own iconography came in Canada where he taught as assistant professor at the Nova Scotia College of Art and Design in Halifax from 1974 to 1978. During this four-year period Fischl worked through minimalist and conceptualist phases and gradually moved away from abstraction.

Fischl's first step was to give his abstract works a specific form. The "house-paintings," for example, were the result of associating the physical components of his shaped abstractions with concrete architectural forms. These "specific objects" were then given elaborate titles and thereby filled with a strong symbolic content. In a final step Fischl expressed his own associations in words—a process similar to the conceptualist practice of naming. The quantity of written information far exceeded that of the imagery because at that time Fischl trusted words more than images. He relied heavily on the subtexts to give his work its direction and meaning.

Fascinated by artists like Suzan Rothenberg, Fischl increasingly added human touches to his abstract art. He began to relate his work not just to houses and bridges but also to everyday objects and the daily doings of the fishermen he observed in the fishing villages near Halifax. Inspired by the realist painter Robert Berlind, with whom he shared a studio in Halifax, Fischl eventually began to draw objects and, later, contoured figures with an oil stick on sheets of glassine paper. He codified representation by merging illusionistically rendered faces with schematically outlined, linear-drawn bodies. Still caught up in the rationale of modernism, Fischl was extremely hesitant, even afraid, to attempt figurative painting. After re-arranging the individual glassine sheets over and over again and combining them with various objects and protagonists into different scenarios, Fischl finally arrived at what he called "moments

2 See Donald Judd, "Specific Objects," *Arts Yearbook,* 1965; Robert Morris, "Notes on Sculpture," *Artforum,* February 1966, October 1966, and June 1967.
3 John Coplans, "Mel Bochner on Malevich. An Interview," *Artforum,* June 1974, p. 62.

with a permanent character." It was this discovery of composed and contextualized figurative scenes, as it were, that prompted Fischl to start thinking seriously about figurative painting.

During his ten-year search to find an appropriate form of artistic expression, Fischl had successfully worked through the abstract expressionist, minimalist, and conceptualist phases that were all acknowledged by the Tribunal of Modernism. Yet *Sleepwalker,* Fischl's artistic conclusion, openly contravened everything the Tribunal of Modernism stood for.

THE TRIAL

Let us return to the imaginary courtroom that Larson described in his earlier-mentioned metaphor. Fischl's opening-statement was simply, "I believe in painting," and he presented *Sleepwalker* as a testimony to his conviction. The Tribunal of Modernism was flabbergasted. *Sleepwalker* did not conform at all to the then prevalent idea of art. Contrary to their expectations, the painting did not advance formally from the known aesthetic position of minimal or concept art and thus severely challenged the Tribunal's belief in the teleological development of art. As described so aptly by Kay Larson's metaphor, Fischl stood before the Tribunal of Modernism shaking with anger but also feeling extremely vulnerable in this hostile environment. Fischl was furious with the Tribunal because it would accept only self-indulgent abstraction and because "true" painting at the time seemed to be exclusively about formalist trifles and devoid of any recognizable imagery and narrative content. Having rebelled publically against the powerful Tribunal of Modernism and its entrenched art historical taste, Fischl was understandably afraid of being expelled from the art world for painting figuratively. Larson's comparison between Fischl's appearance before the Tribunal and the feeling of standing naked cogently emphasizes the similarities between Fischl's own artistic position in 1979 and the situation in which the adolescent protagonist finds himself in *Sleepwalker*. Just as an adolescent will often compromise parental authority with his behavior, Fischl had rebelled against the worn-out authority of the Tribunal of Modernism with his figurative painting. *Sleepwalker* represents Fischl's first exploration into the realm of figurative

painting and pinpoints the discovery of his true subject matter: adolescence as a time of discovery and of experimenting. In this light, the adolescent's groping towards (sexual) identity can be taken as directly related to Fischl's own endeavor to find his artistic identity in 1979.

Fischl did not stand alone in his effort to return figurative painting to the center of attention, but his conviction and boldness made him the principal enemy of the Tribunal of Modernism. In his stand against the Tribunal, Fischl was backed by a considerable group of supporters, ranging from the veterans of painting, to Fischl's artistic predecessors who had taken up realist painting in the 1960s, like Larry Rivers and Alex Katz, and finally Fischl's contemporary comrades-in-arms like David Salle and Julian Schnabel who also fought for a return to figurative painting. Outside the art circles dominated by the Tribunal of Modernism, realism was the American style *par excellence*. Ever since European modernism was first imported to America in the early twentieth century, several attempts had been made to restore realism to its former splendor.

Even though it was Fischl who found himself in the dock in 1979, a great number of veteran painters had for a long time worked at keeping figurative painting alive. In spite of the critical rejection of their medium, of these established artists, among them Malcolm Morley, Alice Neel, Leon Golub, and Lucian Freud, had been painting figuratively as early as the 1940s.

It was in the 1960s that realist painting with its pronounced focus on the human figure emerged as a viable alternative to, as well as an extension of, modernism. The perceptual realists and the photorealists assimilated the lessons of abstraction into a new representational realism. Philip Pearlstein's nudes, for instance, were an example of how the neutral appearance of reality came to be merged with the modernist principle of flatness.

However, combining abstraction and realism was not nearly as important for the emergence of the new figurative painting in the early 1980s as was the renunciation of abstract painting altogether. Philip Guston—whom Fischl admired—was the single most important artist to radically break with abstraction. His later paintings constituted a crucial link between pop art and the new

figurative painting. In 1966, when minimalism was at the peak of recognition, Guston had become increasingly dissatisfied with his own abstract paintings, with the elitist character of the art world, and with the almost absolutistic rule of the Tribunal of Modernism. Guston came to the conclusion that painting was no longer about the reality of paint on a flat surface but also involved thought, memory, and sensations. The Tribunal of Modernism made every effort to isolate him and to ensure that his exhibitions received predominantly negative reviews. This did not keep the younger generation of painters, to which Fischl belonged, from discovering Guston's enigmatic paintings of shoes, hands, and buildings for themselves and from enthusiastically embracing this veteran painter's urge to tell stories on canvas.

At the time of Fischl's 1979 appearance before the Tribunal of Modernism, figurative painting suddenly became the true and authentic medium of the time. After the long years of abstraction, the art world was craving for a form of artistic expression that confronted reality in a more strongly emotional and subjective way. Painters increasingly left minimalist physicality behind and turned to psychology instead. With the return of artistic subjectivity, conceptualist description once again gave way to interpretation and painting recovered its capacity to relate to the world around it. Recharging reality with thought and sensation, the new figurative painting regained the ability to carry and communicate meaning.

Thus the case of "The Tribunal of Modernism vs. Eric Fischl" provided the astonishing spectacle of actually reversing the positions of prosecutor and defendant. Fischl, and with him the veterans of painting as well as the contemporary newcomers, were no longer the defendants—they became the prosecutors instead. The Tribunal of Modernism with its out-dated ideology of teleological development suddenly found itself forced to justify its very existence. It was a "Farewell to Modernism," as the headline of an article in the October 1979 issue of *Arts Magazine* stated. The same year that Fischl showed his *Sleepwalker* was also the year in which the Whitney Museum of American Art in New York presented the epoch-making exhibition *New Image Painting*.[4] Figurative painting was finally acquitted of the charge of not being "true art" and promptly set out to take the world by storm.

After the case of "The Tribunal of Modernism vs. Eric Fischl" had been decided in favor of the artist, Fischl became a key figure in the return to figurative painting in America. As Robert Berlind wrote about Fischl's first solo exhibition at the Edward Thorp Gallery in 1980: "Fischl's explicit literary intentions distinguish his art from much recent work where figuration is little more than an ironic ingredient in an essentially formalist recipe." Berlind went on to assert that the paintings "are made as best as [Fischl] can, which is to say, very well."[5] And while Fischl's *Sleepwalker* became the most frequently reproduced picture in America around that time, the Tribunal of Modernism was forced to adjourn indefinitely.

4 *New Image Painting,* Whitney Museum of American Art, 5 December 1978 to 23 January 1979.
5 Robert Berlind, "Fischl at Thorp," *Art in America,* November 1980, p. 143.

FRAGILE OVERLAYS

THOUGHTS ON THE TECHNIQUE OF ERIC FISCHL'S WORKS ON PAPER

CAROLIN BOHLMANN

A fictional family gave Eric Fischl the creative and thematic impulses for his early drawings: father, mother, son and daughter—the matrix of a pictorial story about a fisherman and his family.

On individual sheets of translucent paper Fischl made life-size drawings of scenes from the life of the Fisher Family. At first glance, they look like film stills that have been placed on top of each other, thus creating sequences that tell a story. (They remind the viewer of photographs of landscapes or of panoramic views that have been stuck together: the camera lens is not sufficiently wide to capture the entire motif, and so several individual photographs are placed next to each other to create the illusion of a panoramic shot.)

The glassines also contain sections that have been juxtaposed so as to create a whole. A large number of different effects can be achieved with this technique; for example, as the figures are usually depicted on individual sheets of paper, they appear isolated. In an interview with Gerald Marzorati in 1985, Fischl commented, "I'd draw one figure on one sheet, another on another, and so on. Then I would do these arrangements for the drawings, transparent overlays."[1]

However, the overlaying and uncovering can also influence the appearance of the painted sections: the oil paint becomes less vivid, more subdued, and also less precise—blurred even, while the upper layers appear darker and show more contrast and detail. Color is not used at all in the glassines: Fischl uses only black outlines and gray tones, thus creating a distance between the objects. These overlays make the relationship between the foreground and background of the glassines more dynamic.

In his glassines, Fischl dissolves the two-dimensional picture plane. The fictional depths of perspective in a pictorial space are here divided into individual layers and lie—transparent—on top of each other. Realistic space is fragmented into several different planes which are only held together by the contours that outline the representation. In this way a tension is created in which the objects use silhouettes to define their existence. They attain only a very tentative affiliation with the subject of the picture, as coherence is only attained through the graphic interfaces linking the individual sheets.

Fischl himself explained at great length how he came to create the glassines:

"I can almost say that glassine unlocked my creative process. It was something about the translucency of the material. Also the size was right. I was working with this three-foot-by-ten yard rolls: three feet is enough to get a life-size figure on and so I could make large scenes. First of all, the way the paper accepted oil paint was really sexy; it had this Vaseline jelly feel to it, slick and viscous at the same time, and you could erase what you didn't like. So you could really work with it and that made it fun. Then I found that I was better at drawing if I could use my whole arm from my shoulder down than if I just used my knuckles.

"That was part of it, and also the translucency of the paper and the fact that I could overlay one thing on another and get this feeling of space. The color of the paper itself—while I can't call it beautiful—was a compelling green that separated itself from the wall and created the light in which the action took place. All those things came together. I found that I could literally project a scene: I could say who's sitting at that table, are they sitting, are they standing, are they walking, are they underneath, what if they were underneath? I could put something on and if it didn't work I could take it off and use it in another scene. I connected to the process right away. I envisioned that I would make a life's work out of it. It didn't seem like there was any reason why it would end. I was actually surprised when I realized it wasn't enough. I also thought it would be an ongoing, evolving soap opera. Soap operas don't ever end; they just introduce new characters. It turned out, though, that I wasn't looking for something that was ongoing: I was actually looking for frozen moments, for something where somebody's gesture, the interaction between that gesture and its environment and what had caused it—all those things created a poignancy that filled the room with meaning. Although I could rearrange the glassines endlessly, I noticed that every time I put one back up I did so in the same way. It was the particular configuration of the scene that gave it meaning."[2]

The viewer is made aware of the total dramatic effect and the intricacy of the overlaying, adding, moving, and displacing. Fischl makes it possible for us to understand the individual steps of his creative process. In this way we can participate in the formation

[1] Gerald Marzorati, "I will not think bad thoughts." An interview with Eric Fischl, *Parkett,* no. 5 (1985), p. 17.

[2] Eric Fischl, in *Eric Fischl 1970–2000,* New York 2000, p. 46.

BIRTHDAY PARTY
page 75

of the picture, and we have the impression that we can influence the story as it is being told: we feel that if we could remove the bath or the broken toy, then, perhaps, the boy would not be beaten (pl. p. 75).

This open system of combinations is also a presentation of relationships, of course—a view of the world as involving a balance of natural forces. Everything is taking place over and over again. The presentation of people as figures in a game allows for any number of variations. Any number of different constellations can be imagined and represented—all the potentialities are there. Replying to the question why he stopped painting glassines, Fischl explained, "That is the way I work, collaging things into different meanings, but that wasn't what I was interested in. Doing paintings got around all that. And painting is plastic. I mean, with paintings you can improvise, make mistakes, change course…"[3]

Beginning in the mid-eighties, his works on paper have indeed become very "painterly" and clearly differentiate themselves from the constructed, multi-layered glassines with the defined outlines of the represented figures and the freedom of ever new combinations of the narrative elements.

Fischl turned to using oil paints on coated paper and applying the paint with expressive brush strokes, thus setting the luminous, light ground into sharp relief. The pictures have become more obviously two-dimensional with a closed narrative structure.

And yet, one can still recognize a connection with the glassines: It seems as if the artist still had the possibility of changing his mind during the creative process: the smooth surfaces of the paper make it entirely possible to work "in reverse." Because the oil paint does not actually penetrate the paper—it can be wiped off again. Therefore, the *alla prima* character of this method of painting is preserved—and above all, the luminous, light-colored ground takes on a dominant presence within the picture.

In this way the reversible character of the creative process is maintained, although a radically different principle is at work here. The overlaying, covering, and displacing techniques used in the glassines are gone—instead the paint is applied and wiped off again. The paint is consciously and unmistakably applied with strong strokes of the brush, as if in a mimetic imitation of the movement being represented. Here, Fischl is not trying to take complete control of the painting medium, rather he is showing the forms that can be created when physical conditions—for example, paint consistency and the force of gravity—are allowed to combine. This emphasis on the medium of the painting distracts the viewer, and color, style and brush strokes take prominence in his or her perception of the picture.

With this style of painting, Fischl introduces movement into the surface of the picture, a movement that lends agitation and animation to the objects portrayed. The outer edges of the forms and objects are defined by the structure of the paint, and the line that determines them is the drawing itself. The outline is replaced by a kind of *chiaroscuro* which structures the representation in terms of the values of color and light.

And it is these light values that mould the bodies. The paint is applied very thinly, almost as a glaze; the underlying backgrounds are wiped away to provide space for the figures that are painted above—without, however, interrupting the structure of the background. The different layers of paint are applied next to each rather than on top of each other, allowing brightness and luminosity to shine through these layers. Thus, the interaction of figure and background is always maintained in a harmony of movement that is both chromatic and dynamic.

Thanks to the dominance of light and the translucent material of the oil sketches the ground is always present, as in the gold ground paintings of the Middle Ages, and also as in the case of the glassines, where the material of the base shines through and unites the different components of the pictorial structure.

It is with these overlays that Fischl establishes fragile links. In the glassines, these links were transitory in as far as they could be changed at any time, as in a game. In the oil sketches on paper, on the other hand, Fischl has decided to capture a moment in time and, despite (or perhaps because of) its transitory nature, to give this moment a special meaning. This fragility is emphasized even more by the smoothness and clarity of the material ground on which he paints. Surfaces of this kind appear opaque and impenetrable, like computer monitors or projection screens.

[3] Marzorati 1985 (see note 1), pp. 17–18.

Indeed there is a close connection with the magical world of moving pictures—whether the electronic television screen or the cinema screen, on which an endless array of moving pictures continues to appear and disappear. The important thing is that when projection screens, backgrounds, pictorial formulas and patterns are no longer fixed, allowing the artist to abstract from them, the lines and colors of the figures themselves also become exchangeable.

In the modern technologies of reproducing pictures, the background and the image are no longer necessarily connected to each other—the backgrounds and even the figures have become interchangeable—a state of affairs that is quite different from that of classical method of painting with oil on canvas, where the manner of application and the texture of the material bring paint and canvas together in an almost irreversible way, thereby establishing the material unity that is responsible for the self-contained nature of the work.

The function of the ground or background as projection screen in Fischl's work makes it clear that this has to do with other, more familiar kinds of image-producing media. In Fischl, figure and background do not necessarily blend together. The figures stand out from the background. The artist has not woven the paint into the ground, as it were, but simply applied it to the surface.

In spite of the apparent non-connectedness of the materials (the ground repels the oil paint), however, Fischl's works on paper do reveal a mechanism which seems to link the picture elements together. A tactile texture emerges which connects the foreground and the background in what might be called a textural unity. In these fragile painted constructs, Fischl succeeds in using a traditional technique, one that is based on the repellent nature of the ground, for the purpose of achieving a material connection. The background seems to function as solace, surrounding the figures and holding them close, providing an alternative to the apparently incompatible nature of the materials.

Looking at the oil sketch of the bathers (*Untitled,* 1987; pl. p. 80) one gets a clear notion of how Fischl has pushed the figures deeper into both the ground and the background. Water is the perfect medium for this particular method of representation—here the ground and background seem to literally play around the body. The entire length of the body cuts right across the depth of the scene and is completely surrounded by water as the element of both foreground and background. The body seems to have been painted quickly, and its movements as it swims through the water are carefully captured—the viewer can almost see the movement of the swimmer, expecting him to come sliding back in the opposite direction. The body appears to be lying flat on the surface of the water—and at the same time, the water oscillates with light reflexes on the skin of the swimmer.

"Light and water in combination has been both a painting condition and a spiritual condition. A body in water changes shape: it's distorted, it wavers, its edges become less clear. It is a metaphor for transformation. The same is true with light that obliterates edges or reinforces them by creating a fracture with its shadows. It represents the transitional and the transitory."[4]

The relationship between the body and the water is ideally suited for a representation that aims to weave together the different layers of a painting. The body can be placed in front of or behind the water; the translucency of the water lets it shine through, but at the same time the water can also disarrange the form of the body. Furthermore, the water acts like a color filter which has been placed in front of what is being represented in order to modulate the color and brightness. These seem to be the qualities that Fischl appreciates in painting—the living quality of the material, the possibility of preserving these moments through painting and to portray their agility and fragility.

Unlike in a photograph which, by default, forces the ground to become texturized, Fischl aims, in his oil paintings, to reverse this "frozen" stasis. He refers to it as a process and at the same time introduces the fragile aspect of conservation. It is not surprising, therefore, that photography plays such an important role in the creation of his paintings. In an interview he commented on this as follows: "When I paint I use photographic sources, but I don't project them right on the canvas, because I am afraid I'd get too seduced by all the detail, and the detail is not what I'm after. ... So it's like: Who cares how I arrived at a given painting—the mechanics anyway. I always begin a painting the same way, whether I'm using photos I've found or ones I've taken. I always

UNTITLED
page 80

[4] Fischl 2000 (see note 2), p. 166.

start by looking for causes: Why are people acting this way? Does it have to do with who they are, where they live, where they are?"[5]

Again and again, Fischl is concerned with portraying the world in which he lives. He is interested in the people around him, their personal worlds, connections, movements, and ways of behaving. This close connection is also an indication of his interest in photography, which has an indexical meaning for him in as far as it has a causal connection to its object—as an image and vestige of the world.

"A photograph is a witnessed moment, and great photographers have incredible skill in recognizing that moment. A painting arrives at that frozen moment through accumulation. It's not something that is taken out of the world; it's something that is actually put into the world. The viewer not only experiences the poignancy of that frozen moment, but also participates in its re-enactment. We're given all the decisions that go into it: what was included, what was excluded, what was distorted, what was refined—building a different bond between the artist and the viewer. We feel the reality of a photograph because it slices a moment. It leaves us apart from the reality, and we become witnesses rather than participants."[6]

Taking a slice out of the flow of movement creates an individual, invariable picture, which then begins an immobile existence as a photograph and at the same time serves as representation of a person. This reduction of the world to a photographed tiny moment is something that Fischl takes very seriously and that he aims to capture and enhance through the medium of painting. He says expressly that he wants to bring photographs back to life. For photography is, at times, not only the reality of a moment that has passed but also the essence of what a person holds within themselves. Fischl aims to decode this and to render it visible through his use of painterly means and through the expressive color overlays of his pictures. In this way he is trying to reverse the mortifying effect of photography, for the creation of a photographic representation involves a loss of movement, of animation, indeed of any further change.

By using photography as a point of departure and, as it were, painting the figures afterwards, Fischl is trying to revive the bodies portrayed. He is aiming to connect the self with picture worlds in order to gain access to that which is new and that which is familiar. That is how he can link everyday scenes, like that of a swimming pool or a beach, with nymphs and gods. And this is achieved not by bringing them closer to one another, but by simple deviation and transformation: the bodies which the artist sees around him are seen as susceptible to being permeated by their classical archetypes—this, in the emphatic sense, is the classical way of seeing. At the same time, this painterly integration also allows him, as described above, to help preserve and shelter the body in the world—a gentle embrace that he achieves by carefully locating and weaving together the fragile figures and their background.

Most recently, his latest watercolors and lithographs have introduced an otherworldly element to his works on paper. Here the background no longer provides any solace—the bodies are isolated, they are no longer contained by a stabilizing background, as was the case in his oil sketches. The varying levels of blurriness and sharp definition imbue the space with a sense of non-reality and create a somewhat mystical aura. This is continued in an even more radical manner in the "tumbling" paintings done after September 11, 2001. The animated brushstrokes which used to connect the background with the figure are now completely absent. What remains are figures that seem to have been assembled out of outlines and body parts. The separation of background and figure is complete. The absence of any discernible source of light creates an unreal atmosphere so that the bodies seem to float. They have nothing, only themselves, and that is what they hold onto as they fall. It is material plunging into nothingness.

UNTITLED
page 101

5 Marzorati 1985 (see note 1), p. 25.

6 Fischl 2000 (see note 2), p. 90.

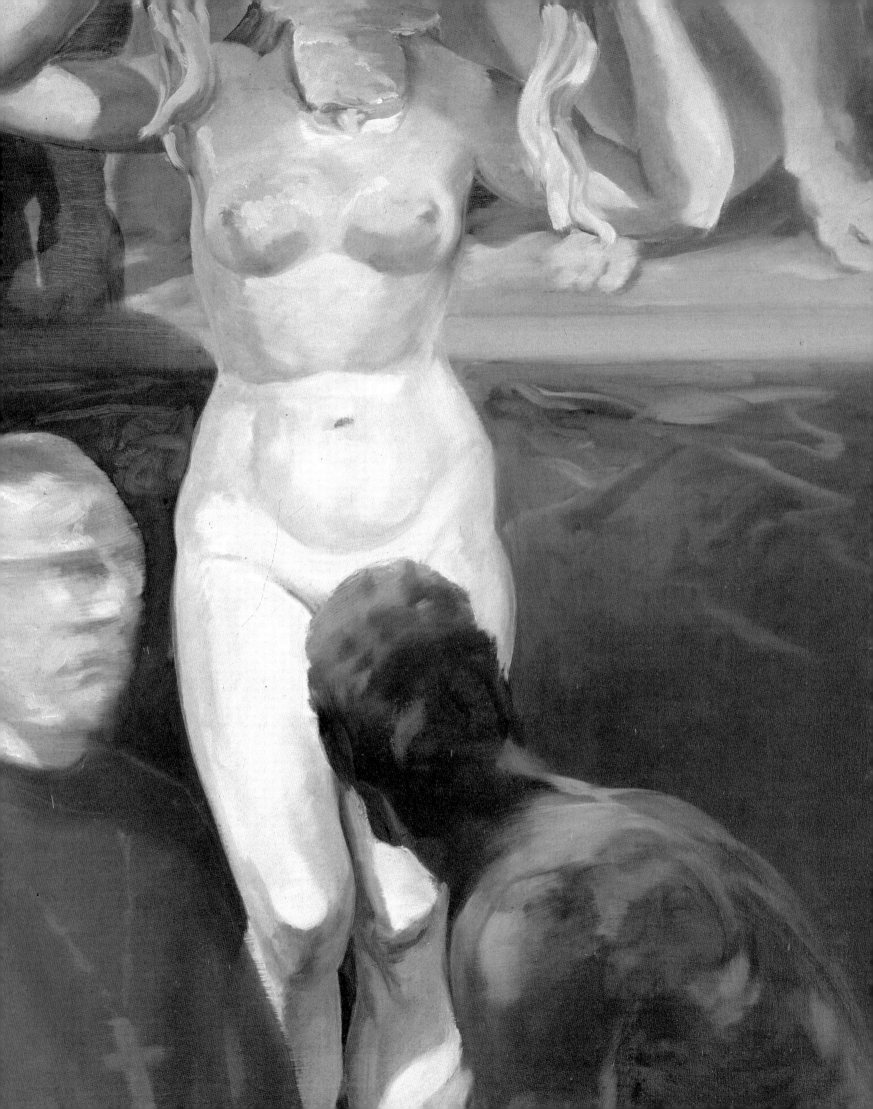

NARRATIVES OF THE SACRED: AN AMERICAN IN ROME

VICTORIA VON FLEMMING

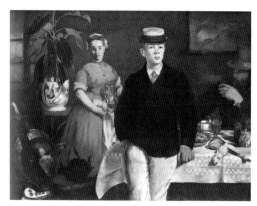

(fig. 1) Edouard Manet, **Breakfast in the Studio,** 1868
46.5" x 60", Munich, Bayerische Staatsgemäldesammlungen

There are wishes that seem to leave us with no choice but to fulfill them. A child's demand, in the guise of a request, to be told a story is obviously one such case in which any resistance seems pointless—perhaps because one begins to hear a distant echo of one's own childhood. And the more space one grants this memory, the louder and more insistent this echoing becomes. There is clearly something archaic about the wish, and one suddenly arrives at the conviction that writing could only have been invented out of the fear that all the stories which were solely narrated might get lost.

When Eric Fischl began his training as an artist, not only was painting regarded as dead, a long time had also been spent trying to kill off narrative. In the 1950s a group of Parisian intellectuals announced the birth of the *nouveau roman,* which replaced political or moral engagement and carefully devised plots consisting of various lines of development and characterizations of individual protagonists, with the cool, factual description of all that could be perceived. At about the same time an effort was made to eliminate the subject as well. The attempted homicide failed, however, and the desire to tell stories triumphed so loudly that it even spread to the French humanities.

But Fischl lived in America. And he was a painter. One who not only attempted to keep painting alive but also—and this is more to the point—one who was trying to breathe new life into a tradition that had been dead and buried for much longer. With his paintings, Fischl wanted once again to tell stories, at a time when narration had turned into a hoary relic in a world of conceptual, abstract, and minimalist art. Narrative seemed to point to a past that was scarcely worth bothering about.

Admittedly the epitome of narrative painting, history painting, described by Renaissance theorist Leon Battista Alberti as the finest and noblest flower of all genres, already seemed inevitably condemned to oblivion by the early eighteenth century. And even though the jurors of the nineteenth-century academies and the Paris salon spared no effort, the fate of narrative painting appeared to have been sealed with, at the latest, the victory of the impressionists, whom the salon had tried to ostracize. The proponents of what came to be called modernism must have seen themselves as the most consequential executors of this agenda.

But even if history painting had become obsolete, narrative was to survive, curiously enough—not just in painters such as Edouard Manet and Edward Hopper, but also in a number of photographic works. Regardless of whether one looks at Manet's *Breakfast in the Studio* (fig. 1), Hopper's *Nighthawks,* or the deserted scene in Robert Frank's *Diner:* in each case there is a mysterious mechanism that is triggered when our gaze alights on the picture. The confrontation with a seemingly narrative-free space is transformed into an encounter with what has yet to be told. One's gaze scans the painting's time-frozen content as if trying to uncover a secret. And suddenly one's thoughts begin to roam. Over and over they start to ask about the past and the future of what one sees, and it is this silent dialogue, starting up unexpectedly, that transforms the scene into a narrative. These are pictures in which the stories no longer unfold before our eyes but rather behind them.

It is all the more astonishing then that this mechanism was already known to the iconographers of antiquity. There is a passage in Pliny which was not only quoted at length by Alberti in his *De pictura* (1435), but which, with the cunning of osmotic knowledge, also found its way into Lessing's Laocoön essay in 1766, and even into the self-reflections of photographer Henri Cartier-Bresson in 1952. And those who have made the study of images their profession can name any number of pictures that reveal a knowledge of this trick. Pliny reported that even Timanthes had already earned special praise for having mastered it. He is said to have been the first to paint a portrait of Iphigenia before her sacrificial death in which the task of depicting the grief in the faces of each of those present was accomplished to perfection: each person was portrayed as conveying his or her own, clearly recognizable facet of the emotion. The sole exception was Iphigenia's father: Timanthes depicted the countenance of Agamemnon hidden by a veil. Paternal grief and above all the dignity inherent in the unbearable pain were both left out and hidden by a veil. It was precisely this, Pliny continues, that revealed the painter's ingenuity: "People thought they could always distinguish more in his paintings than he had painted."[1] Lessing attempted to get to the heart of this phenomenon by involving the free play of the imagination and the artist's ability to choose the right moment: "But only that which permits the free play of the imagination is fertile. The more we see, the more

[1] Pliny the Elder, *Natural History,* vol. IX, book 35, p. 74.

we must be able to imagine. The more we bring with our imagination, the more we must believe we see."[2] And Cartier-Bresson knew that "of all imaginable means of expression photography alone can [fix] a particular moment." This moment consists of "the simultaneous recognition, in a fraction of a second, of the significance of an event as well as the precise organization of forms which gives that event its proper expression."[3]

Neither Iphigenia's sacrifice, nor Manet's *Breakfast,* Hopper's *Nighthawks,* or Frank's *Diner* let one discern more than one sees. And even though all these works are concerned with grief, with the possibilities of reconstructing past and future from the moment, or even with the semantic field surrounding a single instant, they all rely on a clearly nameable competence on the part of the viewer, i.e. on the interplay of perception, imagination, and memory. For the mind can only access what it has at some time perceived and stored in its memory as a representation of the perception.

The painters and sculptors of antiquity and of the early modern times knew about this phenomenology of perception, perhaps as a result of their familiarity with a rhetoric painting with words, or perhaps because they were familiar with Aristotle's observations on sensual perception. What is more astonishing is that antiquity even knew of a variation of this occurrence. Even when the scene or object that was being looked at did not demand that literary texts be called to mind, the viewers would still not rest. Well before Denis Diderot, Philostratos, and numerous, mostly anonymous writers of illuminated poems, have reported how they felt prompted by the silenced and immobilized subject of the paintings quite simply to animate them. In their descriptions of paintings, a nymph was addressed as if she were a long-desired living being, and not only did the occasional cupids begin to romp about in the pictures—the describers of the scene actually imagined themselves participating in the action.[4]

Perhaps this is one of the mysteries of pictures which are narrative although they appear not to be. They fascinate the viewer because they not only permit but actually ask for a unique kind of transgression. They quietly offer to dissolve the frozen moment, thereby responding to one's wish to be told a story. That is what Roland Barthes had in mind when he noted that "there nowhere is

nor has been a people without narrative. All classes, all human groups have their narratives," which he says are conveyed by words or images: "caring nothing for the division between good and bad literature, narrative is international, trans-historical, trans-cultural: it is simply there, like life itself."[5]

The success Eric Fischl had with his pictures that ventured once again to tell stories has not just to do with fulfilling a wish that must be regarded as an anthropological constant, but also with his ability to choose exactly the right moment. It was from Manet that he learned not only about the intrinsic value of color and light but also about non-narrative narrative. His close studies of Manet or Hopper bore rich fruit when Fischl began to explore a subject that was virtually handed to him on a plate.

Anyone who has ever been in the clutches of a large family knows that it contains the sum total of all that can be told. But this sum total will only become a narrative when looked at from a distance. In painting, at least, the subject-matter of '*me, going through puberty, in the family,*' had not yet been discovered.

Fischl set out to explore his own past like a voyeur—visualizing the fantasies revolving around his own curiosity, such as in *Bad Boy,* or exorcizing the family idyll in a single flaming moment, as in *Barbeque* (pl. p. 29): a game with fire, a little muscle-man act put on by a pubertal adolescent, has achieved its goal. Mummy is delighted, daddy is proud—and now it's time to eat: fish from the barbecue. Perhaps father and son caught it together, in the ocean just off Long Island or elsewhere. A lovely day it had been, out there on the sea, as the men worked to feed their family, reenacting some archaic pattern, as it were. And yet there is a flash of anger at the sight of the father's naïvely amused pride.

Doesn't he realize the danger in what his son is doing? Doesn't he know that the young man's tensely-held left arm can be read as a sign of imminent peril? The limbs of burned human beings look like that. Just a tiny slip, a brief distraction, and the ignited spirit could flare up, destroy what one loves and turn the carefree moment into a scene of unending horror. Fathers are more important than mothers at that age, but at times they neglect their responsibilities all too carelessly.

BARBEQUE
page 29

[2] Gotthold Ephraim Lessing, *Laokoon oder über die Grenzen der Malerei und Poesie* (1766), Stuttgart, 1964, p. 23.

[3] Henri Cartier-Bresson, "Introduction to The Decisive Moment," in Nathan Lyons, ed., *Photographers on Photography,* Englewood Cliffs 1966, pp. 41–51.

[4] "Nor should that hare there escape us, we'll chase him with the Cupids ... and shoo it away, the one by clapping its hands, the other by loud cries ... but the animal has doubled back ... and now they're laughing and have toppled over." Philostratos, *Die Bilder,* Greek-German edition by Otto Schöneberger, Munich, 1968, p. 101.

[5] Roland Barthes, "Introduction to the Structural Analysis of Narratives," in Roland Barthes, *Image-Music-Text,* trans. Stephen Heath, Glasgow, 1977, pp. 79–124, here p. 79.

(fig.2) Giovanni Lorenzo Bernini,
Saint Theresa of Avila in Ecstasy,
1645–1652
marble, Rome, S. Maria della Vittoria

BEATA LUDOVICA
page 47

6 "Every day I felt the world sparkled.
 The colors of Rome, the energy
 of the city—everything seemed
 wonderful, new, joyous. It was like
 I was hallucinating all the time."
 Frederic Tuten, "Fischl's Italian
 Hours," *Art in America* (November
 1996), pp. 76–83, here p. 77.

The critics raved when they saw Fischl's family pictures, his Fisher series. Here was an authentic confession, a slap in the face of a prudish and self-righteous generation. This was the response of the sons who had liberated themselves and put their finger on the double standards that surrounded them. Even when Fischl finally turned away from the drama of the talented son and his family, changing his subject and experimenting with new forms, the critics remained favorably disposed to him. That would change only after he returned from Rome in 1996.

He started out with pictures at the back of his mind that were not only to accompany his journey, but also his entire life—something that only dawned on him in Italy during his fellowship at the American Academy in 1995, shortly after having buried his father.

The spacious villa that houses the American Academy sits regally on top of the Gianicolo, one the seven hills of Rome. And just like its imposing cast-iron gates, the institution itself seems to ward off all contact with the lively, bustling city, even though Rome lies directly at its feet. Many of the Americans who sojourn in Rome sense the dangers that this isolation implies, and so they take one of their most appealing cultural traits down to the city: invitations are extended with irresistible charm to anyone who seems sympathetic, interesting or important, and it is with no less charm that the scholars are urged to go down to the city.

Fischl, still paralyzed by his father's death, did go down to the city. And the way he conquered Rome seems to be apparent in some of his pictures. What he searched for is revealed in them all. It was inevitable that during his excursions he would wander along the Via Dandolo. He followed the twists of the street, which are subtly reminiscent of swaying hips, and perhaps discovered at some point, as if by chance, that the quickest way to the bottom was to follow the small steps carved out of white stone that lead straight down the center of a slope covered with pine trees. One gets to them just after one has passed S. Pietro in Montorio on the left, at the level of the Aqua Paolina, commissioned by Pope Paul V—a grandiose staging of the water that is so important to Rome. But Fischl was not interested in this aspect of the Baroque; he was looking for another. For that reason he would have paid equally little attention to the villas and tenement blocks dating from the nineteenth century. But at some time or other he will have arrived at a particular section of Rome that he knew from the stories of others. It began at the Piazza S. Cosimato, at the end of the Via Dandolo. It is the scene of a daily market. In the little stalls with their rattling shutters and rickety wooden tables, the farmers from the surrounding countryside sell the produce of the land. Fischl later recalled that he felt almost intoxicated with the colors of the city.[6] He encountered them very early in the morning, during his first walk around this small corner of the Trastevere quarter.

But at some point, perhaps at the market, Fischl would have directed his steps to the Viale S. Francesco a Ripa and, following its course, crossed the noisy Viale Trastevere, ending up in a small piazza that seemed to have been forgotten by time. Here at last was peace and quiet, the bustling main street lay behind him, and as day turned to evening, the silence around him grew.

At the head of the piazza stands a small, inconspicuous chapel. Nothing pompous—again, this was not the kind of Baroque of which he had heard. Nevertheless Fischl walked in, and presumably he was alone. Only rarely do visitors enter the church to grope their way through the semi-darkness, looking at sculptures and paintings by masters whose names are quickly forgotten again. The one unforgettable exception is *The Blessed Ludovica Albertini* by Gianlorenzo Bernini: a saint carved in ecstasy and agony. (pl. p. 47) Fischl painted her, and in so doing he staged her. This may well explain why he did not choose a nun who was much more famous for her mystic ecstasies, Bernini's *Saint Theresa of Avila* (S. Maria della Vittoria, fig. 2). Her mise-en-scène is already complete, surrounded as she is by marble spectators who are not looking at her, and lit by a lamp that does not illuminate her. But above all, Saint Theresa lacks something that the *Beata Ludovica Albertini* has retained. For all her distance, she was very close.

At least, that is what Fischl's painting asserts: she appears almost in close-up, surrounded by candles which only her worshippers could have lit. These candles are the tell-tale signs of veneration, the traces of today's Rome that link the past and the present. And without knowing as much, that is what Fischl was hoping to find—an interweaving which proved that a curious symbiosis of strategy and ritual had survived.

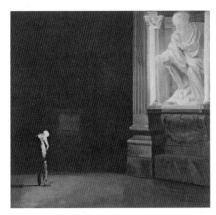

(fig. 3) Eric Fischl, **Anger, Remorse,
Fear or Incontinence,** 1996
Oil on linen, 98" x 103", Private Collection

[7] *EF*: "When I got my photographs
from the developer they were
all dark. *FT*: You mean you hadn't
lit them correctly? *EF*: No, they
were all photographs of dark interi-
ors, or of Rome on rainy days, or
of dark, weighty religious spaces—
the cathedrals and churches."
Tuten 1996 (see note 6), p. 77.

[8] "I always liked that about the Cath-
olic Church: they tremble as they
enter the church. What I loved
in Rome, was that the artists (e.g.
Raphael, Michelangelo, Bernini)
were at the service of that feeling.
They were asked to create a dy-
namic environment that completely
illustrated the aspiration, the fears
and the catharsis of this belief.
So I was envious. I felt deeply that
I was not rooted, while the church
artists had things ready to do."
Tuten 1996 (see note 6), p. 78.

Anyone who looks at Fischl's picture will think that he made a contract with Bernini. That he wanted to convey how important the confrontation between natural and artificial light must have been to the sculptor in his effort to show that dying is an art. The rays of the sun entering almost vertically to light the face and the robe are not just required to render the dying woman visible—the light also has something that is comforting. Dying is not merely suffering, dying is also—and above all—a journey into the light. A light, as the picture tells us, that shines first and foremost for this blessed woman. And it is precisely for this reason that the sculpture can become the medium of personal hope. The hope of floating up to a heavenly light at death, made possible only by the shadows cast by her dark bed. The practice of lighting candles, a ritual still employed to this day, is the everyday codification of this hope.

And thus it makes sense that Fischl's picture has corrected reality in a way that is just as discreet as it is accidental. For only when the sculpture's substructure is allowed to disappear in this darkness illumined solely by candles, giving way in its stead to a mere hint of rocks, only then can we see what Bernini presumably wanted to show: that the art of dying is based on the ability to enter into rapture, to cut loose and start floating. Bernini was hardly interested in the life story of this recently beatified woman; he was interested in a meditation on death. It seems that this is still being understood.

Before Fischl painted his Rome, he photographed it. And to his great amazement the prints did not show what he himself recalled, revealing instead how dark the city can be.[7] This lack of light and color was, however, no mistake; it was intentional, as he was forced to admit to himself. What he did not say was that the darkness might even have turned into a *conditio sine qua non.*

Fischl grew up in a country that decided once and for all to banish any delight in religious images and ceremonious rituals—something that was typical of all the denominations that turned away from Catholicism in the sixteenth century. The belated revenge for this demystification is not without its irony: Catholicism was secretly to infiltrate the United States by way of the immigrants from Central and South America who managed to overcome the border fences. And Fischl, a foreigner searching for his roots in Europe, found in Rome what he had been denied at

home: a narrative of the sacred that had lost none of its magic power. It is a magic that thrives in the dark. When he admired Michelangelo, Raphael, and Bernini, he also envied them the conditions under which they worked. It was a faith not yet demystified that lent their works the power of conviction.[8]

But there is more than that. There is also the fact that Rome is a city which permits regression. It is dominated by a truly omnipresent culture of mercy, a marvelous ability to forgive even the unforgivable, such that this privilege has long turned into license. And only those who have lived there for some time, who are scarcely foreigners any more, experience this as a compulsion that can be enervating at times. This is the most bitter lesson of everyday life.

Fischl is not, however, a Catholic, he is a product of the Protestant theology of sin. That may have been the reason why a giantsized sculpture, an enormous male figure such as could be displayed in one of the apses of St. Peter's, re-awakened in him memories of genuine experiences of male anxiety and shame.

Anger, Remorse, Fear or Incontinence (fig. 3): Here is an old man, standing infinitely alone in the dark belly of a church, his hands nervously fiddling with his fly. In the moment of confrontation with the monumental sculpture that seems to radiate from within, he becomes once again a child. *La vecchiezza rimbambisce,* age makes one childish, as the Italians say. Yet the painting seems to say much more. It seems to tell of suddenly returning childhood memories.

The stone figure is not the man Moses, but nonetheless it seems to resemble a kind of over-father and brings up memories of events that normally concern just mother and child. These are the first sensations that trigger a sense of shame. For it is the mother who sees from the sheets that her son has wet the bed. And it is she who years later discovers that he has masturbated. In both cases it is obvious that the son has soiled himself, has done something with his genitals that is harmful and disgraceful. For that he must be punished, and punishment is the father's business. It is to this end that the mother has to betray her son, thus heightening the already burning shame and humiliation to an almost unbearable degree. For the son admires the father, he wants to be like him.

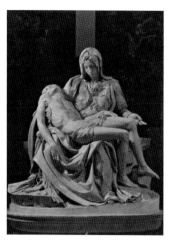

(fig. 4) Michelangelo, **Pietà**, 1498/99
marble, Rome, Vatican, St. Peter

And in his fear of the punishing father he soils himself again, this time in his pants.

And later, when he has grown old and has long lost this father, he will—as if hounded by fate—come to witness what in psychoanalysis is termed compulsive repetition. The confrontation with this sculpture brings to life a drama that he thought he had overcome far back in the past.

But this father, who appears like a stony spirit, is no longer a punisher. His countenance is benevolent, care has been carved into his gestures, and all the imperatives of the past seem to have been transformed into their opposites: Have no fear. Even heretics are subject to the culture of mercy, if only in their daydreams.

'Pietà' is one the trickiest words in the Italian language. And precisely because it can mean both mercy and compassion and, as if that were not enough, it may also denote a very specific, truly catholic subject-matter in art, it is possible that it is in Rome that one can really begin to understand it. But Fischl does not take us to Michelangelo in St. Peter's (fig. 4). Instead he crosses the River Tiber, turning his back on the picturesque district of Trastevere and sauntering along, aimlessly perhaps, until he finds another church that seems to invite him in.

As if by chance he comes upon one of the many adaptations of Michelangelo's *Pietà*. Unlike the bronze copy in S. Andrea della Valle, this one is not flanked by Leah and Rachel or set in an altarpiece; it stands as if forgotten in a niche, on a plinth. Thus one can see what Michelangelo himself did not wish to show. A Mother Mary who laments the death of her grown son with desperately plaintive gestures, her face contorted by loud sobs. The inward-looking silence has given way to an outward-directed pathos; Renaissance has become Baroque. And as if in a mysterious inversion, the noisy presence of daily life breaks into the silence of the sacred space.

In front of the pews, a small group consisting of three figures has assembled. A middle-aged woman, well-tanned, wearing a slightly overtight and overly bright two-piece suit, rests one hand on her hip in a gesture of indignation and seems to be pointing with the other, no less indignantly, at the cause of her wrath. But whatever or whoever it was has been engulfed by the darkness of the in-

IF THE DEAD HAD EARS
page 50

tercolumniation. An Italian woman, one would think, with typically Italian temperament and energy, and it is only the woman's hat that makes one wonder. It is not just the style but the way it is worn that seems to suggest a different country and a different time. The only clue to the situation is provided by the wet chapel floor.

It must have been raining outside, and the heavy summer storm must have prompted the woman to put on the first hat she found and, when that was not enough, to enter the church in order to rescue herself, her hair, and her makeup. In point of fact she had been planning to do something else altogether. The same must have been true for the second person. A strongly built woman, somewhat older and the only one with her back to us, she has likewise broken the tacit dress code in her attempt to save herself from the rain. She had quickly covered her shoulders with a rather short coat that matches neither her skirt nor her sandals. These marginal details, telltale signs of trivial breaches, function as syllables in a narrative that are only assembled into words and sentences by a different and really grave transgression of a taboo. With silent determination, the older woman has brought into the church an article that truly desecrates this sanctum: a red balloon with a metallic shine, twisted into the form of a rabbit.

The torrent of words issuing from the woman dressed in suit and hat is not directed at the older woman with her silly balloon, however, but at the person facing her—a man in black who is listening to her patiently and silently: a clergyman, presumably the church padre whose white collar flashes brightly. In the confrontation with the two women he appears to be taking on a new function: it seems that they expect him to judge, to decide and to reprimand—to restore the order of things that presumably was disturbed not by the balloon, which has now floated up almost to the chancel, but by something that must have happened shortly before in the darkness of the side aisle. The violation that took place there—and that is now the object of an excited report—was responsible, then, for these new and therefore all the more forgivable infractions of decency.

But that's how it is when it rains in Rome: the city is turned on its head, everything stops, and even the few rules that are usually followed are no longer valid. In Rome, a sudden heavy downpour, perhaps accompa-

nied by thunder and lightning, can turn into a truly archaic experience. Within minutes the gutters are transformed into raging streams, and anyone caught out by the sheer force of the elements and hurrying to seek shelter finds themselves part of a fleeting community which sooner or later voices the word *diluvio,* deluge. It is only with the reference to the realm of the sacred that one can attempt to cope in such states of emergency.

It is perfectly all right then to seek refuge, if not in an ark, then at least in the nave of a church. To be sure, the women who sought nothing more than shelter from the storm knew that they should discreetly keep in the darkness of the side aisle. And they also knew that now, as the sun was beginning to bathe the church interior in a warm light, it was time leave their place of refuge. But they had happened to witness an outrageous incident, and so they were relieved when the priest emerged from the darkness into the light-filled church. They had no way of knowing that he might already have intervened to restore order. It may have been his words that caused the fourth person in the scene, a man whose back and thinning hair are lit up by the sun, to play it safe and make for the main entrance rather than the side door which is much closer.

But it is almost irrelevant whether he or something else caused the women's outrage. Either way, the priest will have turned to the sinner with a firmness matched only by his compassion. Pietà, mercy, compassion and grace are the essential marks of his profession. And once he has calmed the women by assuring them of his sympathy, the House of God will at last return to its former tranquility to let him continue on his way. The padre will cross himself briefly before the altar and then attend to whatever it was he was kept from doing a few moments ago. And perhaps he will also dispose of the wreath woven of laurel leaves and camellias, once part of a ceremony but now faded and placed, as if without thinking, opposite the Baroque sculpture group. And in restoring the order of things he may cast a fleeting glance at the Pietà.

Fischl also sought silence from the storm. He would of course have found it in his studio at the American Academy, up there on the Gianicolo. But this friendly, luxurious refuge had no storms to offer and no more than a bizarre excerpt from life. For which

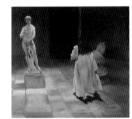

LA SPESA
page 49

reason he chose to do what many tourists do—and the majority of the clergy as well. He stepped out into the heat and brightness, into the hustle and bustle of Rome, in order to savor the subsequent withdrawal into the quiet darkness, and to learn to decide for himself how and when to seek it. It was a withdrawal that did not sever him from life. Even nuns return from their shopping trips with plastic bags. And it must always be difficult for them to ignore what their eyes force them to see outside the convent walls. But *La Spesa* (pl. p. 49), the shopping, tells of truly trans-historic events.

A nun is scurrying across the courtyard as every nun before her has done: in a tell-tale way. The reason for her resolute steps is there for all to see. As if it were not enough that she has to expose herself to the depravities of life outside the cloister walls, she encounters yet another temptation here where she thought to be safe. She has to walk past this naked figure of a man, who thankfully is only a sculpture, albeit a sculpture whose pose—a perfect *contrapposto*—recalls the fascinating beauty of antiquity. But she is faced with a christianized antiquity: This man, who to make matters worse is androgynous, has been transformed into an Adam who hides his sex with a fig leaf, and stands before the nun with a gesture half-way between defense and blessing. Adam did not resist, he allowed himself to be seduced—by a woman, of course. But luckily she was the very opposite of the nun who, armed with her vow of chastity, will resist all the sins of this world. Unless of course desire and curiosity can get the better even of her.

To be sure, she has heard of such things, this nun returning from her shopping trip. And perhaps she also knows that at about the time this sculpture was made, somewhere in the sixteenth century, a famous text was written and quickly placed on the index. In his *Sonetti lussuriosi,* the satirist Pietro Aretino had told of the salacious and by no means unworldly ways of the nuns and monks, in short: of their sexual life. And it was already in Pliny that one could read that the overwhelming beauty of certain sculptures had induced some people to unchaste deeds; and Giorgio Vasari, the great biographer of Renaissance artists, knew that nuns had been afflicted with the temptation to act quite shamelessly before a picture of Saint Sebastian. What would happen if, unobserved in this cloistered seclusion, she gave this Adam a quick stroke of the thigh or backside?

Whatever the nun of *La Spesa* feels moved to do will remain her secret. At some point she will disappear into the darkness again, leaving the stage in order to enter once more into the sacred. The fact that this sacred space has also become a stage a long time ago may have eluded her. But not so Fischl: his eyes have seen that Rome's churches are playing with light and darkness, that the sacred spaces and the marble figures that populate them have long been involved in a magnificent mise-en-scène. What is performed there is the narrative of the sacred— staged in ever-new garb and guises, yet constant in its change.

It must have been this close interplay of light and shade, defined in a completely new way, this almost unquestionable coexistence of past and present, and this mysterious marriage of the sacred and the profane that fascinated Fischl and inspired him to a narrative of his own. Unlike many other Americans, he did not kneel before what he saw. Instead of succumbing helplessly to a culture shock, he turned into a discoverer, a connoisseur, and finally, a chronicler of Rome—in a way, presumably, that is only open to those who grew up beneath a different sky and before a different horizon.

APPENDIX

BIOGRAPHY

1948
Born in New York City, childhood in Port Washington, Long Island.

1968/69
Studies at the Phoenix Junior College and Arizona State University in Phoenix.

1970–73
Studies at the California Institute of the Arts in Valencia, California. There he meets David Salle, Ross Bleckner and Matt Mullican for the first time.

1974–78
Professorship at the Nova Scotia College of Art and Design in Halifax, Canada.
He gets to know his future wife, the painter April Gornik.

1976/77
After an early stage of abstract painting, his pictures become increasingly figurative. He begins to work with the theme of the *Fisher Familiy*, which becomes the main topic in his paintings.

1978
He moves to New York and searches for new content and meaning. He begins to work with the theme of the initiation of a boy.
The paintings express family and social problems within the context of suburban America. These paintings deal with themes of alcohol and sexual dysfunction.

1979
His picture *Sleepwalker*, a painting of a boy masturbating, causes a sensation, which extends his notoriety, first in the United States and then in Europe.

1987
He participates in the *documenta 8* in Kassel, Germany. His themes express a social and political criticism.

1989
Travels to India.

1995
After the death of his father he travels to Rome. Inspired by the special colors and the light of this city, he paints pictures of dark interiors and religious places, in which he grapples with his father's death.

2002
The situation of 9/11 gave rise to a series of watercolors of falling, helpless and suffering people. With his sculpture *Tumbling Woman* he infuriates a big part of American society. The sculpture is representative of the feelings of dislocation and lack of grounding following the disaster. It was mistaken for a literal representation of all those people who either jumped or fell from the Twin Towers. The sculpture created an hysteria and was quickly hidden behind curtains and then removed.

Eric Fischl lives and works with his wife April Gornik in New York and Long Island.

INDEX OF WORKS

PAINTINGS

Sleepwalker, 1979
Oil on canvas
69" x 105"
Private collection

Bad Boy, 1981
Oil on canvas
66" x 96"
Daros Collection,
Switzerland

The Visitor, 1981
Oil on canvas
68" x 96"
Courtesy of Gagosian Gallery

Barbeque, 1982
Oil on canvas
65" x 100"
Steve Martin

Cargo Cults, 1984
Oil on canvas
92" x 132"
Collection Ludwig –
Ludwig Forum for International
Art, Aachen

**Portrait of the Artist as
an Old Man**, 1984
Oil on canvas
85" x 70"
Collection of the San Francisco
Museum of Modern Art
Gift of Collectors Forum in honor
of the 50th Anniversary

**A Brief History of
North Africa**, 1985
Oil on canvas
88" x 120"
Private collection, Courtesy
Mary Boone Gallery, New York

Manhattoes, 1986
Oil on linen
115" x 221"
Collection of the artist

Bayonne, 1985
Oil on linen
102" x 129"
Private collection

Far Rockaway, 1986
Oil on linen
110" x 135"
Gagosian Gallery

Birth of Love, 2nd Version, 1987
Oil on linen
119" x 142"
Louisiana Museum of Modern Art,
Humlebæk, Denmark

Girl with Doll, 1987
Oil on linen
70" x 50"
Collection of the artist

**The Beginning and
the End**, 1988
Oil on linen
75" x 110"
Neda Young, New York

Dog Show, 1989
Oil on linen
68" x 98"
Private collection, Cologne

The Tire Store, 1989
Oil on linen
109" x 75"
Courtesy Ninah and
Michael Lynne

**Portrait of the Artist as
a Woman**, 1989
Oil on linen
68" x 58"
Collection of the artist

**On the Stairs of
the Temple**, 1989
Oil on linen
115" x 140"
Neda Young, New York

Kowdoolie, 1990
Oil on linen
98" x 130"
Collection of the artist

Chicken Man, 1991
Oil on linen
108" x 75"
Collection of the artist

**Why the French Fear
Americans**, 1992
Oil on linen
86" x 98"
Collection Michael
and Joan Salke, Naples,
Florida

**Strange Place to Park
(2nd Version)**, 1992
Oil on linen
86" x 98"
Fonds national d'art contempo-
rain. Ministry of Culture and
Communications.
On permanent loan to the
Musée national d'art moderne,
Paris

**Scene from around a
Reflecting Pool**, 1993
Oil on linen
58" x 64"
Private collection, France

**Frailty is a Moment of
Self Reflection**, 1996
Oil on linen
68" x 58"
Collection of the artist

Beata Ludovica, 1996
Oil on linen
74" x 98"
The Rachofsky Collection and
the Dallas Museum of Art,
Fractional gift from the Rachofsky
Collection

La Spesa, 1996
Oil on linen
75.5" x 82.5"
Collection of the artist

**If the Dead Had
Ears**, 1996
Oil on linen
80" x 98"
Private Collection

**Cyclops Among the
Eternal Dead**, 1996
Oil on linen
65" x 55"
Stefan T. Edlis Collection

What Fell from the Tree, 1997
Oil on linen
58" x 68"
Steve Martin

Fred, 1998
Oil on linen
72" x 68"
Private collection

Mary, 1998
Oil on linen
75" x 58"
Greenville Museum of Modern Art,
Greenville, SC, USA,
Museum purchase from the
Arthur and Holly Magill Fund

April in Paris, 1998
Oil on linen
61" x 71"
Steve Martin

**Portrait of the
Artist**, 1998
Oil on linen
72" x 68"
Anne and Joel Ehrenkranz

Bryan, 1998–1999
Oil on linen
72" x 68"
GUC collection

Steve, 1998–1999
Oil on linen
73" x 58"
Steve Martin

**The Bed, The Chair,
The Sitter**, 1999–2000
Oil on linen
78" x 93"
Collection of the artist

**The Bed, The Chair,
Jetlag**, 1999–2000
Oil on linen
85" x 105"
Neda Young, New York

**The Bed, The Chair,
Dancing, Watching**, 2000
Oil on linen
69" x 78"
Arnold and Anne Kopelson,
Beverly Hills, CA, USA

**The Bed, The Chair,
Play**, 2001
Oil on linen
80" x 112"
Private collection, Courtesy
Jablonka Gallery, Cologne

**The Bed, The Chair,
Projection**, 2001
Oil on linen
72" x 90"
Jablonka Gallery, Cologne

**The Bed, The Chair,
Touched**, 2001
Oil on linen
65" x 84"
Private collection, Courtesy
Jablonka Gallery, Cologne

INDEX OF WORKS

WORKS ON PAPER

Critics, 1979
Oil on glassine paper
72" x 121"
Collection of the artist

Horse and Rider, 1979
Oil on glassine paper
60" x 79"
Collection of the artist

Birthday Party, 1980
Oil on glassine paper
69" x 76"
Collection of the artist

**Saturday Night
(the Aftermath Bath),** 1980
Oil on glassine paper
72" x 84"
Collection of the artist

Woman in Bath, 1980
Oil on glassine paper
49" x 67"
Collection of the artist

**Untitled: Study for Year of the
Drowned Dog,** 1983
Oil on chromecoat paper
28" x 24"
Collection of the artist

Swimming Lovers, 1984
Oil on chromecoat paper
11" x 16"
Collection of the artist

Study for Bayonne, 1985
Oil on chromecoat paper
26" x 35"
Collection of the artist

Study for Bayonne, 1985
Oil on chromecoat paper
35" x 46"
Collection of the artist

**Study for Portrait of the Artist
as an Old Man,** 1985
Oil on chromecoat paper
16" x 11"
Collection of the artist

Untitled, 1985
Oil on chromecoat paper
12" x 16"
Collection of the artist

**Untitled Study for Floating
Islands,** 1985
Oil on chromecoat paper
23" x 17"
Collection of the artist

Untitled, 1987
Oil on chromecoat paper
39" x 50"
Marianne and Harvey Bernstein,
New York, USA

Untitled, 1996
Oil on chromecoat paper
23" x 19"
Collection of the artist

Untitled, 1999
Watercolor on paper
40" x 60"
Jablonka Galerie, Cologne

Untitled, 1999
Watercolor on paper
60" x 40"
Private collection, courtesy
Jablonka Gallery, Cologne

Untitled, 1999
Watercolor on paper
59" x 40"
Private collection, Dublin

Untitled, 1999
Watercolor on paper
60" x 40"
Private collection

Untitled, 1999
Watercolor on paper
60" x 40"
Private collection

Untitled, 1999
Watercolor on paper
60" x 40"
Douglas S. Cramer

Untitled, 2001
Watercolor on paper
60" x 40"
Collection of the artist

Untitled, 2001
Watercolor on paper
60" x 40"
Collection of the artist

Untitled, 2001
Watercolor on paper
60" x 40"
Collection of the artist

Untitled, 2001
Watercolor on paper
60" x 40"
Collection of the artist

Untitled, 2001
Watercolor on paper
60" x 40"
Collection of the artist

Untitled, 2001
Watercolor on paper
60" x 40"
Collection of the artist

SOLO SHOWS

2003
Eric Fischl: Das Esters Projekt,
 Museum Haus Esters, Krefeld
The Drawing and Sculpture
 of Eric Fischl: A Post-Modern
 Prometheus, MacLaren Art
 Centre, Barrie
Mary Boone Gallery, New York

2001
Eric Fischl: Paintings, Works
 on Paper, Jablonka Galerie,
 Cologne

2000
Gagosian Gallery, London
Mary Boone Gallery, New York

1999
Galerie Daniel Templon, Paris
Mary Boone Gallery, New York
Eric Fischl: Unique Works,
 Mary Ryan Gallery, New York
Mario Diacono Gallery, Boston

1998
Eric Fischl: Sculpture, Gagosian
 Gallery, New York
Eric Fischl: Recent Paintings
 and Works on Paper, Galleria
 Lawrence Rubin, Milan

1997
Works on Paper, 1996–1997,
 Baldwin Gallery, Aspen, CO
Saint-Tropez: Photographies,
 Galerie Daniel Templon, Paris

1996
Mary Boone Gallery, New York
Eric Fischl: Prints and Monotypes,
 Numark Gallery, Washington DC

1995
Eric Fischl: Solar Intaglio Prints,
 Alexa Lee Gallery, Ann Arbor, MI
Michael Nagy Fine Art, Potts
 Point, Sydney

1994
Eric Fischl: Œuvres Récentes,
 Galerie Daniel Templon, Paris
Daniel Weinberg Gallery,
 San Francisco
Eric Fischl: Watercolors, Off Shore
 Gallery, East Hampton, NY
Eric Fischl: The Travel of Ro-
 mance, Mary Boone Gallery,
 New York
Eric Fischl: New Paintings and
 Watercolors, Laura Carpenter
 Fine Art, Santa Fe, NM

1993
Eric Fischl: New Solar Plate In-
 taglio Prints, Mary Ryan Gallery,
 New York
Galería Soledad Lorenzo,
 Madrid

1992
St. Tropez 1982–1988: Photo-
 graphs, Michael Kohn Gallery,
 Santa Monica, CA
Eric Fischl Drawings, Montgomery
 Museum of Fine Arts, Mont-
 gomery, AL; Center for the Fine
 Arts, Miami
Mary Boone Gallery, New York

1991
Scenes and Sequences, The Hood
 Museum of Art, Dartmouth Col-
 lege, Hanover, NH
Aarhus Kunstmuseum
Louisiana Museum of Modern Art,
 Humlebæk
Eric Fischl: A Cinematic View,
 Guild Hall Museum, East Hamp-
 ton, NY
Eric Fischl Drawings, Milwaukee
 Art Museum, Milwaukee

1990
Akademie der Bildenden Künste,
 Vienna
Musée Cantonal des Beaux-Arts
 de Lausanne
Koury-Wingate Gallery, New York
Scenes and Sequences, Frederick
 Wight Art Gallery, University
 of California, Los Angeles; Walk-
 er Art Center, Minneapolis, MN;
 Yale University Art Museum,
 New Haven, CT
Eric Fischl: Photographs and
 Prints, Cleveland Center for Con-
 temporary Art, Cleveland
Mary Boone Gallery, New York
Eric Fischl: A Survey of Etchings,
 Woodcuts, and Monotypes from
 the Past Decade, Mary Ryan
 Gallery, New York

1989
Waddington Galleries, London

1988
Eric Fischl: Bilder und Zeichnun-
 gen, Galerie Michael Werner,
 Cologne
Mary Boone Gallery, New York

1987
Mary Boone Gallery, New York
Sable-Castelli Gallery, Toronto
Eric Fischl: Scenes Before the Eye,
 Contemporary Arts Center,
 Honolulu, HI; The Baltimore Mu-
 seum of Art; The Saint Louis Art
 Museum

1986
Eric Fischl: Paintings, Whitney
 Museum of American Art,
 New York
Mary Boone Gallery, New York
Larry Gagosian Gallery,
 Los Angeles

Daniel Weinberg Gallery, Los An-
 geles
Eric Fischl: Scenes Before the Eye,
 University Art Museum, Califor-
 nia State University, Long Beach,
 CA; University Art Museum,
 University of California, Berke-
 ley, CA

1985
Eric Fischl Paintings, Mendel Art
 Gallery, Saskatoon; Stedelijk
 Van Abbe Museum, Eindhoven;
 Kunsthalle Basel; Institute of
 Contemporary Arts, London;
 Art Gallery of Ontario, Toronto;
 Museum of Contemporary Art,
 Chicago
Sable-Castelli Gallery, Toronto
Eric Fischl: The Works on Glassine,
 1970–1980, Mario Diacono
 Gallery, Boston

1984
Mary Boone Gallery, New York
Currents, Institute of Contempo-
 rary Art, Boston

1983
Eric Fischl: Paintings, Sir George
 Williams Art Galleries, Concordia
 University, Montreal
Eric Fischl: Dessins, Saidye Bronf-
 man Centre, Montreal
Larry Gagosian Gallery, Los An-
 geles
Birthday Boy, Mario Diacono
 Gallery, Rome
Multiples/Marian Goodman Incor-
 porated, New York
Nigel Greenwood Gallery, London

1982
Edward Thorp Gallery, New York
University of Colorado Art Gal-
 leries, Boulder, CO
Sable-Castelli Gallery, Toronto

1981
Sable-Castelli Gallery, Toronto
Edward Thorp Gallery, New York

1980
Edward Thorp Gallery, New York
Eric Fischl: Paintings and Draw-
 ings, Emily Davis Art Gallery,
 University of Akron, Akron, OH

1978
Galerie B., Montreal

1976
Studio, Halifax
Galerie B., Montreal

1975
Bridge Shield Shelter, Dalhousie
 Art Gallery, Halifax

GROUP EXHIBITIONS

2003

*Jasper Johns to Jeff Koons:
Four Decades of Art from the
Broad Collections,* Guggenheim
Bilbao
*Pictura Magistra Vitae: I nuovi
simboli della pittura contempo-
ranea,* Fondazione Cassa di
Risparmio, Bologna

2002

*Modernism and Abstraction:
Treasures from the Smithsonian
American Art Museum,* National
Academy Museum, New York;
Des Moines Art Center, Des
Moines, IA; Oakland Museum of
California, Oakland
*Another World: Twelve Bedroom
Stories,* Kunstmuseum Luzern
Living Room, Jablonka Galerie,
Cologne
*Art Downtown: New York Painting
and Sculpture,* 48 Wall Street,
New York
*Jasper Johns to Jeff Koons: Four
Decades of Art from the Broad
Collections,* Corcoran Gallery
of Art, Washington DC; Museum
of Fine Arts, Boston
*Der Akt in der Kunst des 20. Jahr-
hunderts,* Kunsthalle Bremen

2001

*Jasper Johns to Jeff Koons: Four
Decades of Art from the Broad
Collections,* Los Angeles County
Museum of Art, Los Angeles
*Modernism and Abstraction:
Treasures from the Smithsonian
American Art Museum,* Memorial
Art Gallery of the University of
Rochester, Rochester, NY;
Allentown Art Museum, Allen-
town, PA; First Center for the
Visual Arts, Nashville, TN;
Worcester Art Museum, Worces-
ter, MA
*Mythic Proportions: Painting in
the 1980s,* Museum of Contem-
porary Art, North Miami, FL

2000

A Plurality of Truths, Schick Art
Gallery, Skidmore College,
Saratoga Springs, NY
Szenenwechsel XVII, Museum
für Moderne Kunst, Frankfurt am
Main
*Modernism and Abstraction:
Treasures from the Smithsonian
American Art Museum,* The Art
Museum at Florida International
University, Miami; Colby College
Museum of Art, Waterville, ME
*Dreams 1900–2000: Science, Art,
and the Unconscious Mind,*
The Equitable Gallery New York;

Historisches Museum der
Stadt Wien, Vienna; Binghamp-
ton University Art Museum,
Binghampton, NY; Passage de
Retz, Paris
*David Salle, Francesco Clemente,
Eric Fischl,* Gagosian Gallery,
New York
*Convergence: The Hamptons Since
Pollock,* Nassau County Museum
of Art, Roslyn Harbor, NY
*Hypermental: Wahnhafte Wirk-
lichkeit 1950–2000. Von Salva-
dor Dalí bis Jeff Koons,* Kunst-
haus Zürich; Hamburger Kunst-
halle
Modern Art Despite Modernism,
The Museum of Modern Art,
New York
*Modern Contemporary Art at
MoMA since 1980,* The Museum
of Modern Art, New York

1999

*Dreams 1900–2000: Science,
Art, and the Unconscious Mind,*
The Equitable Gallery New York
*The American Century: Art &
Culture 1900–2000,* Whitney
Museum of American Art,
New York
Aspen Art Museum, Aspen, CO
Figuration, Ursula Blickle Stiftung,
Kraichtal; Museion Museum für
moderne Kunst, Bolzano;
Rupertinum Museum für moder-
ne und zeitgenössische Kunst,
Salzburg
Szenenwechsel XVI, Museum
für Moderne Kunst, Frankfurt am
Main
*Decades in Dialogue: Perspectives
on the MCA Collection,* Museum
of Contemporary Art, Chicago

1998

*Cleveland Collects Contemporary
Art,* The Cleveland Museum
of Art, Cleveland, OH
*Ideal and Reality: the Image of the
Body in 20th-Century Art;
from Bonnard to Warhol; Works
on Paper,* Rupertinum Museum
für moderne und zeitgenössische
Kunst, Salzburg
Anos 80/The Eighties, Culturgest,
Lisbon
The Centennial Open, The Parrish
Art Museum, Southampton, NY
Five Artists: the Body/the Figure,
Carpenter Center for the Visual
Arts, Harvard University, Cam-
bridge, MA
Family Viewing, The Museum of
Contemporary Art, Los Angeles
*Modern Collection from the
Ho-Am Art Museum,* Ho-Am Art
Museum, Yongin

1997

*Views from Abroad: European
Perspectives on American Art 3,*
Whitney Museum of American
Art, New York
*Singular Impressions: The Mono-
type in America,* National Mu-
seum of American Art, Smithson-
ian Institution, Washington DC
Feminine Image, Nassau County
Museum of Art, Roslyn Harbor,
NY
Myths and Magical Fantasies,
California Center for the Arts
Museum, Escondido, CA
The PaineWebber Art Collection,
San Diego Museum of Art,
San Diego; Center for the Fine
Arts, Miami
*Get Real: Contemporary American
Realism from the Seavest Col-
lection,* Duke University Museum
of Art, Durham, NC

1996

American Academy in Rome,
Annual Exhibition
NowHere, Louisiana Museum of
Modern Art, Humlebæk
*The Robert and Jane Meyerhoff
Collection,* National Gallery
of Art, Washington DC
The PaineWebber Art Collection,
Museum of Fine Arts, Boston;
Minneapolis Institute of Arts,
Minneapolis
*Thinking Print: Books to Bill-
boards, 1980–95,* The Museum
of Modern Art, New York
*Views from Abroad: European Per-
spectives on American Art 2/
Die Entdeckung des anderen:
Ein europäischer Blick auf die
amerikanische Kunst 2,* Museum
für Moderne Kunst, Frankfurt
am Main; Whitney Museum of
American Art, New York

1995

The PaineWebber Art Collection,
Detroit Institute of Arts, Detroit
L'Effet Cinéma, Musée d'Art
Contemporain de Montréal,
Montreal
25 Americans: Painting in the 90s,
Milwaukee Art Museum, Mil-
waukee
*Silent & Violent: Ausgewählte Künst-
lereditionen,* MAK Center for Art
and Architecture, Los Angeles

1994

*23 Artistes pour Médecins du
Monde,* L'Orangerie du Jardin de
Luxembourg, Paris; Galerie
Enrico Navarra, Paris, New York,
Tokyo; Harcourts Gallery,
San Francisco; Molinar Gallery,
Scottsdale, AZ; Jan Abrams

Gallery, Los Angeles; Fondation
Ebel, Villa Turque, La Chaux-de-
Fonds

1993

Strange Hotel, Aarhus Kunst-
museum
*Four Friends: Eric Fischl, Ralph
Gibson, April Gornik, Bryan Hunt,*
The Murray and Isabella Rayburn
Foundation, New York

1992

*Dürer to Diebenkorn: Recent Ac-
quisitions of Art on Paper,* Na-
tional Gallery of Art, Washington
DC
Drawing Redux, San Jose Muse-
um of Art, San Jose, CA
*American Realism and Figurative
Art: 1952–1990,* Sogo Museum
of Art, Yokohama; Tokushima
Modern Art Museum, Tokushima;
Museum of Modern Art, Shiga;
Kochi Prefectural Museum
of Folk Art, Kochi

1991

*American Realism and Figurative
Art: 1952–1990,* The Miyagi
Museum of Art, Sendai, Miyagi
Interactions, Institute of Contem-
porary Art, Philadelphia
1991 Biennial Exhibition, Whit-
ney Museum of American Art,
New York
*Setting the Stage: Contemporary
Artists Design for the Performing
Arts,* The Columbus Museum
of Art, Columbus, OH
*Mito y magia en America: Los
Ochenta,* Museo de Arte Con-
temporaneo de Monterrey
Sieben amerikanische Maler,
Bayerische Staatsgemäldesamm-
lungen, Staatsgalerie moderner
Kunst, Munich
Forbidden Games, Jack Tilton
Gallery, New York
Master Drawings: 1520–1990,
Janie C. Lee Master Drawings at
65 Thompson Street, New York
Anni 80: Artisti a New York, Palaz-
zo delle Albere, Museo Provin-
ciale d'Arte Sezione Contempo-
raneo, Trento
*Domenicos Theotocopoulos: A
Dialogue,* Philippe Briet Gallery,
New York
*Devil on the Stairs: Looking Back
on the Eighties,* Institute of
Contemporary Art, Philadelphia

1990

Eighty/Twenty, Edmonton Art
Gallery, Edmonton
Drawing Highlights, Parrish Art
Museum, Southampton, NY

The Last Decade: American Artists of the 80s, Tony Shafrazi Gallery, New York

Affinities and Intuitions: the Gerald S. Elliott Collection of Contemporary Art, The Art Institute of Chicago

The Unique Print: 70s into 90s, Museum of Fine Arts, Boston

1989

Eighty/Twenty, Kitchener-Waterloo Art Gallery, Kitchener; Art Gallery of Windsor, Ontario

Figure as Subject: the Revival of Figuration Since 1975, Madison Art Center, Madison, WI

Suburban Home Life: Tracking the American Dream, Whitney Museum of American Art at Philip Morris, New York

Nocturnal Visions in Contemporary Painting, Whitney Museum of American Art at Equitable Center, New York

Bilderstreit, Museum Ludwig, Cologne

Viennese Divan: Sigmund Freud Nowadays, Museum des 20. Jahrhunderts, Vienna

Morality Tales: History Painting in the 1980s, Duke University Museum of Art, Durham, NC; Sheldon Memorial Art Gallery, University of Nebraska, Lincoln, NE; Musée de Quebec, Quebec City

1988

Eighty/Twenty, Art Gallery of Nova Scotia, Halifax

Figure as Subject: the Revival of Figuration Since 1975, Whitney Museum of American Art, New York; Erwing A. Ulrich Museum of Art, Wichita State University, Wichita, KS; Arkansas Art Center, Little Rock, AR; Amarillo Art Center, Amarillo, TX; Utah Museum of Fine Arts, University of Utah, Salt Lake City

Master Workshop Exhibition, Long Island University, Southampton, NY

The World of Art Today, Milwaukee Art Museum, Milwaukee

Drawing on the East End, 1940–1988, Parrish Art Museum, Southampton, NY

Contemporary American Art, Sara Hildén Art Museum, Tampere; Kunstnernes Hus, Oslo

Cal Arts: Skeptical Belief(s), Newport Harbor Art Museum, Newport Beach, CA

Morality Tales: History Painting in the 1980s, The Berkshire Museum, Pittsfield, MA; Wadsworth Atheneum, Hartford, CT; The Lowe Art Museum, University of Miami, Coral Gables, FL; Goldie Paley Gallery, Moore College of Art, Philadelphia

Past/Imperfect: Eric Fischl, Vernon Fisher, Laurie Simmons, Contemporary Arts Center, Cincinnati; Institute of Contemporary Art, University of Pennsylvania, Philadelphia

1987

Cal Arts: Skeptical Belief(s), The Renaissance Society, University of Chicago

Morality Tales: History Painting in the 1980s, Independent Curators Incorporated, New York; Grey Art Gallery and Study Center, New York University, New York; Laguna Art Museum, Laguna Beach, CA

Stations, Montreal International Center for Contemporary Arts, Montreal

Documenta 8, Museum Fridericianum, Kassel

The Viewer as Voyeur, Whitney Museum of American Art at Philip Morris, New York

Avant-Garde in the Eighties, Los Angeles County Museum of Art, Los Angeles

Past/Imperfect: Eric Fischl, Vernon Fisher, Laurie Simmons, Walker Art Center, Minneapolis; Knight Gallery/Spirit Square Center for the Arts, Charlotte, NC

State of the Art, Institute of Contemporary Arts, London

1986

An American Renaissance: Painting and Sculpture Since 1940, Museum of Art, Fort Lauderdale, FL

Origins, Originality, and Beyond, Art Gallery of New South Wales, Sydney; Biennial of Sydney

Europa/Amerika, Museum Ludwig, Cologne

Individuals: A Selected History of Contemporary Art, 1945–1986, Museum of Contemporary Art, Los Angeles

Collection of Douglas S. Cramer, Cincinnati Art Museum, Cincinnati

Still Life/Life Still, Michael Kohn Gallery, Los Angeles

The Success of Failure, Independent Curators Incorporated, New York

1985

Carnegie International, Carnegie Institute of Modern Art, Pittsburgh

XIII Biennale de Paris, Grande Halle du Parc de la Villette, Paris

1985 Biennial Exhibition, Whitney Museum of Modern Art, New York

Nine Printmakers and the Working Process, Whitney Museum of American Art, New York

New Art 85, ARCA, Marseille

Sable-Castelli Gallery, Toronto

Daniel Weinberg Gallery, Los Angeles

1984

Back to the USA, Württembergischer Kunstverein, Stuttgart

Content, Hirshhorn Museum and Sculpture Garden, Washington DC

Paradise Lost/Paradise Regained: American Visions of the New Decade, Biennale Venice

American Neo-Expressionists, Aldrich Museum of Contemporary Art, Ridgefield, CT

An International Survey of Recent Painting and Sculpture, Museum of Modern Art, New York

Via New York, Musée d'Art Contemporain, Montreal

Visions of Childhood: A Contemporary Iconography, Whitney Museum of American Art at Philip Morris, New York

The Human Condition: SFMOMA Biennial III, San Francisco Museum of Modern Art, San Francisco

Tendencias en Nueva York, Palacio de Velazquez, Madrid

Aspekte amerikanischer Kunst der Gegenwart, Neue Galerie, Sammlung Ludwig, Aachen; Nordjyllands Kunstmuseum, Aalborg; Henie-Onstad Art Center, Høvikodden; Mittelrheinisches Landesmuseum, Mainz; Städtische Galerie Schloß Oberhausen

Modern Expressionists, Sidney Janis Gallery, New York

New Painting, The Krannert Art Museum, Champaign, IL

Painting and Sculpture Today, Indianapolis Museum of Art, Indianapolis

Drawings After Photography, Allen Memorial Art Museum, Oberlin College, Oberlin, OH

Large Drawings, Allen Memorial Art Museum, Oberlin College, Oberlin, OH

Szene New York: Sonderschau Art Cologne Internationaler Kunstmarkt, 15.–21. November 1984, Art Cologne

New American Painting: A Tribute to James and Mari Michener, Archer M. Huntington Art Gallery, College of Fine Arts, University of Texas, Austin, TX

The Seventh Dalhousie Drawing Exhibition, Dalhousie Art Gallery, Halifax

American Art Since 1970, Whitney Museum of American Art, New York

1983

1983 Biennial Exhibition, Whitney Museum of American Art, New York

Mary Boone and Her Artists, Seibu Museum of Art, Tokyo

New York Now, Kunstverein für die Rheinlande und Westfalen, Düsseldorf

Back to the USA, Kunstmuseum Luzern; Rheinisches Landesmuseum, Bonn

New York Painting Today, Three Rivers Arts Festival, Pittsburgh, PA

The Painterly Figure, Parrish Art Museum, Southampton, NY

Reallegory, The Chrysler Museum, Norfolk, VI

Group Drawing Exhibition, Daniel Weinberg Gallery, Los Angeles

Self Portraits, Linda Farris Gallery, Seattle, WA

Paintings, Mary Boone Gallery, New York

Small Works, Bonnier Gallery, New York

American Still Life, Contemporary Arts Museum, Houston

Art Itinera 83: Continuing Interest in Painting, Castiglioncello-Castello Paquini

Faces Since the Fifties, Center Gallery, Bucknell University, Lewisburg, PA

1982

Focus on the Figure: Twenty Years, Whitney Museum of American Art, New York

Critical Perspectives, P.S. 1, Long Island City, NY

Narrative Settings, Josef Gallery, New York

By the Sea, Barbara Toll Fine Arts, New York

The Expressionist Image: From Pollock to Today, Sidney Janis Gallery, New York

Edward Thorp Gallery, New York

Figures of Mystery, The Queens Museum, Queens, NY

Milwaukee Art Museum, Milwaukee

Drawing: An Exploration of Line, The Maryland Institute, College of Art Galleries, Baltimore

New New York, Florida State University, Tallahassee, FL

1981

Art for Your Collection, Museum of Art, Rhode Island School of Design, Providence, RI

New York: Visiting Artists, Museum of Art, Rhode Island School of Design, Providence, RI
Summer Pleasures, Barbara Gladstone Gallery, New York
Alumni Exhibition, California Institute of the Arts, Valencia, CA
The Reality of Perception, Robeson Center Gallery, Rutgers University, Newark, NJ
Large Format Drawings, Barbara Toll Fine Arts, New York
Real Life Magazine, Nigel Greenwood Gallery, London
Edward Thorp Gallery, New York

1980
Aspects of Canadian Painting in the Seventies, Glenbow Museum, Calgary

1979
Edward Thorp Gallery, New York
The Great Big Drawing Show, P.S. 1, Long Island City, NY

1978
Neun kanadische Künstler, Kunsthalle Basel
Edward Thorp Gallery, New York
Coasts, the Sea and Canadian Art, The Gallery Stratford, Ontario

1976
Seventeen Artists: A Protean View, Vancouver Art Gallery

1975
The Canadian Canvas, Time Canada Limited, Toronto

BOOKS AND CATALOGUES

SOLO SHOWS

Jörg S. Garbrecht, "Considering Eric Fischl," Ph.D. diss. Oxford 2002.

Eric Fischl: "The Bed, The Chair...". Paintings and Works on Paper, ed. Kay Heymer, exh. cat. Jablonka Galerie, Cologne 2002.

Arthur C. Danto, Robert Enright and Steve Martin, *Eric Fischl: 1970–2000,* New York 2000.

Eric Fischl: The Bed, The Chair... New Paintings, ed. Ealan Wingate, exh. cat. Gagosian Gallery, London 2000.

Eric Fischl: Inediti su tela e carta, exh. cat. Galleria Lawrence Rubin, Milan 1998.

Eric Fischl: The Travel of Romance, exh. cat. Mary Boone Gallery, New York 1994.

Eric Fischl, exh. cat. Galería Soledad Lorenzo, Madrid 1993.

Eric Fischl: A Cinematic View, exh. cat. Guild Hall Museum, East Hampton, NY, 1991.

Eric Fischl, ed. Jens Erik Sørensen, exh. cat. Aarhus Kunstmuseum; Louisiana Museum for Moderne Kunst, Humlebæk 1991.

Eric Fischl: 17 November to 22 December, 1990, exh. cat. Mary Boone Gallery, New York 1990.

Eric Fischl: Bilder und Zeichnungen/Peintures et dessins, ed. Erika Billeter, exh. cat. Akademie der Bildenden Künste, Vienna; Musée Cantonal des Beaux-Arts, Lausanne 1990.

Scenes and Sequences: Recent Monotypes by Eric Fischl, exh. cat. Hood Museum of Art, Dartmouth College, Hanover, NH, 1990.

Jamaica Kincaid and Eric Fischl, *Annie, Gwen, Lilly, Pam and Tulip,* New York 1989.

Eric Fischl, exh. cat. Waddington Galleries, London 1989.

Eric Fischl: Bilder und Zeichnungen, exh. cat. Galerie Michael Werner, Cologne 1988.

Eric Fischl: 14 May to 25 June, 1988, exh. cat. Mary Boone Gallery, New York 1988.

Eric Fischl and Jerry Saltz, *Sketchbook with Voices,* New York 1988.

Peter Schjeldahl and David Whitney, eds., *Eric Fischl,* New York 1988.

Donald Kuspit, *Fischl [An Interview with Eric Fischl],* New York 1987.

Eric Fischl: Scenes Before the Eye. The Evolution of Year of the Drowned Dog & Floating Islands, ed. Lucinda Barnes, Jane K. Bledsoe and Constance W. Glenn, exh. cat. University Art Museum, California State University, Long Beach, CA, 1986.

Eric Fischl Paintings, exh. cat. Mendel Art Gallery, Saskatoon 1985.

Eric Fischl, exh. cat. Mary Boone/Michael Werner Gallery, New York 1984.

Eric Fischl: Dessins, exh. cat. Centre Saidye Bronfman, Montreal 1983.

Eric Fischl: Paintings, exh. cat. Sir George Williams Art Galleries, Concordia University, Montreal 1983.

Eric Fischl: Paintings and Drawings, exh. cat. Emily Davis Gallery, University of Akron, Akron, OH, 1980.

Bridge Shield Shelter, exh. cat. Dalhousie Art Gallery, Halifax 1975.

CATALOGUES

GROUP EXHIBITIONS

Pictura Magistra Vitae: I nuovi simboli della pittura contemporanea/The New Symbols of Contemporary Painting, exh. cat. Fondazione Cassa di Risparmio, Bologna 2003.

Der Akt in der Kunst des 20. Jahrhunderts, ed. Nils Ohlsen and Achim Sommer, exh. cat. Kunsthalle Emden, 2002.

Jasper Johns to Jeff Koons: Four Decades of Art from the Broad Collections, exh. cat. Los Angeles County Museum of Art, Los Angeles; Corcoran Gallery of Art, Washington DC; Museum of Fine Arts, Boston; Guggenheim Bilbao, 2001.

Hypermental: Wahnhafte Wirklichkeit 1950–2000. Von Salvador Dalí bis Jeff Koons, exh. cat. Kunsthaus Zürich; Hamburger Kunsthalle, 2000.

Modern Art Despite Modernism, ed. Robert Storr, exh. cat. The Museum of Modern Art, New York 2000.

Modern Contemporary Art at MoMA since 1980, ed. Paola Antonelli, Joshua Siegel and Kirk Varnedoe, exh. cat. The Museum of Modern Art, New York 2000.

The American Century: Art & Culture 1900–2000, ed. Barbara Haskell, exh. cat. Whitney Museum of American Art, New York 1999.

Figuration, exh. cat. Ursula Blickle Stiftung, Kraichtal; Museion Museum für moderne Kunst, Bozen; Rupertinum Museum für moderne und zeitgenössische Kunst, Salzburg 1999.

Ideal and Reality: The Image of the Body in 20th-Century Art. From Bonnard to Warhol. Works on Paper, exh. cat. Rupertinum Museum für moderne und zeitgenössische Kunst, Salzburg 1998.

Cleveland Collects Contemporary Art, exh. cat. The Cleveland Museum of Art, Cleveland, OH, 1998.

Anos 80/The Eighties, exh. cat. Culturgest, Lisbon 1998.

Modern Collection from the Ho-Am Art Museum, exh. cat. Ho-Am Art Museum, Yongin 1998.

Get Real: Contemporary American Realism from the Seavest Collection, ed. Virginia Anne Bonito, exh. cat. Duke University Museum of Art, Durham, NC, 1997.

Singular Impressions: The Monotype in America, exh. cat. National Museum of American Art, Smithsonian Institution, Washington DC, 1997.

Feminine Image, exh. cat. Nassau County Museum of Art, Roslyn Harbor, NY, 1997.

Views from Abroad: European Perspectives on American Art 2/ Die Entdeckung des anderen: Ein europäischer Blick auf die amerikanische Kunst 2, ed. Jean-Christophe Ammann and Adam D. Weinberg, exh. cat. Museum für Moderne Kunst, Frankfurt am Main; Whitney Museum of American Art, New York 1996.

Thinking Print: Books to Billboards, 1980–95, ed. David Frankel, exh. cat. The Museum of Modern Art, New York 1996.

The Robert and Jane Meyerhoff Collection, exh. cat. National Gallery of Art, Washington DC, 1996.

Silent & Violent: Ausgewählte Künstlereditionen, ed. Peter Noever, exh. cat. MAK Center for Art and Architecture, Los Angeles 1995.

The PaineWebber Art Collection, New York 1995.

Four Friends: Eric Fischl, Ralph Gibson, April Gornik, Bryan Hunt, exh. cat. The Murray and Isabella Rayburn Foundation, New York; The John and Mable Ringling Museum of Art, Sarasota, FL; Oklahoma City Art Museum, Oklahoma City, OK, 1993.

Strange Hotel: International Art, ed. Jens Erik Sørensen, exh. cat. Aarhus Kunstmuseum, 1993.

Sieben amerikanische Maler, ed. Carla Schulz-Hoffmann, exh. cat. Bayerische Staatsgemäldesammlungen, Staatsgalerie moderner Kunst, Munich 1991.

American Realism and Figurative Art: 1952–1990, exh. cat. The Miyagi Museum of Art, Sendai, Miyagi 1991.

Devil on the Stairs: Looking Back on the Eighties, ed. Robert Storr, exh. cat. Institute of Contemporary Art, Philadelphia, PA; Newport Harbor Art Museum, Newport Beach, CA, 1991.

Bilderstreit: Widerspruch, Einheit und Fragment in der Kunst seit 1960, ed. Johannes Gachnang and Siegfried Gohr, exh. cat. Museum Ludwig, Cologne 1989.

Suburban Home Life: Tracking the American Dream, exh. cat. Whitney Museum of American Art at Philip Morris, New York 1989.

Eighty/Twenty, exh. cat. Art Gallery of Nova Scotia, Halifax 1988.

Figure as Subject: The Revival of Figuration Since 1975, exh. cat. Whitney Museum of American Art, New York 1988.

Contemporary American Art, Sara Hildén Art Museum, Tampere 1988 .

Past/Imperfect: Eric Fischl, Vernon Fisher, Laurie Simmons, exh. cat. Walker Art Center, Minneapolis, MN, 1987.

Documenta 8, exh. cat. Museum Fridericianum, Kassel 1987.

The Viewer as Voyeur, exh. cat. Whitney Museum of American Art at Philip Morris, New York 1987.

Avant-Garde in the Eighties, exh. cat. Los Angeles County Museum of Art, Los Angeles, 1987.

Morality Tales: History Painting in the 1980s, exh. cat. Independent Curators Incorporated, New York 1987.

An American Renaissance: Painting and Sculpture Since 1940, exh. cat. Museum of Art, Fort Lauderdale, FL 1986.

Nine Printmakers and the Working Process, exh. cat. Whitney Museum of American Art, New York 1985.

Carnegie International, exh. cat. Carnegie Institute of Modern Art, Pittsburgh, PA, 1985.

Art of Our Time: The Saatchi Collection 4, London 1984.

Aspekte amerikanischer Kunst der Gegenwart, exh. cat. Neue Galerie, Sammlung Ludwig, Aachen; Nordjyllands Kunstmuseum, Aalborg; Henie-Onstad Art Center, Høvikodden; Mittelrheinisches Landesmuseum, Mainz; Städtische Galerie Schloss Oberhausen, 1984.

Szene New York: Sonderschau Art Cologne Internationaler Kunstmarkt, 15.–21. November 1984, exh. cat. Art Cologne, 1984.

Tendencias en Nueva York: Obra Gráfica, exh. cat. Palacio de Velazquez, Madrid 1984.

Content, exh. cat. Hirshhorn Museum and Sculpture Garden, Washington DC, 1984.

Paradise Lost/Paradise Regained: American Visions of the New Decade, exh. cat. Venice Biennale, 1984.

American Neo-Expressionists, exh. cat. Aldrich Museum of Contemporary Art, Ridgefield, CT, 1984.

An International Survey of Recent Painting and Sculpture, exh. cat. Museum of Modern Art, New York 1984.

Via New York, exh. cat. Musée d'Art Contemporain, Montreal 1984.

Visions of Childhood: A Contemporary Iconography, exh. cat. Whitney Museum of American Art at Philip Morris, New York 1984.

The Painterly Figure, exh. cat. Parrish Art Museum, Southampton, NY 1983.

New York Painting Today, exh. cat. Three Rivers Arts Festival, Pittsburgh, PA, 1983.

Back to the USA, exh. cat. Kunstmuseum Luzern, 1983.

1983 Biennial Exhibition, exh. cat. Whitney Museum of American Art, New York 1983.

Aspects of Canadian Painting in the Seventies, exh. cat. Glenbow Museum, Calgary, 1980.

Ian Carr-Harris, Robin Collyer, Greg Curnoe, Paterson Ewen, Eric Fischl, General Idea, N. E. Thing Co. Ltd., Vincent Tangredi, Shirley Wiitasalo, exh. cat. Kunsthalle Basel, 1978

ARTICLES AND REVIEWS

2002

Ted Fullerton, "The Drawing and Sculpture of Eric Fischl," *Sculpture Review,* fall 2002, vol. 51, no. 3, pp. 13–21

Pernilla Holmes, "Report Card: Eric Fischl," *Art Review,* February 2002, p. 67

David Rakoff, "Post-9/11 Modernism: Controversy over E. Fischl's Statue *Tumbling Woman.* Interview with E. Fischl," *The New York Times Magazine,* 27 October 2002, p. 15

2001

James Kalm, "Figuratively Speaking: Eric Fischl," *NY Arts,* February 2001, pp. 74–75

Edward Leffingwell, "Eric Fischl at Mary Boone," *Art in America,* March 2001, p. 131

Suzanne Slesin, "Paint Box," *House & Garden,* February 2001, pp. 79–89

2000

Louisa Buck, "Fischl's Phases at Gagosian," *The Art Newspaper,* July 2000, p. 73

Jessica Dheere, "Racket Over Nude," *ARTnews,* November 2000, p. 50

Robert Enright, "The Pleasure of Their Company," *Border Crossing,* September 2000, pp. 26–46

William Feaver, "Eric Fischl," *ARTnews,* September 2000, p. 181

"Fischl Sculpts Tennis Memorial," *Art America,* October 2000, p. 200

Martin Herbert, "Eric Fischl," *Tema Celeste,* October 2000, p. 87

Richard Polsky, "Polsky's Pick," *Art & Auction,* November 2000, p. 115

Dinitia Smith, "The Essence of a Tennis Champion, Cast in Bronze," *The New York Times,* 27 July 2000, p. B3

Roberta Smith, "Eric Fischl," *The New York Times,* 15 December 2000, p. E41

Judd Tully, "Gogo's New Gallery a Go in London," *Art & Auction,* June 2000, p. 42

Pilar Viladas, "Posh Spice," *The New York Times Magazine,* 29 October 2000, pp. 75–82

Joyce Wadler, "In Capturing Star, Artist Goes for the Spirit," *The New York Times,* 1 September 2000, p. B2

1999

Bill Arning, "Eric Fischl," *Time Out New York,* 10 June 1999, p. 64

"Eric Fischl," *The New Yorker,* 31 May 1999, p. 17

Robert Enright, "The Former 'Bad Boy' of Painting Turns to Portraits," *The Toronto Globe and Mail,* 29 May 1999, p. C12

Grace Glueck, "In Artist's Prints, Work and Play," *The New York Times,* 5 November 1999, pp. E37, E40

Edward Helmore, "When Likeness Strikes," *Interview,* May 1999, pp. 68–69

Ken Johnson, "Eric Fischl," *The New York Times,* 28 May 1999, p. E32

Lee Klein, "Eric Fischl," *The New York Art World,* June 1999, pp. 12–13

Donald Kuspit, "Eric Fischl," *Artforum International,* October 1999, p. 144

Mario Naves, "Currently Hanging," *The New York Observer,* 14 June 1999, p. 29

Emily Oren, "Why Painting Is a Lot Like Tennis," *Books & Culture,* March 1999, pp. 30–31

Francesco Poli, "Eric Fischl," *Tema Celeste,* May 1999, p. 87

Whitney Scott, "M File Recommends," *Manhattan File,* May 1999, p. 24

Steven Vincent, "Mary Boone Shows Eric Fischl Portraits," *Art & Auction,* 1 May 1999, p. 89

Lilly Wei, "Eric Fischl," *ARTnews,* September 1999, p. 145

Stephen Wright, "Eric Fischl: Inside Out, 1982," *Artforum International,* May 1999, pp. 166–167

1998

Jean-Christophe Ammann, "Schlüsselwerke: Reginald Marsh und Eric Fischl," in Jean-Christophe Ammann, *Das Glück zu sehen: Kunst beginnt dort, wo Geschmack aufhört,* Regensburg 1998, pp. 222–227

Phyllis Braff, "The Works of Art That Inspire the Artist," *The New York Times,* 15 November 1998, SW. LI37

Robert Enright and Eric Fischl, "Core Intimacies: Eric Fischl on the Art of Pierre Bonnard," *Border Crossings,* July 1998, pp. 55–61

Paolo Falcone, "Palermo Vive", *Tema Celeste,* July 1998, p. 86

Grace Glueck, "Eric Fischl," *The New York Times,* 6 February 1998, p. E36

Alan Jones, "New York a Milano," *Tema Celeste,* July 1998, pp. 82–83

Mason Klein, "Eric Fischl," *Artforum International,* May 1998, p. 147

Robert Taplin, "Eric Fischl at Gagosian," *Art in America,* May 1998, p. 121

1997

David Frankel, "Eric Fischl," *Artforum International,* February 1997, p. 86

Gerard Haggerty, "Eric Fischl," *ARTnews,* February 1997, p. 114

"Just One Chance," *ARTnews,* April 1997, p. 99

Carol Strickland, "Writing Novels, in a Painterly Fashion," *The New York Times, Long Island Weekly,* 13 April 1997, p. LI12

1996

Julie L. Belcove, "Fresh Paint," *W Magazine,* October 1996, pp. 198–201

"Eric Fischl," *The New Yorker,* 2 December 1996, p. 23

Michael Kimmelman, "Eric Fischl," *The New York Times,* 1 November 1996, p. C32

Hilton Kramer, "Eric Fischl Goes to Rome, Brings Back Lousy Art," *The New York Observer,* 16 December 1996, pp. 1, 23

Kim Levin, "Art/ShortList: Eric Fischl," *The Village Voice,* 26 November 1996, p. 8

Frederic Tuten, "Fischl's Italian Hours," *Art in America,* November 1996, pp. 76–83, 132

1995

Thomasine Bradford, "Eric Fischl: The Travel of Romance," *Art Papers,* January/February 1995, p. 61

Jean-Luc Chalumeau, "Le peintre en bad boy/The Painter as a Bad Boy," *Ninety: Art des Années 90,* May 1995, pp. 12–13

Andrew Decker, "Art Notebook: Contemporary Studies," *Architectural Digest,* December 1995, pp. 44–54

Eric Fischl, April Gornik, "The Art of the Dive," *Travel & Leisure,* February 1995, pp. 114–119, 152

Catherine Flohic, "Eric Fischl," *Ninety: Art des Années 90,* May 1995, p. 10

Tom Holert, "Kampf um den Körper," *Vogue* (German ed.), April 1995, pp. 200–205, 216

Thomas Hoving, "Art for the Ages," *Cigar Aficionado,* June 1995, pp. 214–226

Kay Larson, "The Return of Painting II: New Image—America," *Atelier,* Japan, November 1995, pp. 67–73

Peter Marks, "A Trapeze, an Artist, a Musician," *The New York Times,* 20 October 1995, p. C2

Sidney Tillim, "Eric Fischl at Mary Boone," *Art in America,* February 1995, pp. 94–95

Charles Wylie, "Eric Fischl: Growing Up in the Company of Women II, 1987," *Saint Louis Art Museum Bulletin,* winter 1995, pp. 18–19

1994

Kenneth Baker, "Domestic Eroticism Fischl's New Focus," *San Francisco Chronicle,* 28 May 1994, p. E1

David Bonetti, "Private Images Exibited for Admiring Public," *San Francisco Examiner,* 20 May 1994, p. C9

"Corps vus," *Connaissance des Arts,* May 1994, p. 14

"Eric Fischl," *The New Yorker,* 26 September 1994, p. 30

Bruce Ferguson, "Eric Fischl: Chez lui, avec les tableaux," *Art Press,* May 1994, pp. 24–32

Paul Gardner, "Fear & Desire," *ARTnews,* September 1994, pp. 160–162

Martin Gayford, "Not Much Like Home," *Modern Painters,* December 1994, pp. 68–73

A. M. Homes, "Eric Fischl," *Bomb,* December 1994, pp. 24–29

France Huser, "Eric Fischl: Paradis artificiels," *L'Officiel,* Paris, May 1994, pp. 186–187, 207

Michael Kimmelman, "New Turn for Fischl: Nudes in a Hard Light," *The New York Times,* 16 September 1994, p. C29

Carol Kino, "Eric Fischl," *ARTnews,* November 1994, p. 154

George Melrod, "What's Old Is New," *Art & Antiques,* October 1994, pp. 35–36

Laurence Pythoud, "Eric Fischl: L'Amérique sur un divan," *L'Œil. Revue d'Art Mensuelle,* Paris, May 1994, pp. 62–63

Juliane Stephan, "Fischls Frau," *Frankfurter Allgemeine Zeitung,* 8 October 1994

Martine Trittoléno, "La vie d'artiste," *Vogue* (French ed.), March 1994, pp. 222–227

1993

Dike Blair, "Eric Fischl," *Flash Art,* June 1993, pp. 116–117

"Cuadros Narrativos," *El País,* Madrid, 7 May 1993, p. 27

Paul Cummings, "Interview: Eric Fischl Talks with Paul Cummings," *Drawing,* January 1993, pp. 101–105

Jose Ramon Danvila, "Eric Fischl: Lo cotidiano y lo irreal," *El Punto de Las Artes,* Madrid, 16 April 1993, p. 5

Victoria Erausquin, "La realidad segun Eric Fischl," *Expansion,* Madrid, 1 May 1993

Miguel Fernandez-Cid, "Proclamar la pintura," *Diario 16,* Madrid, 9 April 1993, p. 73

Miguel Fernandez-Cid, "Eric Fischl: La pintura como una forma de tatuaje," *Diario 16,* Madrid, 23 April 1993, p. 75

Jonathan Goodman, "Eric Fischl," *ARTnews,* June 1993, pp. 125–127

Lorna Holmes, "Eye Level: Eric Fischl," *Zone,* April 1993, pp. 51–54

Mark Irwin, "Suburban Wilderness: On the Paintings of Eric Fischl," *The Denver Quarterly,* 1993, vol. 28, no. 1, pp. 80–82

Fietta Jarque, "Las pinturas de Fischl muestran el impacto perturbador de lo trivial," *El País,* Madrid, 19 April 1993

Carlos Jimenez, "El mejor arte Americano refleja nuestra fracaso," *El Mundo,* Madrid, 14 April 1993

Pablo Jimenez, "Eric Fischl: Una mirada a la realidad," *ABC Cultural,* Madrid, 23 April 1993, p. 33

Richard Kalina, "Painting Snapshots, or the Cursory Spectacle," *Art in America,* June 1993, pp. 92–95, 118

Jason E. Kaufman, "Eric Fischl," *Atelier,* Tokyo, April 1993, pp. 72–74

Donald Kuspit, "Eric Fischl," *Artforum International,* February 1993, p. 95

Barbara MacAdam, "Eric Fischl," *ARTnews,* February 1993, p. 106

Maria Santos, "America tendria que ir a Bosnia," *Diario 16,* Madrid, 15 April 1993

Evelyn Schels, "Eric Fischl: Nackte Tatsachen," *Elle* (German ed.), April 1993, pp. 90–97

"Space Inventor," *Border Crossings,* February 1993, pp. 36–38

1992

Phyllis Braff, "On the Ocean Fair and/or at Seasides Here and in Europe," *The New York Times, Long Island Weekly,* 2 August 1992

A. D. Coleman, "Surreal Thing?" *British Journal of Photography,* April 1992, pp. 24–25

"Eric Fischl," *The New Yorker,* 7 December 1992, pp. 25, 28

Richard S. Field, "Eric Fischl's Dream Screen," *American Art,* 1992, vol. 6, no. 4, pp. 40–49

Grace Glueck, "Drew's Expressive Power; Fischl's Belly-Flop," *The New York Observer,* 30 November 1992, p. 23

Klaus Honnef, "Über Geschmack läßt sich nicht streiten," in Klaus Honnef, *Kunst der Gegenwart,* Cologne 1992, pp. 137–165

"Lonely America," *Geijutsu Shincho,* March 1992, pp. 34–47

Kristine McKenna, "Cozy Connection," *The Los Angeles Times,* 2 February 1992, Calendar, pp. 4, 82

Roberta Smith, "Art in Review: Eric Fischl in Familiar Territory," *The New York Times,* 4 December 1992, p. C23

1991

Phyllis Braff, "Fischl and Close's Highly Potent Images," *The New York Times, Long Island Weekly,* 23 June 1991, p. 19

Holland Cotter, "Postmodern Tourist," *Art in America,* April 1991, pp. 154–157, 183

Martha Culliton, "Exhibitionism and Skoptophilia: Fischl's Sleepwalker," *Athanor,* 1991, vol. 10, pp. 53–57

G. Roger Denson, "Eric Fischl," *Flash Art,* March 1991, p. 132

Wayne Draznin, "Eric Fischl," *New Art Examiner,* October 1991, p. 42

Elizabeth Hayt-Atkins, "Eric Fischl," *Galleries Magazine,* February 1991, p. 136

Phoebe Hoban, "Artists on the Beach," *New York Magazine,* 1 July 1991, pp. 38–44

Adrienne Lesser, "Paintings Depict Drama," *The Southampton Press,* 13 June 1991, p. B1

James Lewis, "Eric Fischl," *Artforum International,* March 1991, p. 125

Barbara A. Mac Adam, "Eric Fischl," *ARTnews,* February 1991, pp. 133–134

Lars Morell, "Eric Fischl: Billeder af livet i forstæderne. Interview/ Eric Fischl: Paintings of Life in the Suburbs. Interview," *Skala,* 1991, no. 24–25, pp. 30–35

Hearne Pardee, "Eric Fischl," *Art & Antiques,* March 1991, p. 169

Jed Perl, "Eric Fischl," *The New Criterion,* February 1991, p. 56

Dorothy Spears, "Eric Fischl," *Arts Magazine,* March 1991, p. 79

Amei Wallach, "Drawn to the East End," *The Newsday Magazine,* 17 February 1991, pp. 18–19

Amei Wallach, "The Naked and the Dread," *New York Newsday,* 16 June 1991, section 2, pp. 15–16

Bruno Wollheim, "The Obscure Object of Desire," *Modern Painters,* September 1991, pp. 12–15

1990

"Eric Fischl: Photographs and Prints," *Dialogue,* November 1990, p. 46

Andy Grundberg, "Using the Camera as a Guide and Tool in Painting," *The New York Times,* 8 June 1990, p. C21

Ellen Handy, "Eric Fischl," *Arts Magazine,* November 1990, p. 101

Michael Kimmelman, "Eric Fischl Mixes India's Exotic and Mundane Sides," *The New York Times,* 23 November 1990, p. C4

Kay Larson, "Fischl for Compliments," *New York Magazine,* 17 December 1990, p. 76

"Photography," *The New Yorker,* 18 June 1990, p. 15

Carter Ratcliff, "American Nocturnes," *Elle,* January 1990, pp. 64–66

Mona Thomas, "Eric Fischl," *Beaux-Arts Magazine,* June 1990, pp. 116–117

Nancy Kay Turner, "The Serial Image," *Artweek,* May 1990, pp. 15–16

1989

Steven Aronson, "Portrait of the Artists: Eric Fischl and April Gornik on Long Island," *Architectural Digest,* April 1989, pp. 234–239

"The Art of Quotation: Interview with Robert Rosenblum," *Art and Design,* December 1989, pp. 6–15

Mary Rose Beaumont, "Eric Fischl," *Arts Review,* January 1989, p. 17

Bruce Ferguson, "Camera Ready," *Border Crossings,* September 1989, pp. 69–75

Let Geerling, "Kunst Zonder Eigenschappen," *Archis,* August 1989, pp. 46–51

James Hall, "Neo-Geo's Bachelor Artists," *Art International,* December 1989, pp. 30–35

Joyce Hanson, "Artnotes: Diamonds in the Buff," *New Art Examiner,* September 1989, p. 76

Oystein Hjort, "Kunst, Kitsch, Überkitsch: Nogle af 80-ernes amerikanske kunstnere," *Kritik,* 1989, no. 88, pp. 86–103

Philip Mechanicus, "Eric Fischl," *Avenue,* November 1989, pp. 66–72

Thomas West, "Figure Painting in an Ambivalent Decade," *Art International,* December 1989, pp. 22–29

Rick Woodward, "Film Stills," *Film Content,* March 1989, pp. 51–54

1988

Nancy Grimes, "Eric Fischl," *ARTnews,* September 1988, p. 153

Robert Hughes, "Discontents of the White Tribe," *Time,* 30 May 1988, p. 71

Toshiharu Ito, "Place of Convulsive Sex: Changes of Fischl's Visual Image," *Mizue,* July 1988, pp. 42–55

Philip Jodidio, "Eric Fischl: Une exposition à la Collection Saatchi," *Connaissance des Arts,* November 1988, pp. 126–127

Hilton Kramer, "Fischl Exhibit in the City: Artist in Desperate Need of a Gimmick," *The New York Observer,* 13 June 1988, pp. 1, 10

Carl Little, "Eric Fischl," *Art in America,* September 1988, pp. 183–184

Catherina Liu, "Eric Fischl," *Flash Art,* October 1988, p. 112

Bernard Marcade, "Entre symptome et stéréotype: Eric Fischl ou le réalisme œdipien petit-bourgeois," *Artstudio,* December 1988, pp. 80–89

Daniela Morera, "Ritratti d'Artista: Eric Fischl," *L'Uomo Vogue,* December 1988, pp. 130–132, 244–245

Robert C. Morgan, "The Spectrum of Object-Representation," *Arts Magazine,* October 1988, pp. 78–80

"Recent Acquisitions by the Cincinnati Art Museum," *The Cincinnati Art Museum Bulletin,* December 1988, pp. 5–25

Robert Rosenblum, "Eric Fischl," *Contemporanea,* May 1988, pp. 62–65

John Russell, "Eric Fischl," *The New York Times,* 20 May 1988, p. C23

Richard Shone, "Long, Buckley and the Saatchi Collection," *Burlington Magazine,* 1988, vol. 130, no. 1029, pp. 945–946

Phyllis Tuchman, "Storytelling on Canvas," *Newsday,* 3 June 1988, p. 17

Lawrence Weschler, "The Art of Eric Fischl," *Interview,* May 1988, pp. 62–70

Thomas West, "Eric Fischl," *Art International,* fall 1988, pp. 81–82

1987

Crocker Caulson, "Too Much Too Soon?" *ARTnews,* September 1987, pp. 115–119

Carol Diehl, "Double or Nothing: What Happens When Two Artists Live Together?" *Art & Antiques,* February 1987, pp. 73–80

Susan Freudenheim, "Suburban Hamlets," *Artforum International,* May 1987, pp. 134–140

Gregory Galligan, "The Painterly Logic in Eric Fischl," *Arts Magazine,* May 1987, pp. 18–19

Enrique Garcia-Herraiz, "Eric Fischl," *Goya,* May/June 1987, p. 364

John Loughery, "Eric Fischl," *Arts Magazine,* March 1987, p. 108

Vivien Raynor, "Art: 'Viewers as Voyeur,' At a Whitney Branch," *The New York Times,* 15 May 1987, p. C23

Dinitia Smith, "Art Fever," *New York Magazine,* 20 April 1987, pp. 34–43

Sidney Tillim, "Eric Fischl at Mary Boone," *Art in America,* April 1987, pp. 214–215

1986

"Album: Eric Fischl," *Arts Magazine,* March 1986, pp. 114–115

James Auer, "Fischl's Art Probes and Pains Beneath our Modern Masks," *Milwaukee Journal,* 5 January 1986, p. 8

David Bailey, "Men to Look at Men to Watch," *Vogue,* June 1986, p. 251

Robert Berlind, "Eric Fischl at the Whitney and Mary Boone," *Art in America,* May 1986, p. 153

Michael Brenson, "Is Neo-Expressionism an Idea Whose Time Has Passed?" *The New York Times,* 5 January 1986, section 2, pp. 1, 12

Arthur C. Danto, "Art: Eric Fischl," *The Nation,* 31 May 1986, pp. 769–772

"Eric Fischl," *Current Biography,* June 1986, pp. 13–16

"Eric Fischl," *Domus,* February 1986, p. 73

Jack Flam, "Staring at Fischl," *The Wall Street Journal,* 6 January 1986, p. 18

Lawrence Gipe, "A Retreat to Unresolved Devices," *Artweek,* April 1986, p. 5

Nancy Grimes, "Eric Fischl's Naked Truths," *ARTnews,* September 1986, pp. 70–78

Eleanor Heartney, "Eric Fischl: Whitney Museum; Mary Boone," *ARTnews,* June 1986, pp. 141–142

John Howell, "Hot Artists, Suburban Muse," *Elle,* September 1986, pp. 294–296

Gary Indiana, "Peeping Tom," *The Village Voice,* 18 March 1986, p. 85

Ray Kass, "Current Milestones," *Dialogue,* April 1986, pp. 17–19

Donald Kuspit, "Eric Fischl: Whitney Museum of American Art; Mary Boone," *Artforum International,* June 1986, pp. 123–125

Kay Larson, "The Naked Edge," *New York Magazine,* 10 March 1986, pp. 58–59

Kay Larson, "Basement Bargains," *New York Magazine,* 7 April 1986, p. 74

Michael Laurence, "Eric Fischl," *The West Hollywood Paper,* 17 April 1986, p. 1–2

Douglas McGill, "Probing Society's Taboos—on Canvas," *The New York Times,* 2 March 1986, section 2, pp. 1, 12

Amy McNeish, "Lust in Suburbia," *House & Garden,* April 1986, p. 44

Suzanne Muchnic, "The Art Galleries, La Cienega Area," *The Los Angeles Times,* 18 April 1986, section IV, p. 12

Cynthia Nadelman, "A Star-Struck Carnegie International," *ARTnews,* March 1986, pp. 115–118

Jed Perl, "Storytellers," *The New Criterion,* May 1986, pp. 57–63

John Russell, "Art: At the Whitney, 28 Eric Fischl Paintings," *The New York Times,* 21 February 1986, p. C25

John Russell, *Eric Fischl, The New York Times,* 14 March 1986, p. C26

Daniela Salvioni, "Eric Fischl: Mary Boone and the Whitney Museum," *Flash Art,* June 1986, pp. 54–55

Peter Schjeldahl, "Eric Fischl's Vanity," *Art and Text,* April 1986, pp. 56–58

Mark Stevens, "Sex and Success," *The New Republic,* 21 April 1986, pp. 25–27

Calvin Tomkins, "The Art World, Real and Unreal," *The New Yorker,* 12 May 1986, pp. 99–101

Marjorie Welish, "Contesting Leisure: Alex Katz and Eric Fischl," *Artscribe,* June 1986, pp. 45–47

William Wilson, "Eric Fischl's Mock Taboos of Daily Life," *The Los Angeles Times,* 27 April 1986, pp. 1–2

1985

Avis Berman, "Artist's Dialogue: Eric Fischl, Trouble in Paradise," *Architectural Digest,* December 1985, pp. 72–79

Monica Bohm-Duchen, "Eric Fischl, ICA London," *Flash Art,* October/November 1985, pp. 56–57

Joan Borsa, "Eric Fischl: Representations of Culture and Sexuality," *Vanguard,* April 1985, pp. 20–23

Dan Cameron, "A Whitney Wonderland," *Arts Magazine,* June 1985, pp. 66–69

Bice Curiger, "Eric Fischl," *Artscribe,* July/August 1985, pp. 24–28

Robert Enright, "Eric Fischl," *Canadian Art,* March 1985, pp. 70–75

Eric Fischl, "Figures and Fiction," *Aperture,* December 1985, pp. 56–59

Stephen Godfrey, "Fischl Exhibit Raises Eyebrows," *The Toronto Globe and Mail,* 25 April 1985, p. 17

Stellan Holm, "Eric Fischl," *Clic,* March 1985, no. 3, pp. 36–38

Klaus Honnef, "Nouvelle Biennale de Paris," *Kunstforum International,* May–June 1985, vol. 79, pp. 216–232

Robert Hughes, "Careerism and Hype Amidst the Image Haze," *Time,* 17 June 1985, pp. 78–83

Verena Kulenkampff, "Chronist alltäglicher Schrecken: Die bösen Bilder des Eric Fischl," *Art,* June 1985, no. 6, pp. 56–65

Donald Kuspit, "The Success of Failure," *Artforum International,* April 1985, p. 92

Jhim Lamoree, "Drama's uit het familie-album," *Haagse Post,* 20 April 1985, pp. 48–49

Kay Larson, "The Bad News Bearers," *New York Magazine,* 8 April 1985, pp. 72–73

Kay Larson, "Boomtown Hype—and Real Quality," *New York Magazine,* 17 June 1985, pp. 46–47

Lisa Liebmann, "At the Whitney Biennial: Almost Home," *Artforum International,* June 1985, pp. 56–61

Gillian MacKay, "A Bold Visionary of the Forbidden," *Maclean's,* Canada, 25 February 1985, vol. 98, pp. 73–74

Gerald Marzorati, "I Will Not Think Bad Thoughts," *Parkett,* no. 5, 1985, pp. 8–30

Gerald Marzorati, "Picture Puzzles: The Whitney Biennial," *ARTnews,* summer 1985, pp. 74–78

Jeff Perrone, "The Salon of 1985," *Arts Magazine,* June 1985, pp. 70–73

Robert Pincus-Witten, "Entries: Analytical Pubism," *Arts Magazine,* February 1985, pp. 85–86

Annelie Pohlen, "Eric Fischl, Kunsthalle Basel," *Kunstforum International,* July–September 1985, vol. 80, pp. 288–289

"Prints & Photographs Published," *The Print Collector's Newsletter,* May/June 1985, pp. 55–59

Vivien Raynor, "Art: Paintings at French Gallery Reflect City Life," *The New York Times,* 31 March 1985, p. 52

Barbara Rose, "Fischl," *Vogue,* November 1985, pp. 402–405, 462

John Russell, "Whitney Presents Its Biennial Exhibition," *The New York Times,* 22 March 1985, p. C23

Peter Schjeldahl, "Post-Innocence: Eric Fischl and the Social Fate of American Painting," *Parkett,* no. 5, 1985, p. 32–43

Roberta Smith, "Endless Meaning at the Hirshhorn," *Artforum International,* April 1985, p. 81–85

Robert Storr, "Eric Fischl ou les plaisirs désenchantés," *Art Press,* March 1985, pp. 42–45

Valentin Tatransky, "Eric Fischl," *Arts Magazine,* January 1985, pp. 37–38

Anna Tilroi, "Fischl keert vuilnisbak met untieme leven om," *De Volkskrant,* 19 April 1985, pp. 99–101

Elizabeth Venant, "Fischl Mines the Morality of Eroticism," *The Los Angeles Times,* 28 April 1985, Kalender, pp. 4–5

John Yau, "Eric Fischl," *Artforum International,* February 1985, pp. 85–86

1984

Kenneth Baker, "Eric Fischl: Year of the Drowned Dog," *The Print Collector's Newsletter,* July/August 1984, pp. 81–84

Gary Indiana, "The 'Private' Collector," *The Village Voice,* 23 October 1984, pp. 79–81, 85

Kristian Jensen, "Amerikansk kunst fra New York i dag," *Kunstavisen,* 30 October 1984, p. 12

Kay Larson, "The Real Things," *New York Magazine,* 16 July 1984, pp. 58–59

Lisa Liebmann, "Eric Fischl's Year of the Drowned Dog: Eight Characters in Search of an Autumn," *Artforum International,* March 1984, pp. 67–69

Ida Panicelli, "Eric Fischl, Galleria
Mario Diacono," *Artforum Inter-
national,* March 1984, p. 105
Roberta Smith, "Eric Fischl,"
The Village Voice, 30 October
1984, p. 108
Mark Stevens, "How to Make a
Splash," *Newsweek,* 5 Novem-
ber 1984, pp. 85–86
Robert Storr, "Desperate Plea-
sures," *Art in America,* Novem-
ber 1984, pp. 124–130

1982
Eric Fischl, "I Don't Think Expres-
sionism is the Issue," statement
in Carter Ratcliff, "Expressionism
Today: An Artist's Symposium,"
Art in America, December 1982,
pp. 60–62

This catalogue is published
in conjunction with the exhibition

Eric Fischl. Paintings and Drawings 1979–2001
Kunstmuseum Wolfsburg
13 September 2003–4 January
2004

EXHIBITION

Concept Annelie Lütgens
Art handling Eva Gebhard
Conservation Christiane Altmann
Exhibition office Carmen Müller

Kunstmuseum Wolfsburg

Porschestraße 53
38440 Wolfsburg
Germany
Tel. +49/5361/26690
Fax +49/5361/266966
info@kunstmuseum-wolfsburg.de
www.kunstmuseum-wolfsburg.de

CATALOGUE

Concept Annelie Lütgens,
Gerard Hadders, Andreas Tetzlaff
(Buro Plantage, Schiedam, NL)
Editing Annelie Lütgens
Copy editing Hans Harbort
Translations Malcolm Green
(Gijs van Tuyl, Victoria von
Flemming), Eileen Laurie (Annelie
Lütgens, Carolin Bohlmann)
Graphic design
Gerard Hadders, Andreas Tetzlaff
(Buro Plantage, Schiedam, NL)
Reproduction
Repromayer, Reutlingen
Printed by
Dr. Cantz'sche Druckerei,
Ostfildern-Ruit

© 2003 Kunstmuseum Wolfsburg,
Hatje Cantz Verlag, Ostfildern-Ruit,
and authors
© 2003 for the reproduced works by
Eric Fischl: Eric Fischl
© George Platt Lynes by The Kinsey
Institute for Research in Sex, Gender
and Reproduction, Inc.

Published by
Hatje Cantz Verlag
Senefelderstraße 12
73760 Ostfildern-Ruit
Germany
Tel. +49/711/44050
Fax +49/711/4405220
www.hatjecantz.de

Distribution in the US
D.A.P., Distributed Art
Publishers, Inc.
155 Avenue of the Americas,
Second Floor
New York, N.Y. 10013-1507
USA
Tel.: +1/212/6271999
Fax.: +1/212/6279484

ISBN 3-7757-1379-4 (English)
ISBN 3-7757-1378-6 (German)

Printed in Germany

Jacket illustration (front): Eric Fischl,
The Bed, The Chair, Dancing, Watching, 2000, oil on linen, 69" x 78",
Arnold and Anne Kopelson, Beverly
Hills, CA, USA
Jacket illustration (back): Eric Fischl,
Scene from around a Reflecting Pool
(detail), 1993, Oil on linen,
58" x 64", Private collection, France